S hell is delighted to be the principal sponsor of *Van Gogh*: *His sources, genius and influence*, one of the most important exhibitions to come to Australia in recent years. The event provides Australians with a wonderful opportunity to see many of Vincent van Gogh's greatest paintings in a selection which deepens our understanding of the artist's life and work.

We are grateful to Art Exhibitions Australia Limited, the National Gallery of Victoria and the Queensland Art Gallery for enabling us to join them as partners in such an exceptional enterprise.

For Shell, the exhibition provides a welcome opportunity to make a further contribution to Australian cultural life. At the same time it will deepen and strengthen the close ties between The Netherlands and Australia.

I hope that as many Australians as possible will take the opportunity to see this outstanding exhibition, an event which is unlikely to be repeated.

Ric Charlton
*Chairman and Chief Executive Officer*
Shell Australia Limited

# VAN GOGH

## HIS SOURCES, GENIUS AND INFLUENCE

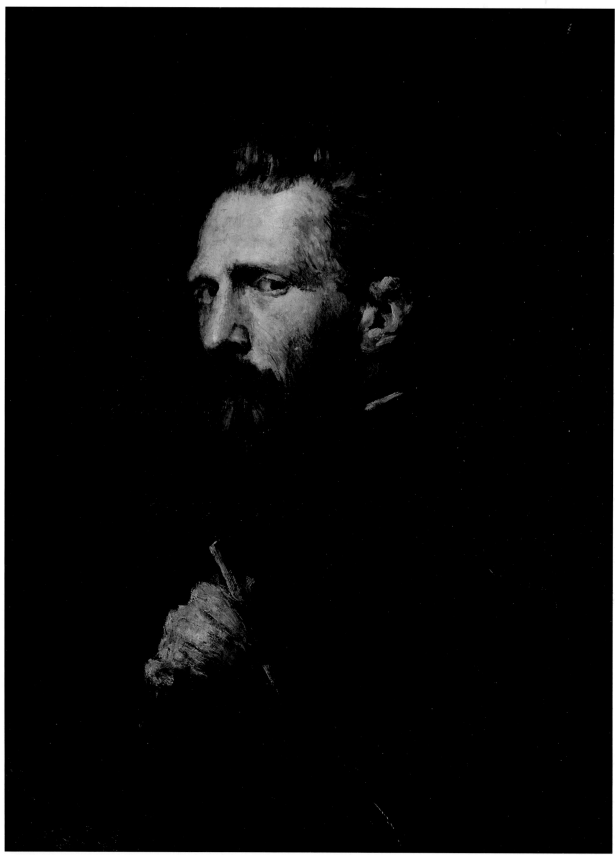

FRONTISPIECE: CAT. 1

John Peter Russell *Portrait of Vincent van Gogh* 1886

oil on canvas  60.0 x 45.0 cm

Vincent van Gogh Foundation  Van Gogh Museum, Amsterdam

[CATALOGUE ENTRY SEE PAGE 110]

*Shell presents*

# VAN GOGH
## *HIS SOURCES, GENIUS AND INFLUENCE*

CURATOR
James Mollison

ASSISTANT CURATOR
Peter Denham

WITH ESSAYS BY Dr Wilfred Niels Arnold
AND Dr Christopher Allen

EDITOR
Judith Ryan

Indemnified by the Australian Government and the State Governments of Victoria and Queensland

**National Gallery of Victoria — Art Exhibitions Australia Limited**

Published by Art Exhibitions Australia Limited
98 Cumberland Street, The Rocks,
Sydney, New South Wales, Australia, 2000.

National Library of Australia Cataloguing-in-Publication data:

*Shell presents*
*Van Gogh: His sources, genius and influence*

Bibliography
Includes index
ISBN 1 875460 05 5
ISBN 1 875460 06 3 (Sponsor edition)
ISBN 1 875460 07 1 (Special edition)

1. Gogh, Vincent van, 1853–1890 - Exhibitions. 2. Painting,
Dutch - Exhibitions. 3. Painting, Modern - 19th century -
Netherlands - Exhibitions. I. Gogh, Vincent van, 1853–1890.
II. Mollison, James, 1932–. III. Ryan, Judith. IV. Arnold, Wilfred
Niels, 1936–. V. Allen, Christopher, 1953–. VI. National Gallery
of Victoria. VII. Art Exhibitions Australia Limited

759.949207494

*Shell presents*
*Van Gogh: His sources, genius and influence*

© Art Exhibitions Australia Limited 1993

First edition

Editor: Judith Ryan
Designer: Jo Waite
Finished art: Niki Vounoridis
Word processor: Judy Shelverton
Typesetter: Typographical Services
Printer: Frank Daniels Pty Ltd
Colour separations: Show Ads

### Exhibition Dates

**National Gallery of Victoria**
19 November 1993 – 16 January 1994

**Queensland Art Gallery**
22 January – 13 March 1994

**Organized by the National Gallery of Victoria
in association with Art Exhibitions Australia
Limited**

Indemnified by the Australian Government and the
State Governments of Victoria and Queensland

## EDITOR'S NOTE

All exhibits are reproduced in colour.

One work, Cat. 53, Picasso's *Still Life* 1901 is for exhibition in
Queensland only.

Dimensions are given in centimetres; height precedes width.

A number preceded by the letter 'F' refers to the standard
de la Faille catalogue of the paintings and drawings of Vincent
van Gogh, on which the dating is based.

References to Vincent's correspondence give first the letter
number in the Complete Letters, then the place and the date of
the letter, based on the Dutch 4 volume edition of Van Gogh's
letters. 'LT' indicates a letter from Vincent to Theo; 'W' a letter
from Vincent to his youngest sister Wilhemina; 'R' a letter from
Vincent to fellow Dutch artist Anthon van Rappard; and 'B' a
letter from Vincent to artist friend Emile Bernard.

Catalogue entries have been prepared by various contributors,
as follows:
Beverley Bradshaw [Cat. 38]
Jane Clark [Cat. 32,33]
Sonia Dean [Cat. 9,10,17,18,19,20,22,23,34]
Peter Denham [Cat. 49,52,55,56,57,58,59,60,61]
Geoffrey Edwards [Cat. 16,31]
Tony Ellwood [Cat. 35]
Henry Gaughan [Cat. 12]
Terence Lane [Cat. 2,4,26]
Cathy Leahy [Cat. 28]
Margaret Legge [Cat. 11,29,39,41,42,48,50]
John McPhee [Cat. 46,47]
James Mollison [Cat. 8, page 60]
Felicity St John Moore [Cat. 24,43,44,45]
Paul Paffen [Cat. 3,5,6,7,13,14,15,21,30]
Judith Ryan [Cat. 27,54]
Geoffrey Smith [Cat. 1,36,37,40,51,53]
Susan van Wyk [Cat. 25]

The index has been compiled by Martel Denham.

# INTRODUCTION

The work of Vincent van Gogh — so little known when the artist was alive — is now universally acclaimed. Much of this recognition, however, has been mistakenly based on the romantic myth of his life.

When Robert Edwards, Chief Executive of Art Exhibitions Australia Limited, and I visited The Netherlands to obtain support for this show, we attempted to borrow works which would demonstrate the clear progression of the artist's work. Our intention was to show Vincent's art together with paintings by artists who influenced him and followed his example. This approach enabled us to gain the support of the two museums with the largest collections of his work: the Van Gogh Museum, Amsterdam and the State Museum Kröller-Müller, Otterlo.

We could never afford to mount a full-scale retrospective of the art of Vincent van Gogh. In making our selection, we soon came to the realization that we were dealing with the art of the possible. In the light of major exhibitions and the retrospective held in 1990 to celebrate the centenary of the artist's death, we decided to present an overview of what these exhibitions had achieved. *Shell presents Van Gogh: His sources, genius and influence* reveals Vincent van Gogh's debt to a wide range of artistic influences, provides a survey of his own singular style and confirms that his work was a great inspiration to certain artists in the years immediately following his death.

To represent Vincent van Gogh's unique achievement, we selected works by those artists with whom Van Gogh was familiar at the start of his career. A man of diverse tastes, his nineteenth-century sources included British narrative artists, Dutch artists of The Hague School, French Barbizon painters, and the Impressionists and Neo-Impressionists of Paris. All proved influential as he progressed towards his own remarkable output.

Unfortunately the great majority of Van Gogh's drawings and many of his paintings are now too fragile to travel. Those we have chosen from his short, highly productive career, enable us to follow the development of his work. We see his tentative beginnings, the brightening of his palette after discovering the high-key colour of the Impressionists, and his phenomenal final period in which his art flourished in the strong sun of the South of France.

A severe critic of his own work, Van Gogh would not have foreseen that his art would serve as an inspiration to the following generation of artists. The exhibition concludes with works by a number of the leading artists from the early twentieth century which verify Van Gogh's far reaching influence and celebrate the artist as one of the principal figures of the modern movement.

When we visited Ronald de Leeuw, Director of the Van Gogh Museum, Amsterdam, after twenty minutes he wished us well with our exhibition and for this we owe him many thanks. I hope that *Shell presents Van Gogh: His sources, genius and influence* will make good our statement to him that we wanted our show to bring about a better understanding of the man and at the same time provide a greater appreciation of his art.

James Mollison AO
*Director and Curator of the exhibition*

# FOREWORD

**S**hell presents *Van Gogh: His sources, genius and influence* provides, for the first time in Australia, real insights into Van Gogh's work in the context of his life and times and with reference to the significant artists who came before and after him.

Art Exhibitions Australia Limited is delighted to be one of the partners involved in the organization of an exhibition of such enduring importance. This event is a prime example of the purpose for which our Company was established with a brief to initiate and manage major exhibitions with long lead times, management complexity and a high degree of financial exposure. In the case of this project, the first initiative to bring Van Gogh to Australia was taken as long ago as 1988.

We are especially grateful to our principal sponsor, Shell Australia, for its invaluable contribution to the project, and to our other supporters who have provided such significant assistance to make the exhibition possible, in particular Singapore Airlines, Australian air Express, Sheraton Pacific Hotels and Channel Nine.

Our Company was established to build productive partnerships: without the generosity of our supporters we could not arrange exhibitions of such significance. Those partnerships also include, of course, the fruitful co-operation we have established with Australia's major galleries and museums.

For this important project, the Company has worked in collaboration with the National Gallery of Victoria, especially its Director, James Mollison, whose scholarship, energy and commitment transformed a dream into reality for Australia, and with the Queensland Art Gallery, the other venue at which the exhibition will be shown.

James Mollison and our Chief Executive, Robert Edwards, were successful in negotiating with two great institutions in The Netherlands, the Van Gogh Museum, Amsterdam and the State Museum Kröller-Müller for the loan of the quintessential works which form the core of this exhibition. We are extremely grateful to those lenders, and to the other major galleries around the world who provided works for the exhibition, for their generosity and trust in making this event possible.

Art Exhibitions Australia also greatly appreciates the vital support of many other organizations and individuals, including Dr Simon Levie, whose scholarly advice and practical assistance have been invaluable; the Australian Government, for its crucial Indemnification Scheme administered by the Department of The Arts and Administrative Services; and the State Governments of Victoria and Queensland, which provided additional indemnity to enable such a unique exhibition to tour.

Finally, in thanking those who have contributed so much energy and enterprise to make an exceptional exhibition possible, I simply say to all Australians: whatever you do, don't miss this unique opportunity.

Michael Darling
*Chairman*
Art Exhibitions Australia Limited

# ACKNOWLEDGEMENTS

Frst and foremost, I would like to thank Robert Edwards for having the faith to invite me to curate *Shell presents Van Gogh: His sources, genius and influence*. This exhibition could not have been realized in Australia without the financial and administrative support of Art Exhibitions Australia Limited, and the staff and Trustees of the National Gallery of Victoria are proud to be its partner in the exhibition.

I would like to express my gratitude to all those individuals without whose willing support for our proposal this exhibition would never have happened. The substantial support of Ronald de Leeuw, Director of the Van Gogh Museum, Amsterdam and Dr Evert J. van Straaten, Director of the State Museum Kröller-Müller gave us the foundation on which the exhibition is based. Even with these loans, the exhibition would not have been possible without the generous support of so many other lenders throughout the world, importantly Earl A. Powell III, Director of the National Gallery of Art, Washington and Peter P. M. de Boer of the Stichting Collectie P. en N. de Boer. I would also like to thank Stephanie Barron and Judi Freeman, Los Angeles Museum of Art; Dr Joseph Brown, Melbourne; Françoise Cachin, Musée d'Orsay, Paris; Edmund Capon, Art Gallery of New South Wales, Sydney; Betty Churcher, National Gallery of Australia, Canberra; Timothy Clifford, National Galleries of Scotland, Edinburgh; Prof. Dr Helmut Friedel, Städtische Galerie im Lenbachhaus, Munich; Prof. Dr Dieter Honisch, Staatliche Muzeen zu Berlin, Nationalgalerie; Clay Johnson III, Suzanne Barnes and Kimberley Bush, Dallas Museum of Art; Yasuo Kamon, Bridgestone Museum of Art, Tokyo; Lou and Brenda Klepac, Sydney; Dr Ulrich Luckhardt, Hamburger Kunsthalle; Dr Mario-Andreas von Lüttichau, Museum Folkwang, Essen; Patrick McCaughey, Wadsworth Atheneum, Hartford; Neil MacGregor, National Gallery, London; Philippe de Montebello and Gary Tinterow, The Metropolitan Museum of Art, New York; M. Teresa Ocaña, Museu Picasso, Barcelona; Richard E. Oldenburg and Riva Castleman, The Museum of Modern Art, New York; Ron Radford, Art Gallery of South Australia, Adelaide; Dr Manfred Reuther, Nolde-Stiftung, Seebüll; Dr Katharina Schmidt, Offentliche Kunstsammlung Basel; Alan Shestack, Museum of Fine Arts, Boston; Tomas Llorens Serra, Fundación Colección Thyssen-Bornemisza, Madrid; Nicholas Serota, Tate Gallery, London; Dr D. P. Snoep, Frans Halsmuseum, Haarlem; Mikinosuke Tanabe, The National Museum of Western Art, Tokyo; David Thomas, Bendigo Art Gallery and Deirdre Wilmott, State Library of Victoria, for their generosity and co-operation.

This exhibition would have been beyond our means without the fundamental support of the Australian Government and the State Governments of Victoria and Queensland. A project of this scale entails enormous expenditure and we are fortunate to have Shell Australia as our major sponsor. Ric Charlton, Chairman and Chief Executive Officer, first heard the show mentioned at a meeting of the Business Council of the National Gallery of Victoria. It is his unwavering support that has made this exhibition financially possible. The National Gallery of Victoria is also indebted to the many other supporters, acknowledged elsewhere, whose assistance is integral to the success of this project.

The organization and assemblage of this exhibition have been extremely complex undertakings. The project began as an act of faith that such an exhibition would promote a broader appreciation of art in this country. I would especially like to thank Dr Simone Levie, formerly Director of the Rijksmuseum, Amsterdam and a proven friend of Australia and Australians, who helped to procure the loan of essential works. I would also like to thank David Jaffé, NGV Felton Bequest Advisor, London, the large team at the National Gallery of Victoria and the staff of Art Exhibitions Australia Limited, whose names are mentioned elsewhere, for providing vital assistance in organizing the exhibition and compiling the catalogue. I am especially grateful to Peter Denham for the work he has done to facilitate every aspect of this exhibition and I am in debt in terms of the content and shape of the catalogue to Judith Ryan, who continues to be a model for our profession.

As Director and as representative of the Gallery it is a privilege to be able to introduce a public event of this importance and as Curator it has been a great honour to work with so many brilliant people on the exhibition.

James Mollison AO

# CONTENTS

Facing page: Detail of Cat. 42

Vincent van Gogh *The green vineyard* F475

Arles September 1888  oil on canvas  72.0 x 92.0 cm

State Museum Kröller-Müller  Otterlo, The Netherlands

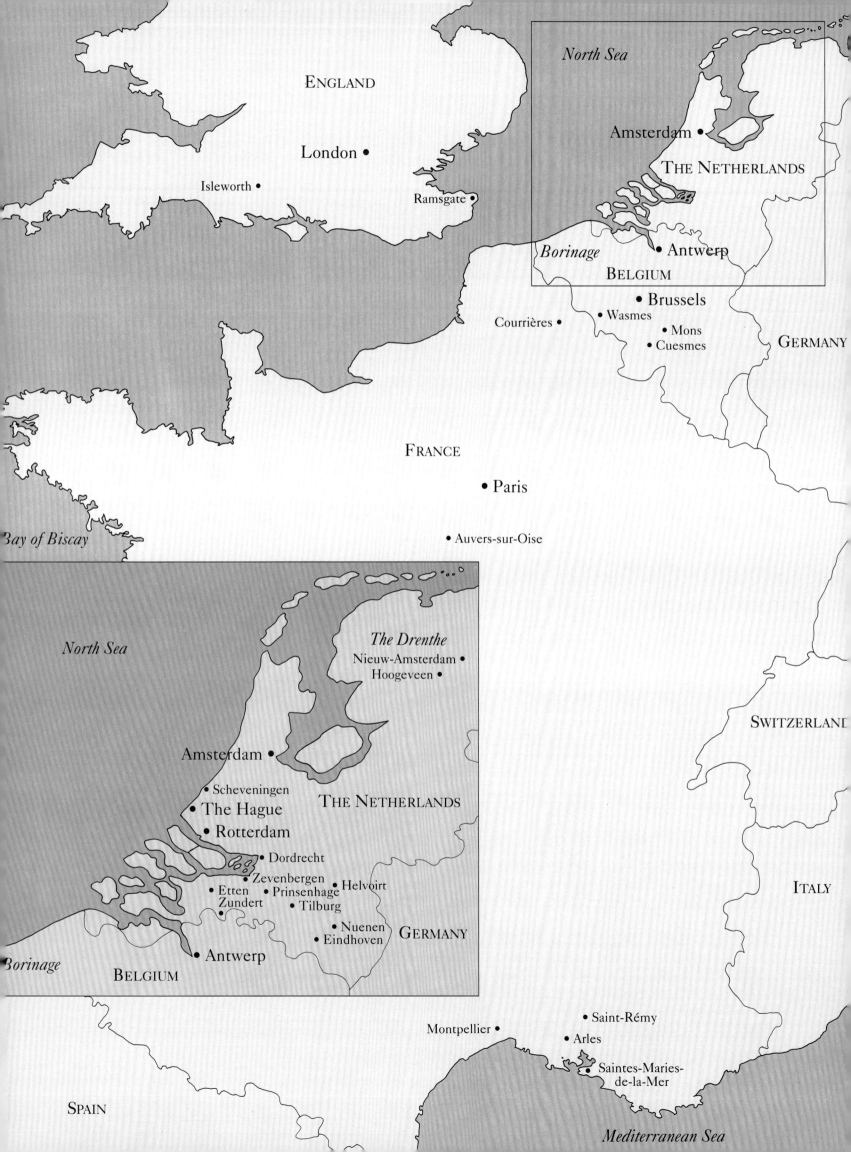

# VINCENT VAN GOGH
## *VITA*

Vincent van Gogh was a wonderfully accomplished artist whose work is now widely appreciated. The extraordinary aspects of the man complement the interest in his creations. His career began with uncertainty, looked for a while like a vocational circus; but then he decided to be an artist and thereafter was diligent in study and practice, exhibited an abiding commitment, and maintained a laser-like focus.[1] Periodically, there were medical crises, personal problems, bizarre happenings, and devastating disappointments, and yet he always returned to glorious productivity. Vincent[2] died on 29 July 1890, at the peak of artistic power, of complications from a self-inflicted gunshot wound. He had walked the earth for thirty-seven years; only ten as an artist. Whilst we celebrate Vincent's artistic legacy in this important exhibition and stand in awe of his genius, the facts of his life as revealed in his letters, demand close attention.

## FAMILY AND SCHOOLING

Vincent Willem van Gogh was born on 30 March 1853, in the little town of Zundert in the south west of Holland towards the Belgium border and named after his two grandfathers. He was the first surviving child of Theodorus van Gogh (1822–85), a Calvinist pastor from Benschop. Vincent's mother, Anna van Gogh *née* Carbentus (1819–1907), was the daughter of a bookbinder and bookseller in The Hague. Her sister Cornelia also married into the Van Gogh family, to Uncle Vincent, who started a modest shop in The Hague for artists' supplies and built it into a large, financially successful art gallery. Uncle Cent, as he was called by Vincent and his siblings, amalgamated with the renowned art dealers Goupil & Cie (Co.) of Paris in 1858. The double familial attachment to Anna and Theodorus van Gogh was largely responsible for Vincent's obtaining a position at Goupil's where he worked in The Hague, London and Paris for close to seven years.

Two other uncles on his father's side were prominent in the art world. Uncle Hein (Hendrik van Gogh) had shops in Rotterdam then Brussels, the latter being quite successful and eventually taken over by Goupil. Uncle Cor (Cornelis van Gogh) founded his own art company in Amsterdam in 1862; this house was also influential in Holland. The artistic environment created by the extended family, Vincent's exposure to art within Goupil & Cie as well as his visits to some of the best museums of Europe, and his rubbing shoulders with artists and connoisseurs: all played an inestimable role in the future development of Vincent van Gogh as a creative artist. These exposures to art complemented his meagre years of primary and secondary schooling.

Vincent attended a village school in Zundert, and then in 1864 transferred to a private boarding school in Zevenbergen. After two years he made sufficient progress to be admitted with

[1] W. N. Arnold, *Vincent van Gogh: Chemicals, Crises, and Creativity*. Birkhäuser, Boston, 1992. This source should be consulted for a more detailed account and further references.

[2] The artist preferred to use the first name alone for professional purposes, after the precedents of Rembrandt (van Rijn) (1606–69) and others.

Facing page
Western Europe with inset of The Netherlands, showing places where Van Gogh lived and worked.

good standing to the new, well-endowed, State Secondary School in Tilburg. Here he received superior instruction in Dutch, German, French, English, arithmetic, history, geography, botany, zoology, drawing, calligraphy, and gymnastics.[3] This period lasted a little less than two years. He had received a solid high school education. His reasons for not finishing the last term, returning to Zundert, and not taking up employment for another year have not surfaced.

## ART DEALER

On 30 July 1869, Vincent became a junior clerk with the branch of Goupil & Cie in The Hague (Fig. 1). He received at least one increase in salary during this period of close to four years. Armed with a good recommendation from the manager, H. G. Tersteeg, Vincent transferred in mid May of 1873 to the London office of Goupil. He received another salary increase but the once obliging assistant changed into a judgemental and verbal connoisseur. His preoccupation with activities outside those of his employ was a recurring theme in the years before he dedicated himself to painting; for instance, reading English literature while working in the London gallery, perusal of the Bible during the last sojourn in the Paris gallery, being more inclined to talk about either art or religion than books in the Dordrecht bookstore, absorbing art instead of Latin while preparing for the ministry in Amsterdam, and writing about paintings rather than religion during his studies in Brussels.

During the London period Vincent suffered the first of at least three unhappy and inept love affairs in his life. He visited home briefly in June 1874, spent a few months at the head office, returned to London, and then, much to his displeasure, was assigned to Paris in May 1875.

After several discussions involving his father, Uncle Cent, and Mr Boussod (the company was now called Boussod, Valadon & Cie, successors to Goupil & Cie), it was mutually agreed that Vincent should resign effective 1 April 1876. The immediate cause of the employers' chagrin was Vincent's going home (now Etten) at Christmas, when gallery sales were usually brisk. But he had already found his own way from a newspaper advertisement: he was to be a teacher in a boys' school located at Ramsgate, on the east coast of England.

## SCHOOL TEACHER

It was a non-salaried position; the headmaster, Mr Stokes, provided only room and board. A few months later the school was moved to Isleworth, closer to London. The job had no future and Vincent started to think about becoming a clergyman, or at least an evangelist, but was surprised to learn that he was too young. He did receive a small stipend from a Reverend Jones for reading Bible stories to young children at nearby Turnham Green. This opportunity proved fulfilling, and grew into an assistantship in the Methodist church in Richmond. Vincent offered a couple of sermons but was homesick and, after returning to Etten for Christmas, tendered his resignation.

## BOOKSELLER

After a short break Vincent assumed a position in January 1877 with Blussé and Van Braam, booksellers of Dordrecht, Holland. He was a clerk for about thirteen weeks. His duties were keeping records and giving advice on artistic prints rather than actually waiting on customers. He carried out a mission of kindness to his birthplace in Zundert to visit a sick farmer, spent the

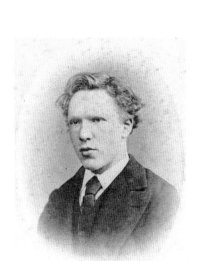

Fig. 1 Vincent in 1871
when he was attached to the Goupil
& Cie branch in The Hague
Vincent van Gogh Foundation
Van Gogh Museum, Amsterdam

3  H. F. J. M. Van den Eerenbeemt, 'Van Gogh in Tilburg', *Brabantia*, November 1971.

night in the churchyard, and experienced a warm feeling about pastoral work. The notion of theological study entered his head and just had to be addressed. After a short visit to Etten he was ready to undertake preliminary private lessons in Greek and Latin; he would live in Amsterdam after May 1877 with his Uncle Jan (Johannes van Gogh) and seek advice from Uncle Johannes (Johannes Stricker, brother-in-law to Vincent's mother).

## THEOLOGIAN

The Reverend Stricker was a noted preacher in Amsterdam and he gave Vincent some private lessons on the doctrine of the church. He also recommended Dr Mendes da Costa, a scholar of classical languages to assist in preparation for the state university entrance examination. It would have taken Vincent seven years to become fully qualified in theology; he lasted one year in preparative studies and did not take the test. In mid July 1878 Vincent, his father, and the Revd Jones of Isleworth approached the School of Evangelization in Brussels about entry into a three-year course.

A three months' probationary period as a novice in the Laeken school, near Brussels, was terminated by Vincent who undertook Bible teaching further to the south, in the Borinage district. In Pâturages he also volunteered to visit the sick, and in January 1879 was named acting pastor of Wasmes, near Mons. The Revd Theodorus van Gogh visited the Borinage in March and was utterly dismayed with his son's lifestyle, which included renouncing the comforts of even modest living quarters, and donating to the poor miners the clothes off his back. The discomfort of the son was compounded by non-renewal of his contract after June 1879. Disillusioned with formal religion, and torn between evangelism and art, Vincent van Gogh entered a period that is best described as wandering.

## WANDERER

The middle of August 1879 found him back in Etten. He spent all of his time reading Charles Dickens, Harriet Beecher Stowe, Victor Hugo and Jules Michelet. On one occasion father and son walked together to Prinsenhage to see Uncle Cent's paintings but, under steadily increasing animosity on the home front, Vincent returned to the Borinage and lived on irregular gifts from his father and brother Theo (1857–91) (Fig. 2). Later he would wonder, 'How can I be useful, of what service can I be? *There is something inside of me, what can it be?*'.[4]

In the same letter Van Gogh made at least three additional and important points. First, on the comparison between literature and visual art he wrote: 'The love of books is as sacred as the love of Rembrandt — I even think the two complement each other ... My God, how beautiful Shakespeare is! Who is mysterious like him? His language and style can indeed be compared to an artist's brush, quivering with fever and emotion. But one must learn to read, just as one must learn to see and learn to live.'

Secondly, about religion he wrote: 'I must tell you that with evangelists it is the same as with artists. There is an old academic school, often detestable, tyrannical, the accumulation of horrors, men who wear a cuirass, a steel armour of prejudice and conventions ... I think that everything which is really good and beautiful — of inner, moral, spiritual and sublime beauty in men and their works — comes from God ... the best way to know God is to love many things. Love a friend, a wife, something — whatever you like.'

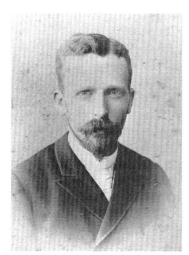

Fig. 2 Vincent's brother
Theodorus (Theo) van Gogh in Paris
photograph 1889
Vincent van Gogh Foundation
Van Gogh Museum, Amsterdam

4  LT133, Cuesmes, July 1880, *The Complete Letters of Vincent van Gogh*, 3 vols, ed. J. van Gogh-Bonger, Thames and Hudson, London, 1988. The numbering of letters follows this standard source, but the dating follows that of the 1990 4 volume Dutch edition of the letters.

Thirdly, he declared that, 'A very necessary study is that of medicine; there is scarcely any-body who does not try to know a little of it, who does not try to understand what it is about, and you see I do not yet know one word about it.' The thoughts expressed here set the stage for the future. They also served to rationalize for himself, as well as Theo, the substitution of artistic creativity for evangelical work. He proposed that the two activities were equally acceptable to a supreme being.

## ARTIST

The next letter to Theo, dated 20 August 1880, gives a clear indication of Vincent's determina-tion to be an artist.[5] Vincent wrote about busily sketching large drawings based upon depictions of peasant life by Jean-François Millet (1814–75). He also requested more prints from Theo, and mentioned writing to Tersteeg for Bargue's *Cours de Dessin* (Course in drawing).[6] Eighteen days later he announced completion of ten sheets after Millet and sixty sheets of Bargue's exercises. He was off and running as an artist.

A sudden move to Brussels, to be near art and artists and to have more room, occurred in October 1880. Vincent gravitated to the branch of Goupil & Cie to seek local advice. He also followed Theo's suggestions and contacted Willem Roelofs, a successful Dutch painter living in Brussels, and Anthon van Rappard (1858–92), a serious but unfulfilled artist who had studied in the Academies of Amsterdam and Paris before moving to Brussels. Vincent continued with the exercises of Bargue and also took some lessons in perspective. The six months in Brussels were artistically bright, but living conditions were dim.

By January 1881 Vincent contemplated a move to The Hague, where he could receive more help from Tersteeg, who had already sent him books on anatomy and the Bargue manual, and from the artist Anton Mauve (1838–88), his cousin by marriage. In the next letter he men-tioned drawing *for the third time* all the exercises of Bargue. His father (Fig. 3) was embarrassed by Vincent's wretched life style, but the immediate reason for Vincent's departure from Brussels in April was the opportunity to see Theo, who was visiting the family in Etten.

### Etten

He continued to draw, and was visited twice by Van Rappard (see Cat. 8). In September 1881 Vincent was encouraged by Mauve to start painting, but the event of the year was Vincent's unrequited love for a widowed cousin, Kee Vos, the second daughter of the Revd J. P. Stricker. Theo sent money so that Vincent could visit the lady at home and make a renewed plea. It is of interest to note that on the way to Amsterdam Vincent stopped off for a month in The Hague to receive instruction from Mauve, and that he spent the bulk of the stipend on the affairs of art rather than the heart. As it turned out, Vincent was refused audience with the girl and banished by the angry father. The consequences were also felt at home and contributed to his father's decision to kick him out on Christmas day 1881. Vincent went to The Hague and obtained quarters not far from Anton Mauve.

### The Hague

The immediate response from Mauve and several other artists was social co-operation and a will-ingness to share techniques. The promise of a joyous and productive period was soon threatened

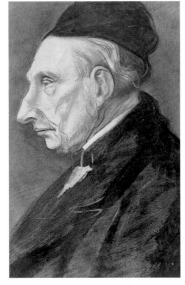

Fig. 3 Vincent van Gogh
*The artist's father Theodorus van Gogh*
F876 Etten July 1881
pencil, ink and wash 33.0 x 25.0 cm
Mrs A. R. W. Nieuwenhuizen
Segaar-Aarse, The Hague

5 LT134, Cuesmes, 20 August 1880.
6 A three-volume series of exercises
in anatomical drawings.

4

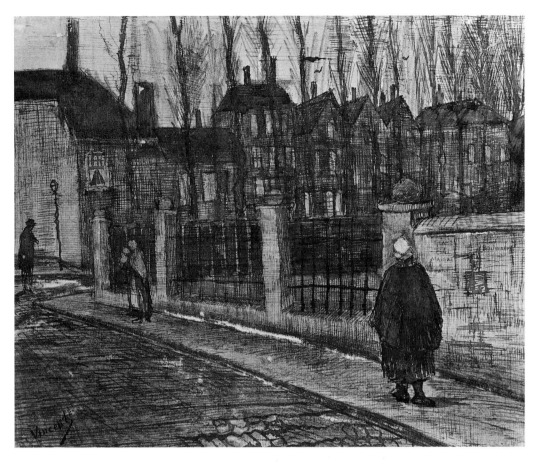

Fig. 4 Vincent van Gogh
*Jewish quarter of The Hague,*
*The Paddemoes* F918
The Hague February–March 1882
pen and ink, pencil 25.0 x 31.0 cm
State Museum Kröller-Müller,
Otterlo, The Netherlands

by a bout of illness towards the end of January 1882, but the next week he recovered sufficiently to resume his art work.

Van Gogh made progress with his drawings. Tersteeg bought a small one for 10 guilders, and Uncle Cor commissioned twelve small views of the city for 30 guilders. He finished the drawings in a few weeks. His uncle was so pleased that he ordered six more; these took longer to complete. Vincent delivered seven pieces including two large drawings which today are considered among his best (Fig. 4). The artist hoped for more orders but he received 20 guilders and no comment. His relationship with Mauve deteriorated.

Vincent had taken up with a pregnant prostitute, Clasina (Sien) Hoornik (see Cat. 28), who was three years his senior. Her four-year-old daughter, ten-year-old sister, and mother, rounded out the instant family. They served as free models for Vincent but the added expense of support was too much to be covered by Theo's regular stipend. As her pregnancy progressed Sien had problems and Vincent dutifully assisted her to a hospital in Leyden for attention. He planned to marry her.

In June 1882 Theo was surprised to receive a letter describing Vincent's gonorrhea infection. He had been hospitalized but was back in his studio by 1 July. The hospitalization had a bizarre corollary: Vincent claimed that attending physicians were willing to attest to his sanity. He was convinced that his father had been in earnest in 1880 about sending him to an asylum.

Sien returned with her new baby and Vincent had visions of domestic bliss. However, he was beset with visitations by Tersteeg, who was disturbed by the outlook and, to the artist's consternation, felt compelled to involve both his father and Uncle Cent. Vincent's letters to Theo were now filled with moral rationalizations and the promise of a civil marriage to Sien. The union

did not take place and there followed a long series of letters in which she is not even mentioned.

Vincent was now convinced that he must work doubly hard to make up for the late start in his artistic career and for the time lost to illness. He made several day visits to Scheveningen by streetcar to paint seascapes. He had spent two years mostly devoted to drawings and watercolours but now felt confident to attempt painting in oils. The first three were described in August 1882. In the same month he read books by Emile Zola (1840–1902) in which he took great pleasure.

During this period in The Hague Vincent's admiration for selected artists, past and present, increased. Millet received special accolades (see Cat. 11–15). Van Gogh also worshipped the British masters of wood-engraved, magazine illustration (see Cat. 2–4) and by 1883 he had acquired most of the illustrations from the *Graphic*, even back to its inception in 1870. He also experimented with a relatively new process for transferring drawings into lithography. Vincent even toyed with the idea of seeking employment in England as an illustrator.

At the beginning of 1883 the relationship with Sien began to unravel. Vincent blamed her mother. He spent much of the remaining months taking day visits to Scheveningen to paint and to escape Sien's family. Vincent feared that Sien would revert to walking the streets, contemplated moving his foursome (minus the mother) to the country, but was eventually overwhelmed by debts and doubts. He made the break and took the train to the north east where he hoped to live more cheaply and to explore new motifs.

## The Drenthe

This region had been recommended by Mauve (see Cat. 7) and Van Rappard (see Cat. 8). The Drenthe trip was ill timed because of the oncoming winter and hurriedly planned as usual. However, it was a period of reassessment and philosophizing, sitting around peat fires, and observing a new way of life in the countryside. The tour should have encouraged sketching but Vincent became preoccupied with his lack of paints. The work rate actually decreased compared with The Hague, but letter writing proceeded briskly and included some of his longest, most beautiful communications. Vincent remained convinced of the attractiveness of The Drenthe region but his hope of returning some day was never fulfilled. He joined his parents (now in Nuenen) the first week of December 1883. He planned for only a few months but stayed almost two years.

## Nuenen

Vincent felt that his father had not made sufficient accommodation about the ouster of Christmas 1881, or to subsequent events. In particular, the artist's relationship with Sien was not properly resolved and Vincent even restated his intention of marrying her. The early months of 1884 were filled with the artist's concern for future income and accusations directed at Theo for not trying to sell his paintings and drawings. In subsequent letters the point slowly emerged that Vincent wanted Theo to equate his allowance with payments for his work.

In August 1884 Antoon Hermans, a retired goldsmith and antique dealer from nearby Eindhoven, commissioned six large compositions of Vincent's choosing to be used as a guide for interior decoration by the owner himself. Van Gogh provided sketches of a sower, a plowman, a shepherd, the harvest, potato digging, and an ox wagon in the snow, to encompass seasons and peasant activities. Vincent later gave rudimentary lessons to two other amateur artists, Anton Kerssemakers, a reasonably well-to-do tanner and Willem van de Wakker, also of Eindhoven.

Much time and money were spent in painting peasant heads, hands and full figures.

On 26 March 1885 the Revd Theodorus van Gogh fell down at the entrance to his home. He had died instantly from a stroke. None of the children claimed an inheritance so that their mother could feel more secure. She elected to take in a boarder so Vincent moved to a studio, a room rented from the sexton of the Roman Catholic church at Nuenen.

In spite of regular and increased stipends from Theo, Vincent managed to spend even more on materials and models and produced sizeable bills for which the brother was eventually held accountable. Most of the paintings from this period were significant and culminated in *The potato eaters* (see Fig. 28), Vincent's first real masterpiece and a 'painting' rather than a 'study' by his own definition. Perusal of the letters from this period provides an exciting sequence starting with the application of finishing touches, the request for funds to cover packaging and shipment, listening to the paint dry, final delivery to Theo in Paris, and then concern about its reception.

The Nuenen period is important for Vincent's first exploration of colour theory in general and his embrace of the ideas of Eugène Delacroix (1799–1863) in particular. He asked Theo for further books on the subject, but his hero continued to be Millet, the master of peasant genre. Of the new artists of France he wrote: 'There is a school — I believe — of impressionists. But I know very little about it'.[7] Vincent made a trip to Amsterdam in the company of Kerssemakers to visit museums and the two absorbed the magic of Rembrandt. Toward the end of November 1885, after receiving assurances from a local doctor that his mother was reasonably well, Vincent decided to move to Antwerp, where he lived in a little room over the shop of a dealer in artists' pigments.

## Antwerp

Vincent's initial reactions to the Belgian port were positive and his letters full of interest. In January 1886 Van Gogh presented some examples of past work and was admitted to the Academy of Fine Arts by the director, Karel Verlat. He took instruction from Eugeen Siberdt in drawing from the live model, Franz Vinck on drawing ornaments, and Piet Havermaet in rendering antique objects. Vincent also joined some private clubs of artists to gain further access to models. The Antwerp period was a productive learning experience, however, Vincent was argumentative and not particularly well received by instructors because he tended to incite fellow students into more experimental approaches. Evaluations of his work were mixed; few tears were shed by the instructors after his departure for Paris, with the goals of living with Theo and joining the studio of Fernand Cormon (1845–1924).

## Paris

Much had changed in ten years and now he was an artist rather than a clerk. This Paris sojourn would last almost two years. It was a period of discovery and familiarization with the art of the Impressionists, a time to make lasting friendships with some of them, an opportunity for further development, and a savage test of Theo's patience. Theo was now the manager of a branch of Boussod,Valadon & Cie in Montmartre. His more liberal views were barely suffered by the management but he was a fine salesman and attained a position of informal leadership among the Impressionists.

There was a communication to Horace Levens, an English artist whom Vincent first met in Antwerp, in which we find early references to Monet and Degas and an indication that Vincent

[7] LT402, Nuenen, April 1885.

spent three or four months in Cormon's studio. He met Emile Bernard (1868–1941) and Henri de Toulouse-Lautrec (1864–1901) at that liberal gathering place but otherwise found the experience unexciting.

Contrary to popular belief, changes in palette after coming to the French capital were far greater than those subsequently associated with the move to the South. Van Gogh turned away from the sombre tones of Nuenen epitomized by *The potato eaters* to a brighter, livelier colour scheme in Paris. In part the change was a natural evolution resulting from further exploration of colour theory, but now there was a feast of paintings by current French artists and their example provided the requisite confidence-builder.

The two leaders of Impressionism were Claude Monet (1840–1926, see Cat. 18), who was already reasonably successful, and the paternal Camille Pissarro (1830–1903, see Cat. 20, 23), who taught, influenced, and encouraged so many other artists, but was never very successful in his own life. Vincent also admired the contemporary accomplishments of Edgar Degas and the past advances made by Edouard Manet (1832–83, see Cat. 19), but he felt more at ease with the younger artists such as Toulouse-Lautrec, Paul Signac (1863–1935, see Cat. 22), Georges Seurat (1859–91, see Cat. 21)) and Emile Bernard.

Vincent had a few adventures in Pointillism and the influence of Signac is apparent in his use of fairly broad strokes of colour, but he did not have the temperament for the finer dots adopted by Seurat. This style was embraced then abandoned within the stretch of a few canvases, although Vincent later recognized Seurat as the leader of the 'Petit Boulevard'. This was his innovative name for the less established artists including himself, Bernard, Gauguin, and Lautrec who showed at the Café du Tambourin, on the boulevard de Clichy, compared with Monet, Sisley, Renoir, Degas, and others that Theo showed on the 'Grand Boulevard,' that is, 19 boulevard Montmartre.

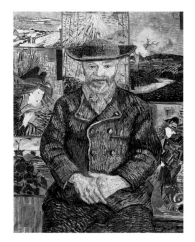

Fig. 5 Vincent van Gogh
*Portrait of Père Tanguy* F363
Paris autumn 1887
oil on canvas 92.0 x 75.0 cm
Musée Rodin, Paris
©ADAGP, Paris and
DACS, London 1993

Van Gogh was also intrigued by the compositions, brave colour schemes, and strong brush strokes of Adolphe Monticelli (1824–86), who had spent time in Paris and then lived for most of his productive career in Marseilles (see Cat. 16). The work of Monticelli was very influential on Vincent, there were also similarities in their way of living that developed in the South. Vincent felt that Monticelli had come in a direct professional line from Eugène Delacroix, and later he referred to some of his own work as evolving into a 'metaphysical philosophy of colour à la Monticelli'.[8]

Vincent became a regular at the Café du Tambourin, where he was introduced to the charms of absinthe[9] by Toulouse-Lautrec. He also developed a mutual regard for Julien Tanguy (Père Tanguy, Fig. 5), a dealer in artists' pigments. His shop was close to Vincent's residence and he carried Vincent's work for several years and sold one for which the artist was credited with twenty francs.

Vincent's introduction to things Japanese, *Japonaiseries* as they were called, was significant. In Japan unsold wood-block prints were used to wrap oriental crockery for shipment to Europe and these Japanese works on paper were embraced by the young artists of Paris. Vincent was not alone in taking stylistic succour from Japan. The development of Cloisonism (see note on p. 60), the use of simple, clearly-outlined forms in flat colours, by Bernard and Gauguin was influenced by Japanese compositions. Vincent frequented the shop of Siegfried Bing, who reputedly had ten thousand prints in the attic. He took about ninety francs worth on consignment and didn't sell

8  LT503, Arles, July–August 1888.
9  A fashionable, but toxic alcoholic beverage.

8

many, but they were images of lasting influence which were later incorporated into several of his paintings.

As early as October 1886, Vincent expressed a desire to visit the South of France, and Toulouse-Lautrec is credited with recommending Arles. Vincent had a general feeling that the exotic aspects of a warmer climate might be the 'Japanese' of France. Several other reasons have been offered for his departure. The growing attachment to Monticelli was a factor as was his idea of setting up a co-operative studio dwelling in the South. The Paris winters of 1886 and 1887 were also unusually cold, but his move to Arles was probably prompted by his lack of artistic acceptance in Paris.

Vincent decorated Theo's apartment with his canvases, paid a last minute visit to the Seurat's studio, packed his clothes and materials, including his perspective frame, and jumped on the overnight train to the South. On 20 February 1888, he landed in Arles, a town dating from Roman times, on the Rhone River. He was slightly irked to find two feet of snow on the ground, and still more falling. He took a room within walking distance of the station.

## Arles

On 1 May 1888 Vincent rented a house, actually the right wing of a complex, and this building was immortalized as the Yellow House in a drawing, a watercolour, and an oil painting. It had been vacant for some time and was in need of repairs and improvements; there was running water, but the toilet was in the hotel next door. Vincent did not sleep in the Yellow House until 17 September 1888, after helping to pay for repainting and the installation of illumination gas.

Van Gogh's early letter to Toulouse-Lautrec from Arles went unanswered although there is no evidence to indicate a lessening of mutual esteem. Toulouse-Lautrec stoutly defended the art of Van Gogh in Paris and later in Brussels, and they had a brief but warm renewal of friendship in 1890. Van Gogh also corresponded with the Australian artist John Peter Russell (1858–1931, see Cat. 1, 51).

The American Dodge MacKnight, who spent some time in Fontville, about six miles from Arles, and the Belgian Eugène Boch (see Fig. 41) were invited to live in the Yellow House. Mourier-Petersen[10] felt he had spent enough time in the South, and Bernard couldn't make up his mind whether or not to serve his military obligation. So none of the four elected to join Vincent during what proved to be a rather short tenure in the Yellow House.

Anton Mauve died in 1888. After receiving the obituary notice in late March Vincent was moved to dedicate his just finished painting *Pink peach tree in blossom*, to his first mentor (see Cat. 7). Vincent was obviously feeling nostalgic for Holland because he dedicated a version of *The Langlois Bridge* to Tersteeg, and a still life to the Dutch painter George Breitner, with whom he had worked in The Hague in 1882, and he gave a picture to his sister Wilhemina in early April.

Vincent continued his avid pursuit of good literature. He absorbed the culture of the South by reading Alphonse Daudet's *Tartarin sur les Alpes* and made several allusions to the hero of that story. He made several visits to the abandoned Abbey of Montmajour and compared the surrounds to 'Paradou' in Zola's *La Faute de l'Abbé Mouret* (The Sin of Father Mouret). He also enjoyed Balzac's *Le Médecin de Campagne* (The Country Doctor).

In mid September Vincent purchased a mirror expressly to do self-portraits in lieu of working from models. All of the self-portraits were supposedly done this way, that is, the mirror image

[10] A former medical student from Denmark, and an amateur artist, friendly with Van Gogh, who had come South for a nervous disorder.

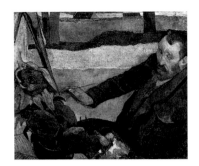

Fig. 6 Paul Gauguin 1848–1903
*Van Gogh painting sunflowers* 1888
oil on canvas  73.0 x 92.0 cm
Vincent van Gogh Foundation
Van Gogh Museum, Amsterdam

is depicted. At this stage Vincent was working at a furious pace, sometimes six and twelve-hour stretches of painting followed by twelve hours of sleep. The enterprise was partly driven by the desire to accumulate a body of work before the hoped-for visit of Gauguin.

After lengthy correspondence in which Vincent expressed degrees of hope, doubt, despair, and even resignation, Paul Gauguin (1848–1903, see Cat. 24, 25, 52) finally joined him on 23 October 1888. The interaction between the two artists was important and electric, but they spent only two months together. There were claims of mentorship by Gauguin, but it is clear that Vincent had reached a consistently high level of artistic skill before Gauguin's arrival. Nonetheless, they exchanged art work and it is also apparent that the two artists had a positive influence on each other.

From all accounts, including his own,[11] Paul Gauguin brought a degree of organization to the day-to-day affairs of the household. There was productivity; in the eight weeks he was in Arles Gauguin produced at least sixteen pictures and Van Gogh probably twice that number. Gauguin had come into desperate straits and, notwithstanding the generosity of Theo to carry the pair, they seem to have reinforced each other's discomforts about the lack of recognition and the difficulty in selling canvases (see Fig 6).

Van Gogh and Gauguin made an excursion to Montpellier to view the Bruyas collection. This was an important encounter for both of them but differences in opinion about the relative contributions of the artists in that outstanding collection, and subsequent discussions on art and philosophy generally, degenerated into abrasive comments from both sides. Alarming but poorly documented events, which included Vincent's throwing a glass of absinthe at Gauguin's head and culminated in the ear-cutting incident of 23–24 December, landed Vincent in hospital and prompted Gauguin to leave Arles.

The early prognosis was poor, but on the last day of December, to the pleasant surprise of doctors and friends, the patient made a rapid recovery. On 7 January, he returned to the Yellow House and that day declared to his mother and sister that 'there is a chance that there will be nothing the matter with me for a long time to come'.[12] On 9 January, Vincent told Theo that he was suffering from insomnia and, without consultation with the doctor, was treating himself with massive amounts of camphor. It was an exaggerated application from Raspail's book of home remedies.

During the first week of February Vincent suffered a relapse and was again taken to the hospital, this time for ten days. On the day of discharge, 17 February, Vincent wrote with his usual clarity and insight. In fact, during periods of recovery Van Gogh comprehended and wrote letters, willingly discussed his condition with physicians, weighed the possibilities for the future, and also maintained the quality of his work. His rapid recovery from crises (Fig. 7) and subsequent periods of lucidity are pivotal to the diagnosis of Vincent's underlying disease.

Vincent returned to work at the Yellow House but was resigned to the possibility that a further medical crisis might lead to his confinement in an asylum. As a precaution he continued to eat and sleep at the hospital. His worst fears were realized by a petition from the townspeople seeking intervention by the Mayor, causing his involuntary confinement at the Arles Hospital.

Shortly afterwards Vincent raised the curious option of joining the French Foreign Legion, but Theo disapproved and the idea died a natural death. They discussed the prospect of Vincent going to an asylum in Aix, Marseilles, or Saint-Rémy, and decided on Saint-Rémy for a period of three months. Theo's letter to the Saint-Paul-de-Mausole Asylum at Saint-Rémy included

11 P. Gauguin, *Paul Gauguin's Intimate Journals* (trans V. W. Brooks), Liveright, New York, 1949.
12 569a, Arles, 7 January 1889.

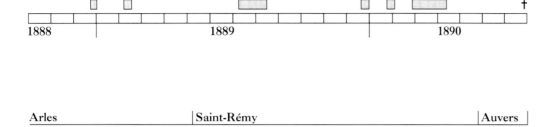

Fig. 7 *Van Gogh's crises*
The centre track shows calendar years, marked in months. The six periods of debilitating illness are depicted as upper track stippled bars. Locations are indicated in the lower track.
*After Arnold 1992, p. 61.*
© *Birkhäuser Boston*

requests that his brother be allowed to paint outside the establishment and be offered at least half a litre of wine with his meals. On 8 May 1889 Vincent made the short journey by train to Saint-Rémy.

## Saint-Rémy

They were met by the director, Dr Théophile Peyron, who made only cryptic notes in the register. The benefits derived by Vincent from internment stemmed from a structured environment with regular meals, decreased alcohol intake, and ingestion of potassium bromide as a calmative. After a period of orientation and assessment he was given an extra room for painting. Vincent was eventually allowed the latitude of selecting motifs outside the institution although he was accompanied by an attendant. During this time Theo's only child, named Vincent Willem after his uncle, was born and the artist painted *Blossoming almond tree* (Fig 37) especially for him. However, the attacks returned and Vincent was subject to four major crises while at Saint-Rémy.

Initial respect for Dr Peyron lessened as doubts about the usefulness of confinement increased. Other possibilities that were explored included boarding with the family of a sympathetic artist such as Camille Pissarro, Victor Vignon, or Auguste Jouve, or staying at an asylum near Paris, something like the institution at Montevergues where work therapy was favoured. Dr Peyron was still doubtful about the wisdom of a change but together with Theo decided to follow the suggestion of Pissarro's and seek boardinghouse accommodation for Vincent in Auvers-sur-Oise under the observation of Dr Paul Gachet (1828–1909, Fig. 8). They worried about Vincent's safety during the proposed trip but the long overnight journey to Paris was uneventful. He arrived in Paris, mid morning the next day, 17 May 1890, and met for the first time Theo's wife, Johanna van Gogh-Bonger (1862–1925). She would become the keeper of the art, compiler of Vincent's correspondence, and translator of the letters into English.

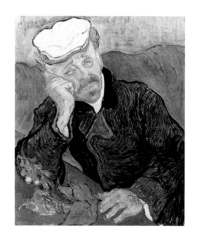

Fig. 8 Vincent van Gogh
*Portrait of Dr Gachet* F754
Auvers-sur-Oise early June 1890
oil on canvas 68.0 x 57.0 cm
Musée d'Orsay, Paris

## Paris and Auvers-sur-Oise

Vincent was reunited with his own works on Theo's walls, as unframed canvases, and even in piles under the bed. The brothers visited Père Tanguy's shop but it seems unlikely that Vincent contacted any artists at this time. He asked Theo for a letter of introduction to Dr Gachet and left for Auvers-sur-Oise after just three days. Vincent resided at a little café with boarders run by Arthur Ravoux. The building, which has been slightly altered over the years, faces the town hall of Auvers, a small village then as now, where one finds very attractive countryside just thirty kilometres from the heart of Paris.

Vincent was impressed with the town that had been home to Charles-François Daubigny (1817–78, see Cat. 10) and motif to Jean-Baptiste Corot. Honoré Daumier had lived a little north at Valmondois. Jules Dupré had died a year before in nearby l'Isle-Adam and Camille Pissarro

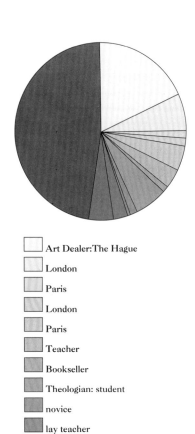

Art Dealer:The Hague

London

Paris

London

Paris

Teacher

Bookseller

Theologian: student

novice

lay teacher

acting pastor

?

Artist

Fig. 9 *Occupations*
The chart indicates the order, clockwise
from the top, and the relative times
which Vincent spent in five major
vocations after high school. The total
period was a little over twenty-one
years of which slightly less than fifty
per cent was spent as an artist.
*After Arnold 1992, p. 28.*
© *Birkhäuser Boston*

13  650, Auvers-sur-Oise, 11 July 1890.

had spent some years downstream at Pontoise. Paul Cézanne enjoyed two periods in Auvers and Gauguin had visited some years before Vincent, mostly to work with Pissarro. Armand Guillaumin still frequented the area. Dr Gachet made his home there in 1872. From 1873 he practised etching in his spare time and three friends, Pissarro, Guillaumin, and Cézanne combined with him to pull many prints in his attic studio. The same press was used for Vincent's only etching, *Man with a pipe*, which was executed on 25 May 1890, the first afternoon that Van Gogh visited Paul Gachet for lunch.

Dr Gachet prescribed work therapy for Vincent; this was music to his ears. On the other hand he rejected Gachet's attempts at better nutrition. Vincent, Theo, Johanna, and young Vincent were all entertained at the Gachet home one Sunday afternoon. It was probably the last happy time together for the brothers. Vincent introduced his little namesake to the animals and birds of the Gachet menagerie.

Van Gogh's productivity in Auvers was immense, something of the order of a canvas a day. He painted Gachet's daughter Marguerite in the garden and also at the piano. His command of the brush was everywhere, and even within four days of a most disturbing visit to Paris, Vincent finished three pictures.

On 6 July, he caught an early train to Paris and spent the day with Theo, Johanna, young Vincent, Toulouse-Lautrec (who stayed for lunch), the writer and art critic Albert Aurier, Andries and Annie Bonger, and possibly others. There was obvious uncertainty about Theo's position at Boussod & Valadon. We now know that Theo's health was about to worsen again.

On 11 July, Vincent wrote to his mother that he was happy that she would be seeing the new grandchild shortly.[13] On 14 July, Theo wrote to Vincent that they were glad he was feeling less dispirited but on 20 July, he wrote to his wife that he hoped Vincent was not getting melancholy and was not under the threat of a new attack.

Dr Mazery, a local physician, was called by Gustave Ravoux after he discovered that Vincent had shot himself in the afternoon or early evening of 27 July, and had returned to his room bleeding. Vincent asked for Dr Gachet. The two doctors conferred and elected not to remove the bullet, but dressed the abdominal wound and made the patient as comfortable as possible. The next morning Dr Gachet sent Anton Hirschig to Paris with a message for Theo, who reached Vincent that same morning, 28 July. Vincent died in the early morning of 29 July (Fig. 9). Theo had a notice of the funeral, scheduled for 2.30 p.m. on 30 July 1890, printed in Pontoise and distributed in Paris.

The Gachets and others assisted Theo in arranging the coffin, flowers, and Van Gogh paintings about the small reception room in the Café. Given the short notice it is remarkable how many friends arrived for the funeral. Three years later Emile Bernard painted the scene from memory and included himself, Theo van Gogh, Charles Laval, Andries Bonger, Lucien Pissarro, Auguste Lauzet, Père Tanguy, Gustave Ravoux, Dr Gachet and others. Worried again by adversity, even beyond death, Vincent's body was refused transit on the parish hearse because he was a suicide, and the remains travelled up the hill to the small cemetery on a cart borrowed across the river at Méry-sur-Oise.

In his account to Albert Aurier, Emile Bernard remembered that they lowered Vincent into the grave and Dr Gachet attempted some words of farewell which were halting because he too was weeping. In a letter to his mother Theo sorrowed that, 'It is a grief that will last and which I

certainly shall never forget as long as I live ...' (He died within six months of his brother, after experiencing bouts of illness with symptoms resembling the same underlying disease as Vincent's.) Their mortal remains now lie side by side in the cemetery at Auvers. The headstones are simple; on the left, 'ici repose [here reposes] Vincent van Gogh (1853–1890)' and on the right, 'ici repose Théodore ([sic], should read Theodorus) van Gogh (1857–1891)'.

## VINCENT VAN GOGH'S ILLNESS

The artist suffered six medical crises during his last two years. The first started with the ear-cutting episode in Arles, which landed Vincent in hospital and precipitated Gauguin's return to Paris. But there had already been indications of instability and a threat by his father to have him institutionalized as early as 1880.[14]

Vincent's ailment was characterized by episodes of acute mental derangement and disability wherein he was unable to paint or write. They were separated by intervals of lucidity and extreme creativity. Attending physicians, friends, family members, and the artist himself remarked on the rapidity of recovery after each crisis: there was never a permanent loss of function. A careful review of all the data from the artist's letters and other contemporary sources indicates that Vincent suffered from an inherited disorder manifested by severe and manifold neurological problems ranging from gastro-intestinal pains to fits with hallucinations. His condition was exacerbated by his life style which was marked by inadequate nutrition, abuse of alcoholic beverages, chronic smoking, environmental exposure, and the development of an abnormal affinity for terpenes.[15] The gamut of symptoms is best explained by a toxic psychosis.

Within that category, and accommodating the age of onset as well as the exacerbation factors, the disease entity that most closely fits all of the extant data is *acute intermittent porphyria* (AIP).[16] Infections, fasting and malnutrition, alcohol and several other drugs can precipitate crises in persons with this underlying disease. We have shown that the terpenes to which Vincent exposed himself in the form of turpentine, camphor, and the liqueur called absinthe, would be particularly detrimental for someone carrying the defective gene conferring AIP.[17] Elsewhere, I have summarized biochemically-documented cases of AIP from the twentieth century, which show analogies to the illnesses of Vincent, Theo, and Wilhemina.[18]

Of course there has been no shortage of speculation on this subject and indeed various disorders will accommodate particular signs and symptoms. Any reasonable suggestion, however, must explain *all* of the information at hand and not just selected aspects. Accordingly, acute intermittent porphyria, exacerbated by malnutrition and absinthe abuse, is the best working hypothesis to explain the underlying illness of Vincent van Gogh.

It is important to emphasize that all of Van Gogh's creative work was accomplished during periods of lucidity. Vincent was not a mad artist, he was an exceptional man who suffered from an inherited metabolic disease. He was wonderfully creative because of intelligence, talent, and hard work. He was a genius in spite of his illness — not because of it.[19]

*Wilfred Niels Arnold*

14 LT204, The Hague, 1 June 1882.

15 W. N. Arnold, 'Vincent van Gogh and the thujone connection', *Journal of the American Medical Association* 260, pp. 3042–44.

16 L. S. Loftus & W. N. Arnold, 'Vincent van Gogh's illness: acute intermittent porphyria?' *British Medical Journal* 303, pp. 1589–91.

17 H. L. Bonkovsky , E. E. Cable, J. W. Cable, S. E. Donohue, E. C. White, Y. J. Greene, R. W. Lamprecht, K. K. Srivastava, & W. N. Arnold, 'Porphyrogenic properties of the terpenes — camphor, pinene, and thujone; with a note on the illness of Vincent van Gogh'. *Biochemical Pharmacology* 43, pp. 2359–68.

18 Arnold 1992, op. cit.

19 This essay is dedicated to the memory of Gilbert and Ursula Vandenbroucke, who proudly preserved and maintained the house and garden of Dr Gachet, in Auvers-sur-Oise. As friends and colleagues they encouraged my research on Vincent van Gogh.

# VINCENT VAN GOGH
## *THE SOWER AND THE HARVEST*

Sometimes I cannot believe that I am only thirty years old, I feel so much older ... but one doesn't expect to get from life what one has already learned it cannot give; rather one begins to see more and more clearly that life is only a kind of sowing time, and the harvest is not here.[1]

Within less than two years of Vincent van Gogh's death, a perceptive young critic, R. N. Roland-Holst, wrote that the romantic notoriety of his life was becoming an obstacle to the true appreciation of the artist's work.[2] A century later, the myth has become a cliché of global proportions. Everyone has heard of the man with the bandaged ear, the plodder who went mad and became a genius. In our own country, only a few years ago, we witnessed the extraordinary spectacle of an entrepreneur paying a record price for a picture of irises and then proclaiming the affinity he felt with the heroic painter.

The myth of Vincent van Gogh is difficult to avoid or ignore because the artist's work cannot be separated from the man's life. But if we are to understand his art we must replace the myth — in which everything about Van Gogh's career is discontinuous and inexplicable — by a coherent account of his life and work as the development of a vocation. I believe we will discover an intelligible progression, though one that leads him, in the end, to intolerable contradiction.

Two facts are of fundamental importance for an understanding of Van Gogh's development. The first is that his vocation was originally religious: his artistic calling grew out of the frustration of his evangelical hopes and his sensibility remained in the broadest sense religious. Art, like other areas of human thought, is bounded by the two horizons of the political and the religious: it speaks of our relation to our fellow human beings and of our relation to nature or to God. Some minds are more strongly drawn to one or the other, and Van Gogh looked towards the horizon of the religious. Although he witnessed the sufferings of the proletariat of his time, and deeply sympathized with them, and although he often spoke of historical events in his letters, his art was concerned with the eternal relations between humanity and nature.

The second fact is that these concerns found expression in a dominant metaphor: the labours of the fields, through which humanity extracts a living from nature. Van Gogh was not interested in wild or untouched nature, but in nature inhabited and cultivated. In particular, the actions of sowing and harvesting are so close to the centre of his imaginative universe that he refers to them time and again to express his understanding of his own work as an artist:

[1] LT265, The Hague, 8 February 1883.

[2] R. N. Roland-Holst , 'Vincent van Gogh', *De Amsterdammer*, 21 February 1892; quoted in Zemel 1980, p. 25; 'There are two dangerous reefs on which our correct judgement of Vincent van Gogh's art can run aground, and the dangerous reefs are formed by the many writers who have connected their appreciation for his art too much with van Gogh the person, his fantastic spirit, and his consequent demeanour. As a result, for them, van Gogh's art has become the illustration of the sad drama of his life.'

Facing page: Detail of Cat. 36
Vincent van Gogh
*Trees in a field on a sunny day* F291
oil on canvas  37.5 x 46.0 cm
Stichting Collectie
P. en N. de Boer, Amsterdam

I consider making studies like sowing, and making pictures like reaping ... Sometimes I long for harvesttime, that is, for the time when I shall be so imbued with the study of nature that I myself can create something in a picture.[3]

These agrarian themes run through his work, and in their transformations we can follow the development of the artist's thought and vision.

Vincent, the name he preferred, knowing that his surname was unpronounceable,[4] was born in 1853. It is hardly surprising that he was drawn to religion: his father was a pastor and in the normal course of events he might have been expected to follow in this profession. Instead he was placed at the age of sixteen, in 1869, with the art dealers Goupil & Cie in The Hague (the business had been established by his uncle Vincent and taken over by the French firm, in which Uncle Vincent was now a partner). Little is known of these first years but, when the correspondence with his brother Theo which was to last throughout his life began in August 1872, he seemed still to be happy in his profession. Theo was about to join the Brussels branch of Goupil, and Vincent wrote to him that it was 'such a fine business'.[5] Goupil was not, however, interested in the new art movements of the 1860s: there was no sign, among the artists they handled, of Manet, Degas and those who were soon to be called the Impressionists.

In May 1873, Vincent was moved to the London branch of Goupil and seemed at first extremely happy; but in the following year he fell in love with his landlady's daughter Eugenie Loyer and was rebuffed: 'In July '74, he came home for the holidays in a melancholy, depressed mood. From that time on there was a change in his character: he inclined more and more toward religious fanaticism and led a secluded life, living alone in rooms and seeing nobody. He rarely wrote home, which caused his parents great anxiety.' [6]

The family arranged for him to spend the last few months of 1874 in Paris. The First Impressionist Exhibition had taken place there some months earlier, but Vincent was not to become aware of the movement for over a decade. He returned to London at the beginning of 1875, but was transferred permanently to the Paris office, now Boussod & Valadon. In his last letter to Theo from London he quoted Ernest Renan:

To act in this world one must die to oneself. The people that makes itself the missionary of a religious thought has no other fatherland than this thought.

Man is not on this earth merely to be happy, nor even to be simply honest. He is there to realize great things for society, to attain nobility and to rise above the vulgarity in which almost all individuals drag out their existence.[7]

Vincent's religious preoccupation grew deeper during the course of 1875, and his letters to Theo were full of spiritual exhortations. Evidently he had neglected his duties at the firm, for in January 1876 he asked M. Boussod if he were to be employed for another year: '... and said I hoped he had no serious complaints against me. But the latter was indeed the case, and in the end he forced me, as it were, to say that I would leave on the first of April ... When the apple is ripe, a soft breeze makes it fall from the tree; such was the case here; in a sense I have done things that have been very wrong ...' [8]

This was the beginning of a six-year period of increasing anxiety during which Vincent came close to despair. In the second half of 1876, he returned to England to work as an assistant

3  LT233, The Hague, 19 September 1882.
4  LT471, Arles, 24 March 1888.
5  LT2, The Hague, 13 December 1872.
6  Jo van Gogh-Bonger, in *Complete Letters*, I, p. 7.
7  LT26, London, 8 May 1875.
8  LT50, Paris, 10 January 1876.

schoolmaster and as an occasional preacher. There he discovered the desperate misery of London's urban proletariat, and also the black-and-white art of the new periodicals whose subject was modern life in the great city. Returning home at the end of the year, he made a new start in 1877 working in a bookshop in Dordrecht. Again he spent most of his time reading the Bible and writing sermons. He also neglected his dress and personal appearance, a criticism to which he later became extremely sensitive, although he made no attempt to change his ways.

Soon he left the bookshop and persuaded his family to let him take up the preparatory work for formal theological studies. He moved to Amsterdam, where he stayed with another uncle, Vice-Admiral Johannes van Gogh, director of the naval shipyards. For a year, Vincent persevered, finding classical languages particularly arduous, then abandoned these studies for a short missionary's training course in Belgium in early 1878. He wanted to work with poor and humble people, and could not believe that a deep knowledge of classical letters and theology were necessary to preach the Gospel.

It is good to continue believing that everything is more miraculous than one can comprehend, for this is truth; it is good to remain sensitive and humble and tender of heart, even though sometimes one has to hide this feeling ... it is good to be learned in the things that are hidden from the wise and intellectual ones of the world but are revealed, as if by nature, to the poor and the simple, to women and to little children. For what can one learn that is better than what God has given by nature to every human soul — which is living and loving, hoping and believing ...

Nothing less than the infinite and the miraculous is necessary, and man does well not to be contented with anything less, and not to feel at home as long as he has not acquired it.[9]

Without having secured an appointment, he moved in December to the Borinage region, to live among the poor miners. In January 1879 he was finally granted a temporary position for six months as a lay evangelist.

In these grim surroundings, Vincent shed the remaining signs of his upper-middle class origins. He gave away his clothes and what little money he had, and chose to live in conditions even more squalid than those of the miners. He did his best to help these poor people both spiritually and materially, but behaviour that might have been thought saintly in the time of Saint Francis was considered unseemly by the Evangelical Committee, and his appointment was not renewed on the grounds that he was a poor preacher.

This was a bitter rebuff for Vincent, and the period from mid 1879 to mid 1880 was one of deep misery and disorientation. He wandered 'like a tramp'[10] in the Borinage, writing only a few, but very significant letters to his brother.

As moulting time — when they change their feathers — is for birds, so adversity or misfortune is the difficult time for human beings. One can stay in it — in that time of moulting — one can also emerge renewed; but anyhow it must not be done in public ... the only thing to do is to hide oneself. Well, so be it.[11]

By August 1880, Vincent had emerged from his 'moulting time' with the decision to

9   LT121, Amsterdam, 3 April 1878.
10  LT329, Drenthe, c. 27 September 1883.
11  LT133, Borinage, July 1880.

become an artist. He moved to Brussels in October, and by January began receiving from Theo the financial help which would sustain him for the rest of his life.

He started by copying prints of the works of Jean-François Millet, particularly *The sower* (see Cat. 11), which recurs throughout his later work, and *The diggers* (see Cat. 14). In the first letter of his career as an artist, he asked Theo for a set of etchings by Jacques-Adrien Lavieille after Millet's *Travaux des champs*;[12] and shortly afterwards wrote: 'I have already drawn *The Sower* five times, twice in small size, three times in large, and I will take it up again, I am so entirely absorbed in that figure.'[13] Inevitably, these subjects embodied, to a mind steeped in the scriptures, passages from Genesis and from the Gospels in which agrarian labour and especially the growing of corn are powerful metaphors for human life and destiny.

> In the sweat of thy face shalt thou eat bread, till thou return unto the ground; for out of it wast thou taken; for dust thou art, and unto dust shalt thou return ... Therefore the Lord God sent him forth from the garden of Eden, to till the ground from whence he was taken.[14]

Vincent's early drawings depict a fallen world in which men and women must labour to extract their living from a hard earth. A fallen world is one from which God's grace has been withdrawn, but it is not meaningless or absurd; indeed it implies the continued existence of order and divine providence. The labour of fallen humanity is understood as the fulfilment of a divine command.

This is the point at which Vincent's career as an artist began, as a transformation of his failed religious calling. He had committed himself unreservedly to Christianity, and when it rejected him, he was left alone in a world without meaning. It was art that allowed him to rebuild meaning from chaos: for in drawing the labours of the peasants in a fallen world, he was able to picture a universe from which God, although perhaps distant, was not absent. From the ruins of his earlier faith he reconstructed a 'partial belief';[15] this was the initial attraction of art for Vincent, although his work as an artist was to lead him, eventually, very far from his starting-point.

Vincent spent the winter of 1880–81 in Brussels, and returned in April to his parents' home, now in Etten. Here occurred perhaps the most painful event of his emotional life. He fell in love with his recently-widowed cousin Cornelia Adriana Vos-Stricker, known as Kee, but once again his love was spurned. For a long time Vincent refused to believe her mind could not be changed, and he finally gave in only after a terrible scene at the house of Kee's parents in Amsterdam, during which he held his hand in the flame of a lamp and refused to remove it until he had seen her.

> Then, not at once, but very soon, I felt that love die within me; a void, an infinite void came in its stead. You know I believe in God, I did not doubt the power of love, but then I felt something like, 'My God, my God, why hast Thou forsaken me,' and everything became a blank. I thought, Have I been deceiving myself? ... 'O God, there is no God!'[16]

Partly because Kee was the widow of a clergyman and partly because her own father was one, these events also confirmed his view of the inhumanity of the church and its ministers. Kee's rejection repeated the church's rejection of his vocation. Disappointment now became

12  LT134, Cuesmes, 20 August 1880.
13  LT135, Cuesmes, 7 September 1880.
14  Genesis 3, 19–23.
15  T. S. Eliot used the expression of Baudelaire: T. S. Eliot, *Selected Prose*, ed. John Hayward, Penguin, London, 1953, p. 187.
16  LT193, The Hague, 14 May 1882.

open hostility, and Vincent's conception of God moved even further away from orthodox Christianity. He liked to quote Victor Hugo's saying that religions pass, but God endures;[17] and he frequently spoke of 'quelque-chose là-haut': *something up there.*

For me that God of the clergymen is as dead as a doornail. But am I an atheist for all that? The clergymen consider me so — so be it — but I love, and how could I feel love if I did not live and others did not live; and then if we live, there is something mysterious in that. Now call it God or human nature or whatever you like, but there is something which I cannot define systematically, though it is very much alive and very real, and see that is God, or as good as God.[18]

The pain of Kee's rejection was lasting. Some years later, speaking to Theo, Vincent said that it was still as acute as on the first day.[19] His immediate reaction, at the end of 1881, was to find someone who would accept his love, a creature so abject that she could not refuse it, and so unappealing that to love her was almost an act of mortification. This was Clasina Maria Hoornik, called Sien, an alcoholic prostitute who had a daughter and was pregnant with another child.

... for my part I have always felt and will feel the need to love some fellow creature. Preferably, I don't know why, an unhappy, forsaken or lonely creature. Once I nursed for six weeks or two months a poor miserable miner who had been burned. I shared my food for a whole winter with a poor old man, and heaven knows what else, and now there is Sien ... I must add that if I were wrong in doing this, you were also wrong in helping me so faithfully ... I have always believed that 'love thy neighbour as thyself' is no exaggeration, but a normal condition.[20]

In spite of the objections of his family, Vincent rented a house in The Hague, where he lived with Sien and her children and worked throughout 1882 and most of 1883. He applied himself to drawing the figure, posing his models as diggers, and although he was to develop greater strength over the following years, he had already found his characteristic attitudes. At other times he drew fishermen in the dunes, peat-diggers, or long melancholy roads bordered with pollard willows. He also experimented with lithography and thought that he might find employment as an illustrator, like the English black-and-white artists he admired.

He was of course right when he wrote to Theo at the end of 1881: 'with painting my real career begins',[21] although a long gestation period still lay ahead. But to his family this must have seemed like another false start, compounded by what they considered a completely unsuitable relationship. Vincent had always been inclined to extremes of mood and behaviour, and mental illness was now openly discussed in the family; his father even considered having him committed to an asylum. H. G. Tersteeg, under whom he had worked at Goupil in The Hague, told him that he was of 'unsound mind and temperament'.[22] Vincent was deeply disturbed by these accusations and denied them strenuously:

*Never* has a doctor told me that there was something abnormal about me in the way and in the sense Tersteeg dared to tell me this morning. That I was not able to think or that my mind was deranged. No doctor has told me this, neither in the past nor in the present;

17  LT253, The Hague, 12–18 December 1882: 'I think it is a splendid saying of Victor Hugo's "les religions passent, mais Dieu demeure" ... the forms may change — a change which is just as necessary as the renewal of the leaves in spring.'

18  LT164, Etten, c. 21 December 1881.

19  LT313, The Hague, 18 August 1883.

20  LT219, The Hague, 23 July 1882.

21  LT165, Etten, 22–24 December 1881.

22  LT216, The Hague, 18 July 1882.

certainly I have a nervous constitution, but there is definitely no real harm in that. So those were serious insults on Tersteeg's part, just as they were on Pa's, but even worse, when he wanted to send me to Gheel.[23]

This was an important period in Vincent's development but it was not a joyous one. His subjects are worn and battered by life, holding on with tenacity and resignation. One of the most memorable figures is an old man with his head in his hands, to which he gave the title (in English): *Worn out* (CAT. 26). Another figure he called (also in English) *Sorrow* (see Cat. 28); Sien posed for this gaunt nude in which Vincent saw the same desperate clinging to life as in a clump of old trees with gnarled roots that he drew at the same time (Fig. 10).[24]

By the beginning of 1883, Vincent was finding his relationship with 'the woman' increasingly barren and oppressive. In the summer he was upset by Theo's suggestion that his work was still rather dry, and felt that he needed to escape to the country to renew his inspiration. In the end, after some complicated rationalization about his duty to art as against his duty to Sien, he left her in September 1883 and travelled north to Drenthe. His departure marked the point from which the artistic vocation became exclusive in its demands.

It was at this time that he started trying to convince Theo to become a painter as well. The

23  LT216, The Hague, 18 July 1882.
24  LT195, The Hague, 5 April 1882.

suggestion was so obviously contrary to his own material interests (he was dependent on the money his brother earned) that his persistence in letter after letter seems inexplicable until we recall that he had earlier preached to Theo in the same way about Christianity. Finally, in 1885, the assimilation became explicit when he wrote to Theo: 'Mother is unable to grasp the idea that painting is *a faith*'.[25]

Vincent had become interested in potato diggers in The Hague, and he drew them in Drenthe, kneeling in the earth to pull up their harvest. It was a subject that allowed him to bring humanity and nature into closer involvement: the bodies seem almost part of the earth, although this idea was to find its fullest expression in *The potato eaters* of 1885 (see Fig. 28).

At the end of 1883 he returned home again — his parents were now in Nuenen. Here he enjoyed far greater physical comfort, but the strain of living with his mother and especially his father was almost unbearable. Much of it was taken out on Theo in a series of painful letters; suffering from renewed guilt over the abandonment of Sien, he even managed to blame Theo for this decision. The real reason for the crisis was that Vincent, who had always written to Theo as an older brother to a younger, was beginning to understand that the true relations of power between them were now reversed. Filled with resentment of his father, Vincent feared that Theo would become 'Father No. II' and insisted: 'I definitely refuse to become your protégé'.[26] This led to a maddeningly perverse series of letters in which he repeatedly 'threatened' to stop taking Theo's money.

During the following year, 1884, Vincent attempted to define a business relationship with his brother that would not make him feel like the recipient of charity — 'Let me send you my work, and keep what you like for yourself, but I insist on considering the money I receive from you after March as money I have earned'.[27] This did not prevent him from tormenting Theo throughout the year with reflections on his bourgeois character, and as late as December 1884 he was still suggesting that they should 'separate'.[28] In the meantime Theo was beginning to tell Vincent about the new school of Impressionism.

It is interesting that Vincent's main subject at the beginning of 1884 was weavers at their looms (Fig. 11). He saw them as little figures who were the servants of machines much bigger than themselves, an image that seemed to have some analogy with his anxious and aggressive state of mind at the time. In the middle of the previous year, he had used the image of the weaver to describe a state of mental distress:

> The work is an absolute necessity for me. I can't put it off, I don't care for anything but the work; that is to say, the pleasure in something else ceases at once and I become melancholy when I can't go on with my work. Then I feel like a weaver who sees that his threads are tangled, and the pattern he had on the loom is gone to hell, and all his thought and exertion is lost.[29]

At the end of 1884 he was busy with studies of peasant heads (see Cat. 30), and in April 1885 he completed his first ambitious painting, *The potato eaters* (see Fig. 28). It was a figure composition — he still thought of the figure as the basis of his art — but the work expresses the intimate involvement of humanity with the earth: 'I have tried to emphasize that those people, eating their potatoes in the lamplight, have dug the earth with those very hands they put in the dish, and so it speaks of *manual labour*, and how they have honestly earned their food.'[30]

Fig. 10 Vincent van Gogh
*Study of a tree* F933 recto
The Hague April 1882
chalk, ink, pencil and wash
51.0 x 71.0 cm
State Museum Kröller-Müller,
Otterlo, The Netherlands

Fig. 11 Vincent van Gogh
*The weaver: the whole loom facing front* F30
Nuenen May 1884
oil on canvas 70.0 x 85.0 cm
State Museum Kröller-Müller,
Otterlo, The Netherlands

25  LT398, Nuenen, 5 April 1885.
26  LT358, Nuenen, c. 1 March 1884.
27  LT360, Nuenen, c. 1 February 1884.
28  LT386a, 9 December 1884.
29  LT288, The Hague, 3 June 1883.
30  LT404, Nuenen, c. 30 April 1885.

All the heads were finished, and even finished with great care, but I immediately repainted them, inexorably, and the colour they are painted in now is like *the colour of a very dusty potato, unpeeled of course.*

While doing this I thought how perfect that saying of Millet's about the peasants is: 'Ses paysans semblent peints avec la terre qu'ils ensemencent.' [His peasants seem to be painted with the earth they sow.][31]

This picture, with its almost sacramental overtones and compositional allusions to the Last Supper, marked the completion of a period in Vincent's development. After some fine drawings of the wheat harvest in the summer, he moved to Antwerp at the end of November, admiring Rubens and discovering Japanese prints, and attending classes at the Ecole des Beaux-Arts. By late February, however, he came to reject the academic principles of the tuition and decided to move to Paris, to join Theo and further his studies at Fernand Cormon's Paris atelier.

It was in Paris that he discovered Impressionism. As his own inspiration was so different, it was perhaps fortunate for him that Impressionism no longer dominated the avant-garde of painting. The First Impressionist Exhibition had been held in 1874, and the Eighth, which opened in Paris not long after Vincent's arrival, in May, was also the last. Several of the most prominent names in the movement were absent, but new ones had appeared, notably Georges Seurat (see Cat. 21) whose *Sunday afternoon at the Grande Jatte* 1884–86 (Fig. 12) was the first masterpiece of Neo-Impressionism. This movement claimed at first to reduce Impressionism's intuitive understanding of colour and light to the exactness of 'scientific method'; but it was a 'science' which drew even further away from the Realism out of which Impressionism had grown.

Another group of artists, represented in the exhibition by Paul Gauguin (see Cat. 24, 25, 52), proceeded in the opposite direction. They attempted to break through the barrier of retinal 'impressions' in order to grapple with the intrinsic spirit and life of things. Vincent was to find inspiration in their work and in Japanese prints, which taught him how bold stylization could

31   LT405, Nuenen, beginning May 1885.

Cat. 20

[CATALOGUE ENTRY SEE PAGE 50]

Fig. 13 Vincent van Gogh
*The sower* F422
Arles June 1888
oil on canvas 64.0 x 80.5 cm
State Museum Kröller-Müller,
Otterlo, The Netherlands

dramatize form and movement. But he also admired and learnt from the Neo-Impressionists. He became particularly friendly with Paul Signac (see Cat. 22) and Camille Pissarro (CAT. 20, illustrated page 23), the veteran Impressionist who had joined the new movement.

Before his arrival in Paris, Vincent had been concerned with monochromatic tonal effects, and was therefore opposed to the bright colours and pale tonality of Impressionism. His first works in Paris were still in this early manner, but over the winter of 1886–87 he absorbed the lessons of Impressionism. In the course of 1887, with his usual frenetic energy, he painted and organized exhibitions both of Japanese prints and of his friends' paintings. It was also at this time that he began to paint self-portraits (see Cat. 35), as though at last he felt the confidence to define himself no longer as a humble student, but as an artist.

Life in Paris, however, was extremely taxing to a man of his highly-strung temperament, and Vincent drove himself to exhaustion during the winter of 1887–88. He could not eat and he drank and smoked excessively in his attempts to ease the strain. His behaviour at home almost drove Theo, himself tired and sick, to desperation. Finally, he left for Arles in February 1888.

Here the correspondence, interrupted of course in Paris, resumed and continued uninterrupted for the rest of Vincent's life. The remittances also resumed. Theo sent his brother 150 francs a month, which was quite a generous allowance: his friend the postman Joseph Roulin (see Cat. 45) supported a wife and three children on a stipend of only 135 francs. A cheap hotel room could be had for 1 franc a night, dinner for 1 franc or 1.50, and the rental of the Yellow House was only 15 francs per month. A writer might thus have lived comfortably enough on Vincent's allowance, but since he spent so much on art materials, he often ended up without enough to eat; on one occasion he reported to Theo that he had lived for four days on twenty-three cups of coffee and some bread bought on credit. It should be added, however, that Vincent had also acquired in his early Christian period habits of self-denial that persisted long afterwards and sometimes seemed to aggravate his real poverty.[32]

Arriving in Arles in late February, Vincent found an ideally Impressionist subject to hand: the blossoming fruit and almond trees. But as summer drew on and brought with it the ripening wheat and then the harvest, his art moved increasingly away from Impressionism. His brush strokes became more animated, as though each one were expressing a vital movement; and he used what he had learnt about complementary colours to dramatize the character of the things he painted rather than to reproduce optical sensations. Vincent himself was aware of this development:

It is only that what I learnt in Paris is leaving me, and I am returning to the ideas I had in the country before I knew the impressionists. And I should not be surprised if the impressionists soon find fault with my way of working, for it has been fertilized by Delacroix's ideas rather than by theirs. Because instead of trying to reproduce exactly what I have before my eyes, I use colour more arbitrarily, in order to express myself forcibly.[33]

Once again, the figure of Millet's *The sower* (see Cat. 11), Vincent's starting-point as an artist (see Cat. 29, Fig. 26) and his most important single theme, preoccupied him: 'The idea of the "Sower" continues to haunt me all the time.'[34]

[32] LT572, 489, 488, 480, etc.
[33] LT520, Arles, 11 August 1888 (two examples follow — portraits of Boch and Escalier).
[34] LT535, Arles, c. 12 September 1888.

I have had a week's hard, close work among the cornfields in the full sun. The result is some studies of cornfields, landscapes, and — a sketch of a sower.

A ploughed field, a big field with clods of violet earth — climbing toward the horizon, a sower in blue and white. On the horizon a field of short ripe corn.

Over it all a yellow sky with a yellow sun.[35]

It is significant that the image of the sower (Fig. 13 and see Fig. 27) is so strongly associated with the sun. The suggestion that Vincent's *quelque-chose là-haut* might be identified with the sun, implicit in some earlier drawings, is here confirmed. Vincent almost says as much in a letter written shortly afterwards: 'Oh! those who don't believe in this sun here are real infidels.'[36]

In May, Vincent rented a little house in Arles, the 'Yellow House', in the hope of founding a studio where a group of artists might eventually work together, as he believed Japanese artists did. He began his campaign to persuade Gauguin to leave Pont-Aven, in Brittany, and to join him in Arles. With help from Theo, who agreed to extend financial assistance to Gauguin as well, this plan was finally realized, and Gauguin arrived in Arles in October 1888.

Vincent had been anxious about Gauguin's arrival, hoping to make a good impression with his work and hoping also that Gauguin would like Arles. But he did not, and made no secret of the fact; and although Vincent greatly admired his slightly older contemporary, their artistic personalities were so different that there was little that he could directly assimilate. This profound disparity was recognized by Gauguin himself: 'He likes my paintings, but when I do them he always finds that I am wrong here and there. He is a romantic and I am rather drawn towards the primitive. In regard to colour, he likes the accidental quality of impasto, such as Monticelli uses, and I detest messiness of execution.'[37]

There were also deep personal tensions from the start, and they culminated in the terrible events that took place just before Christmas. Apparently, after the two had been drinking and quarrelling, Vincent threatened Gauguin with a razor; then he cut off a part of his left earlobe and took it to a girl in a brothel. It is unclear what really happened, because Gauguin was the principal witness, and his account, written years later and demonstrably falsified in places, was an attempt to justify his own dubious role in these events.

The facts of the incident are obscure, and its meaning even more open to speculation. It has provided material for many psychiatric interpretations, just as the nature of Vincent's mental condition has given rise to much debate. Suggested causes have ranged from alcoholism to syphilis or epilepsy, and some of the most recent research is summarized in Wilfred Niels Arnold's essay (p. 13). In view of his brother's later collapse and some other instances of mental illness in the family, genetic predispositions cannot be ignored; but retrospective diagnosis will always be contentious.

Whatever physiological factors may be present, 'madness' is also an historical and cultural phenomenon and one of particular importance in the nineteenth century. It is a remarkable coincidence that the German philosopher Nietzsche's definitive collapse into madness occurred on 3 January 1889, only days after Vincent's attack, and that the great critic and writer John Ruskin, who had been suffering mental crises for ten years, finally descended into madness in 1889.

The significance of this 'coincidence' is that all three men were great minds struggling with what Nietzsche called so notoriously 'the death of God'. The passing of faith in the Christian

35  LT501, Arles, c. 21 June 1888.
36  LT520, Arles, 11 August 1888.
37  Rewald 1956, pp. 230–31.

God and His providential rule, which among other things left the terrible injustices and suffering of nineteenth-century society without hope of redemption, caused profound anguish and disorientation. For these three at least the anguish reached a crisis at almost the same moment; and Nietzsche's 'death of God' is a useful formula with which to approach the work of Vincent's last period, the most splendid and visionary of his career, but completely foreign to the Christian or quasi-Christian world-view embodied in his first images.

His first crisis lasted less than ten days, but was followed by a second at the end of January 1889, after which, in May, he admitted himself to the asylum of Saint-Paul-de-Mausole in Saint-Rémy-de-Provence, not far from Arles. For the rest of his life, between sporadic attacks, he was quite lucid.

The window of his room at the asylum looked out on to a wheatfield that he was often to paint, 'a square field of wheat in an enclosure ... above which I see the morning sun rising in all its glory' (see Fig 43).[38] He spent the first weeks painting in the asylum, but in June he went out to paint the harvest. In mid July, while working in the fields, Vincent suffered a new attack, which lasted for some five weeks.

When he started painting again, he did not at first leave the asylum, but reworked themes from his summer pictures. The practice of reworking compositions had already proved fruitful in Arles: a painting was sometimes followed by a drawing and then another painting. The process made possible a certain detachment from the immediate impression and a strengthening of the expressive design. One of the subjects that was now repeated in several versions was the reaper in the enclosed wheatfield.

> ... I am struggling with a canvas begun some days before my indisposition, a 'Reaper'; the study is all in yellow, terribly thickly painted, but the subject was fine and simple. For I see in this reaper — a vague figure fighting like the devil in the midst of the heat to get to the end of his task — I see in him the image of death, in the sense that humanity might be the wheat he is reaping. So it is — if you like — the opposite of that sower I tried to do before. But there's nothing sad in this death, it goes its way in broad daylight with a sun flooding everything with a light of pure gold.[39]

Like the sower of the previous year, the reaper is one of Vincent's touchstone subjects, one of a set of images that he chose as his own at the outset of his career as a painter, and that were originally imbued with complex Christian overtones. But now a reversal of scale embodies a profound change of meaning. In the earlier drawings, most of the composition was taken up by the peasant's burly figure, and nature was little more than the inert or resistant earth; here the tiny reaper is almost lost in the turbulence of nature's energy.

Man had been God's agent in a created world and the sowers and reapers governed the processes of life. Now, the earth is endowed with abundant, spontaneous energy, and if the rhythms and cycles of life are ruled by any external agency, it is the burning sun above. The sun had been important in earlier works, but now it becomes a central image, its vibrant golden disc reigning over harvests, fields of young wheat and even olive groves. Without any archaeological interest in origins of religion, Vincent has reverted to a primitive cosmos of earth and sun, in which man is little more than a servant of forces far beyond his control and even his understanding. For the deities of this cosmos are neither just, like the God of the Old Testament, nor

38    LT592, 22 May 1889.
39    LT604, Saint-Rémy, 5–6 September 1889, 'I have a great desire to do the "Reaper" once again for Mother ... for her birthday ... For I am persuaded that Mother would understand it — for it is in fact as simple as one of those coarse wood engravings that you find in country almanacs.'

merciful, like that of the New. It is a world without transcendent rationality, purpose, or therefore intelligibility.

The reaper and the wheat are both images of humanity, and the harvest is part of a natural cycle. Nature ordains the times of life and death: in the London *Wheatfield with cypresses*,[40] the dark silhouette of these trees associated with death, like black flames emanating from the under-world, marks the moment of ripeness and therefore of reaping.

Ripeness and death: this inseparable pair, to which Vincent had long before referred when speaking of his dismissal from Goupil, is symbolized by the corn and the cypress. In turn, the cypress is associated, in the repertoire of archetypal images that Vincent now completed, with the stars. In *The starry night* (Fig. 14), the cypresses occupy a place in the composition that is reversed, like a mirror image, in the later *Wheatfield with cypresses* (Fig. 15). The stars stand for life on the other side of death:

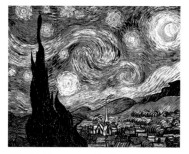

Fig. 14 Vincent van Gogh
*The starry night* F612
Saint-Rémy June 1889
oil on canvas 73.7 x 92.1 cm
The Museum of Modern Art,
New York
Acquired through the
Lillie P. Bliss Bequest

> ... looking at the stars always makes me dream, as simply as I dream over the black dots representing towns and villages on a map. Why, I ask myself, shouldn't the shining dots of the sky be just as accessible as the black dots on the map of France? Just as we take the train to get to Tarascon or Rouen, we take death to reach a star.[41]

These remarks, with their whimsical tone, were written almost a year before Vincent executed his extraordinary work. In the painting he has turned the stars into a celestial storm, raging above the church that occupies (like a memory of all the little country churches of which his father was successively the pastor) the centre of the composition. These stars hold out no comforting hope of another life; they embody the simultaneous exhilaration and terror of Vincent's new religion of natural forces.

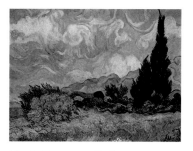

Fig. 15 Vincent van Gogh
*Wheatfield with cypresses* F615
Saint-Rémy July 1889
oil on canvas 72.5 x 91.5 cm
The Trustees of the National Gallery,
London

Vincent felt acutely, if unconsciously, the lack of transcendent meaning and providential purpose which he had taken for granted in his youth and which had survived even his break with orthodox Christianity. Painting had been at first a way for him to reconstruct a 'partial belief', but in the end art itself had led him away from Christianity and to the discovery of a vertiginous world beyond the 'death of God'. That Vincent experienced this loss as a wrenching dislocation is confirmed by the terrifying religious hallucinations he suffered during his attacks: '... I am astonished that with the modern ideas that I have, and being so ardent an admirer of Zola and de Goncourt ... that I have attacks such as a superstitious man might have and that I get perverted and frightful ideas about religion such as never came into my head in the North.'[42]

At the same time, Vincent returned to a number of Christian subjects, transforming them, however, as though trying to work out some kind of reconciliation with his new understanding of the world.

In October, Vincent received a copy of the first reference to him by a critic, which had come out on 19 August, during one of his attacks, J. J. Isaäcson wrote:

> Who interprets for us in forms and colours the mighty life, the great life once more becoming aware of itself in this nineteenth century? One I know, a solitary pioneer, he stands alone struggling in the deep night, his name, Vincent, is for posterity.

He added, in a footnote: 'About this remarkable hero — he is a Dutchman — I hope to be

40  F615, July 1889.
41  LT506, Arles c. 9 July 1888.
42  LT607, Saint-Rémy, 19
September 1889.

able to say something later.'[43] 'In my estimation', Vincent commented to his mother, 'I consider myself certainly below the peasants ... Well, I am ploughing on my canvases as they do on their fields.'[44] Perhaps disturbed by what he considered excessive praise, Vincent suffered an attack on Christmas Eve, almost the anniversary of the first. It was of short duration, but was followed by a similar attack on 21 January 1890. It has been suggested that the imminent birth of Theo's child, which would present his brother with new responsibilities, may have contributed to Vincent's anxieties at this time. But Vincent greeted the birth of his nephew with joy, and was deeply touched that he was to be given his own name: Vincent Willem. He painted for him a blue sky full of almond blossoms, like an ode of celebration.

Vincent was also disturbed at this time by his second enthusiastic review, from the critic Albert Aurier. Less than a fortnight later, he suffered an attack which, unlike the previous short ones, lasted for two months, until late April; immediately afterwards he wrote to Theo:

> Please ask M. Aurier not to write any more articles on my painting, insist upon this, that to begin with he is mistaken about me, since I am too overwhelmed with grief to be able to face publicity. Making pictures distracts me, but if I hear them spoken of, it pains me more than he knows.[45]

Vincent had told Theo the previous year that he felt the atmosphere of the old cloisters might be provoking the religious hallucinations,[46] and this new attack convinced him that he must leave Saint-Rémy. Before his departure, in early May, he painted an extraordinary adaptation of Rembrandt's etching of the *Raising of Lazarus*, replacing the figure of Christ with the brilliant disc of the sun.

On 16 May he left for Paris, and after a few days there travelled to Auvers-sur-Oise, where he was to live at an inn, under the supervision of Dr Gachet, a collector and friend of many artists, including Cézanne. Here he continued to paint for the next two and a half months. Outstanding works from this period include the last two long and low wheatfield compositions, which have generally been dated around the time of his death. In the more famous of the pair *Crows in the wheatfields* (Fig. 16), a flock of crows rises from a wheatfield into which a crooked path disappears.

On Sunday 27 July, Vincent borrowed a pistol with which he said he wanted to shoot crows, went out into the fields to paint, and shot himself in the chest. The bullet missed his heart, and he managed to get back to the inn, where Ravoux, his host, concerned that he had not come down to dinner, discovered him lying on his bed, his face to the wall in the eternal attitude of one awaiting death. Dr Gachet was called, and dressed the wound. Vincent explained to him that he had acted deliberately and lucidly; he had not been in the grip of madness. He asked for his pipe and spent the night awake, apparently in no pain, smoking. The next day Gachet was able to contact Theo at the gallery. He came at once; Vincent told him: 'Do not cry, I did it for the good of everybody.'[47] The two brothers spent the day together, talking, until at one or one-thirty the following morning, he died in Theo's arms.

Why did Vincent shoot himself? Whatever determined the action itself, its time and place seem to embody a kind of poetic necessity: if Vincent was to take his own life, it was in keeping with his deepest intuitions about the cycles of nature and his own existence that it should have been in the fields and at harvesttime.

43 Pickvance 1986, p. 50.
44 LT612, Saint-Rémy, c. 20 October 1889.
45 LT629, Saint-Rémy, 29 April 1890.
46 LT605, Saint-Rémy, 7–8 September 1889; LT607, Saint-Rémy, 19 September 1889.
47 Rewald 1956, p. 380.

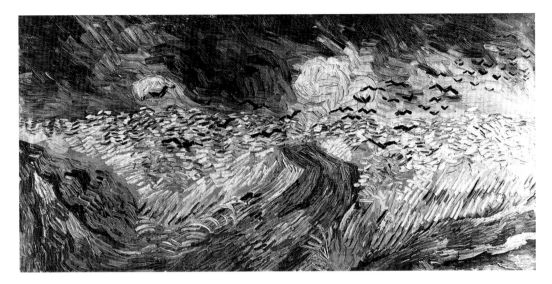

Fig. 16 Vincent van Gogh
*Crows in the wheatfields* F779
Auvers-sur-Oise June–July 1890
oil on canvas 50.5 x 103.0 cm
Vincent van Gogh Foundation
Van Gogh Museum, Amsterdam

The funeral was held on 30 July. The room where the coffin lay was hung with his recent pictures and filled with yellow flowers. The mourners who came from Paris included Emile Bernard, Lucien Pissarro and Père Tanguy, the old paint-dealer whose portrait Vincent had painted. Theo, brokenhearted, and following his brother in this as in other remarkable instances during his life, suffered a mental collapse in October. According to Pissarro, he had 'a violent quarrel with his employers on the subject of a painting by A. G. Decamps. Subsequently, in a moment of exasperation, he resigned from the gallery and all of a sudden went mad.' His brother-in-law Andries Bonger wrote to Dr Gachet on 10 October that since the day before Theo had been in a state of extreme 'overexcitement' and that he was 'haunted by the memory of his brother'. He began to form various unrealistic plans, but soon became violent and was later taken to Holland by his wife. In the last weeks of his life he sank into complete apathy.[48] Theo died on 25 January 1891, less than six months after Vincent, and lies beside him at Auvers.

Do you know what I think of pretty often ... that even if I [do] not succeed, all the same ... what I have worked at will be carried on ... And what does it matter personally then! I feel so strongly that it is the same with people as it is with wheat, if you are not sown in the earth to germinate there, what does it matter? — in the end you are ground between the millstones to become bread.[49]

*Christopher Allen*

[48] ibid., pp. 384–85.
[49] LT607, Saint-Rémy, 19 September 1889.

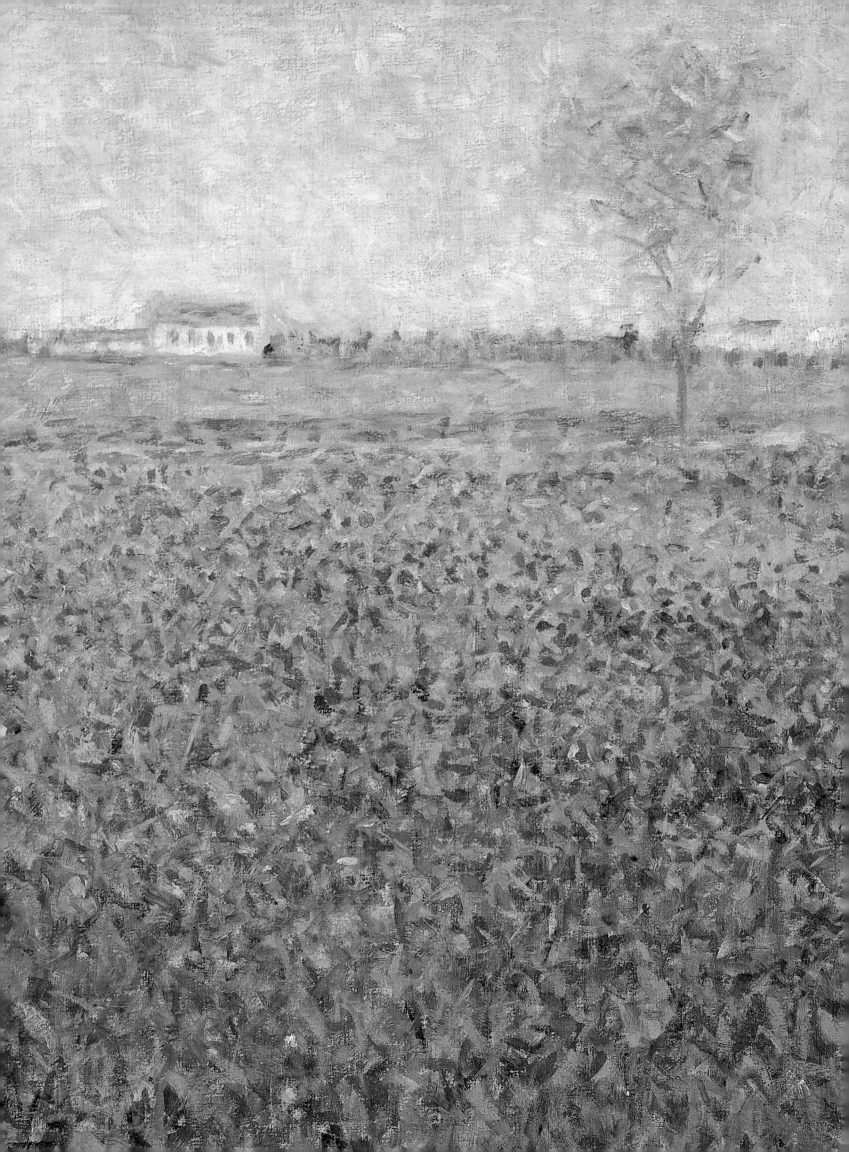

# *Sources*
## of Vincent van Gogh

Facing page: Detail of Cat. 21
Georges Seurat
*Field of lucerne, Saint-Denis* c. 1884–85
oil on canvas  64.0 x 81.0 cm
inscribed l. l. : Seurat
National Galleries of Scotland

THOMAS FAED 1826–1900

## 2 THE MITHERLESS BAIRN 1855

oil on panel 63.2 x 90.0 cm
inscribed l. r. : Faed 1885 London
National Gallery of Victoria Purchased with
the assistance of a Government Grant 1886

FRANK HOLL 1845–88

## 3 THE DESERTER 1875

pen and ink, heightened with white
19.0 x 14.0 cm inscribed l. r. : Frank Holl
National Gallery of Victoria Purchased 1881

FRED WALKER 1840–75

## 4 THE RIGHT OF WAY 1875

oil on canvas 78.5 x 112.0 cm
National Gallery of Victoria Purchased with
the assistance of a Government Grant 1891

CAT. 3

Van Gogh visited Britain in May 1873 when he was transferred to the London branch of art dealers, Goupil & Cie. During his two year stay, Vincent viewed pictures at the Royal Academy and public and private galleries, but his exposure to British art was principally through prints.

Van Gogh claimed that 'the English black-and-white artists are to art what Dickens is to literature. They have exactly the same sentiment, noble and healthy, and one always returns to them.'[1] In the early 1880s in The Hague he seriously began to collect prints and eventually had over fifteen hundred images which he meticulously mounted on sheets of grey paper and sorted into categories. Some of the British images provided the point of departure for major pictures such as *The chair and the pipe* (see Cat. 44), the Heads of the People series, and *The potato eaters* (see Fig. 28).

Van Gogh appears to have had difficulty with Thomas Faed's painting. He preferred less sentiment, more honesty. Van Gogh may have sensed the bogus origins of *The mitherless bairn*, Faed's most famous and most reproduced picture. It was later shown that the subject — a destitute orphan being welcomed into the bosom of a crofter's family — was based on an incident in Faed's childhood, when a boy, saying he was an orphan, was taken in and fed and petted until he grew so insolent that he had to be turned away. He was then revealed as the son of two tramps who were the terror of the district.

Frank Holl's *The deserter* was published as a double page spread in the *Graphic*, on 25 September 1875. Van Gogh directly referred to it in a letter to Theo written in May 1882 likening Sien, his companion and model for twenty months, to the woman in this image.[2]

Fred Walker, a watercolourist, illustrator and painter of rustic genre subjects, was one of Van Gogh's most admired British artists. In May 1885 Van Gogh wrote to Theo that the artists Walker and Pinwell 'did in England exactly what Maris, Israëls, Mauve, have done in Holland, namely restored nature over convention; sentiment and impression over academic platitudes and dullness ... I remember peasants in the field by Pinwell, *The harbour of refuge* by Walker, of which one might say, "peints avec de la terre" [paints with the earth].'[3]

Walker's *The right of way* which Van Gogh may have seen at the Royal Academy, where it was shown in 1875, makes no claim to being a social realist picture: it is a landscape of a kind which we know through Van Gogh's letters he respected as very honest painting.

1    R13, The Hague, 18–19 September 1882.
2    LT194, The Hague, 4–12 May 1882.
3    LT406, Nuenen, 4 May 1885.

## WILLEM MARIS 1844–1910
## 5 DUCKS

watercolour 20.9 x 37.2 cm
inscribed l. l. : Willem Maris
National Gallery of Victoria
Gift of William Drummond 1914

## JACOB MARIS 1837–99
## 6 THE OLD MILL

watercolour 39.5 x 30.5 cm
inscribed l. r. : J Maris
National Gallery of Victoria
Felton Bequest 1909

Nature and farm life were central themes for The Hague School of artists whose idealized, timeless images locked out telling signs of modernity and urbanization. The Hague School artists, like Jacob Maris and his younger brother Willem, were fascinated by the atmospheric changes in nature and responded to these phenomena by working to capture specific frames of nature's fleeting moments.

Quicker, looser brush work was favoured over the academic practice of disguising all traces of the brush. Artists worked within a restricted range of tones, usually grey, yellow or green, rather than contrasting, bright colours. Individual motifs, like ducks, appear to blend with their surroundings through this unified tonal range.

Near his house at Voorburg, Willem Maris had a duck pond where he could easily observe the waterbirds at close quarters. He painted them in numerous variations in oil and watercolour, as seen here.[1] The genre found a ready market among buyers.

The Hague School artists usually chose subjects reflecting national themes and character, consequently windmills appeared as a principal motif in their work, particularly that of Jacob Maris. This choice of typically Dutch subject matter contributed to the positive reception that greeted Hague School art when it entered the art market or was displayed in international exhibitions.

Van Gogh shared with The Hague School artists a strong affinity for untainted locations: 'these very spots where nothing is left of what one calls civilization, where all that is definitely left behind, these very spots are those one needs to get calmed down'.[2] He believed in the power of nature and wrote to Theo in September 1881, 'I have to observe and draw everything that belongs to country life — like many others have done before, and are doing now'.[3]

Art produced by The Hague School helped to shape Van Gogh's early stylistic and aesthetic attitudes as an artist (see Cat. 27). Furthermore, references to The Hague School artists regularly appear in Van Gogh's correspondence, illustrating that the work of these artists was not forgotten (see Cat. 32, 33).

1    Such subjects painted so often are difficult to date.
2    LT307, The Hague, 29–30 July 1883.
3    LT150, Etten, c. September 1881.

CAT. 5

CAT. 6

35

## ANTON MAUVE 1838–88
## 7 RETURNING HOME: END OF THE DAY

oil on panel 25.5 x 40.7 cm

inscribed l. r. : A Mauve

Art Gallery of New South Wales

Purchased 1945

Anton Mauve, a leading member of The Hague School, was married to Van Gogh's cousin. Van Gogh familiarized himself with Mauve's work during his years of employment with Goupil & Cie. Mauve was well known for his genre paintings of farm life, particularly flocks of sheep. In 1879 Vincent wrote to Theo: 'A picture by Mauve or Maris or Israëls says more, and says it more clearly than nature herself.'[1]

In September 1881, Van Gogh travelled to The Hague from Etten, to seek technical advice from Mauve and was given encouragement by the established artist. Back in Etten, Van Gogh was sent a gift from Mauve of a paint box filled with paint and all the necessary tools of an artist's trade. After moving to The Hague, Vincent studied drawing with Mauve from January to March 1882 and, although a quarrel ended their direct association, Mauve's influence continued.

Fig. 17 Vincent van Gogh *Potato eaters* F1661
Nuenen mid April 1885 lithograph 26.5 x 30.5 cm
Vincent van Gogh Foundation Van Gogh Museum, Amsterdam

---

1 LT130, Wasmes, June 1879.

## ANTHON VAN RAPPARD 1858–92
## 8 THE WESTERKADE IN UTRECHT WITH BARGES 1885

oil on canvas 25.0 x 45.0 cm

inscribed l. l. : A RAPPARD. '85

Lou and Brenda Klepac, Sydney

Another Dutch artist with whom Van Gogh was closely associated at the beginning of his career was Anthon van Rappard. Vincent first visited Van Rappard in Brussels at Theo's suggestion in October 1880, when he was fresh from The Borinage and his bitter disappointment there as a lay preacher.

Van Rappard was a more advanced artist at twenty-two than Vincent was at twenty-seven. Despite temperamental differences their friendship lasted longer than any other in Vincent's life. The pair were mutually supportive of each other's work; Vincent painting in Van Rappard's studio in the months before he moved home to Etten. The young artists shared a passion for French and British reproductive engravings, collecting thousands of examples between them.

In this painting the ease of execution and the beauty of the dark paint show the solid technical basis of Van Rappard's art. Van Rappard believed that technique was important. Vincent did not, and made it clear to his well-trained friend that 'art is something greater and higher than our own adroitness or accomplishments or knowledge'.[1] He also commented to Van Rappard: '... As I see it, both you and I cannot do better than work after nature in Holland (figures and landscapes). Then we are ourselves, then we feel at home, then we are in our element. The more we know of what is happening abroad, the better, but we must never forget that we have our roots in Dutch soil.'[2]

The friendship continued until 1885 when Anthon wrote a severely critical letter about Vincent's lithograph *Potato eaters* (Fig. 17): 'Fortunately you can do better than that ... now they are only posing. How far from true that coquettish little hand of the woman in the background is — and what connection is there between the coffee kettle, the table and that hand that is lying on top of the handle? What on earth is that kettle doing?... And why isn't the man to the right allowed to have a knee, a belly and lungs? Or are they located in his back? And why must his arm be a yard too short?'[3]

Vincent considered the friendship at an end. Van Rappard died of pneumonia, when he was thirty-three years old.

---

1 R43, Nuenen, second half of March 1884.
2 R2, Etten, 15 October 1881.
3 R15a, Utrecht, 24 May 1885.

## THEODORE ROUSSEAU
## 1812–67
### 9 A GROVE OF TREES C. 1844–52

oil on wood 41.6 x 63.8 cm
National Gallery of Victoria
Felton Bequest 1955

Before 1850 landscape painting was acceptable to the French arbiters of taste provided it was carefully detailed, the setting for a reconstruction of classical mythology or history, or evocative of a distant, romantic land.

This was changed by a group of outdoor painters, contemptuously called the Barbizon school, after the village where they painted. The official arbiter of taste of the day[1] said of Barbizon pictures: 'This is the painting of democrats, of those who don't change their linen, who think that they can deceive men-of-the-world: this art displeases and disgusts me.' He was referring to one of the starting points of modern art: art based on observation rather than imagination. Van Gogh greatly admired the Barbizon painters for their honesty in depicting the places where they lived and the lives they shared with the peasants.

Etienne Pierre Théodore Rousseau was born in Paris. He painted in the Auvergne mountains for a time until, at the age of eighteen, he had one of his Romantic landscapes accepted by the Salon, the official showcase of French art. From 1846 he lived and painted in the village of Barbizon, becoming a prominent member of the Barbizon group and a friend of Millet.

On 7 September 1880, Vincent wrote from Cuesmes that he had made a large sepia drawing after Théodore Rousseau's *Four dans Les Landes* (Communal ovens in Les Landes), and had made two watercolour copies of it before he had finished it.[2]

*A grove of trees* was also inspired by Les Landes, a low-lying, marshy landscape with stretches of water, clumps of trees and vast changing skies. In his paintings made in Les Landes, in the south west of France, Rousseau focused on the minutiae of bracken and grasses, but most particularly on the intensely clear light. In Les Landes, he worked out of doors, observing the changing atmosphere and light effects, in a way which presupposes the Impressionists.

## CHARLES-FRANCOIS DAUBIGNY
## 1817–79
### 10 BARLEY FIELDS C. 1876

oil on canvas 38.4 x 55.2 cm
inscribed l. l. : Daubigny
Collection: Bendigo Art Gallery
Gift of Mrs G. C. Scott 1947

Charles-François Daubigny came from a family of painters. As a young man he earned his living as an illustrator. From 1830 he began exhibiting regularly at the Salon. In 1843 he went on his first painting trip through the forest of Fontainebleau, near the village of Barbizon, beginning his association with the group of landscape painters living there.

*Barley fields* is dated with Daubigny's paintings of orchards from 1876. The unusually divided composition with a receding figure reflects the calm domestic landscapes characteristic of this circle of painters.

For the Barbizon school of landscape painters [1], including Corot and Millet, landscape became the means of expressing a profound emotional experience. The significance of Daubigny's work for the Impressionist painters lay primarily in his innovative approach to nature and his consistent practice of painting in the open air.

---

[1] Count Nieuwerkerke, appointed the Louis Napoleon, Superintendent of the Académie des Beaux Arts and President of the Annual Salon Jury.
[2] LT135, Cuesmes, 7 September 1880.

[1] The work of The Hague School and of the Barbizon painters was readily collected by the customers of art dealers Goupil & Cie, where Vincent van Gogh worked from 1869–76.

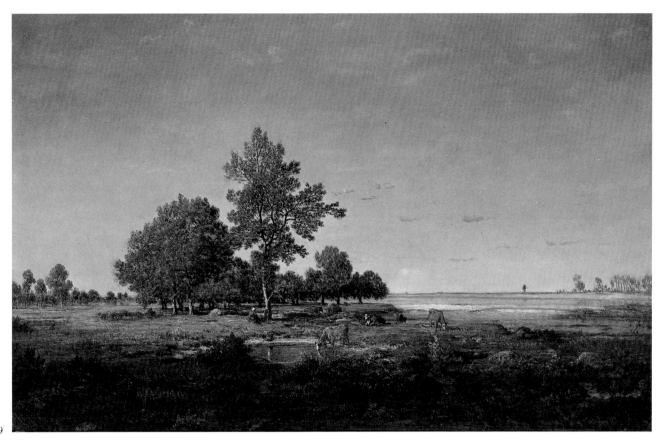

CAT. 9

CAT. 10

JEAN-FRANCOIS MILLET
1814–75

## 11 THE SOWER 1851

lithograph (3rd state) 19.0 x 15.5 cm
Art Gallery of South Australia
A. R. Ragless Bequest Fund 1975

## 12 BUCKWHEAT HARVEST, SUMMER (II) C. 1868–74

oil on canvas 85.5 x 111.1 cm
inscribed l. r. : J.F.Millet
Museum of Fine Arts, Boston
Gift of Quincy Adams Shaw
through Quincy A. Shaw Jr and
Mrs Marian Shaw Haughton

Millet's images of the dignity of peasant labour have been viewed as sentimental in modern times, but were new and topical — even dangerously so — at the time of their creation.

In France the revolution of 1848[1] brought the life of the common people to centre stage. In 1850 when Millet showed his oil painting of *The sower* at the Paris Salon a highly politicized audience responded according to individual hopes and fears: the work seemed savage and threatening to some, heroic to others.[2] Millet himself maintained a reformist political stance rather than a revolutionary one, nevertheless he did not mind troubling the complacent viewer.

*The sower* is a brooding image, a peasant striding across the bare soil of a ploughed hillside, his head and shoulders looming dark against the sky. The gesture is expansive, but the shadowed face is enigmatic, and the labourer works as stolidly as the oxen on the horizon.

Millet's contemporaries were very conscious of his Realist refusal to make pictures which were merely pleasing, whether in subject or in the handling of paint. It was suggested Millet's peasants were painted with the earth they planted, thereby pointing simultaneously to the harshness of the painting and to the people's involvement with the life of the soil.

Sowing represents the hope of regeneration in nature. Millet's understanding of this was coloured by a blend of humanistic and religious sentiment. His biographer Sensier asserted that the labourer with his sowing bag filled with grain, 'the hope of the new year', is engaged in 'a sort of holy vocation'. A slightly different perspective is

summed up pithily in Millet's repeated quote from the Bible: 'In the sweat of thy face shalt thou eat bread' (Genesis 3:19).

The artist was the son of a farmer from Normandy. In 1849 he made a decisive break with the city of Paris, where he had already begun to paint peasant subjects, and moved the thirty or so miles to Barbizon in the forest of Fontainebleau. There he joined Théodore Rousseau and the other painters of the so-called Barbizon school, devoted to the essentially naturalistic representation of the landscape. Guided above all by the practice of painting out of doors, their vision was also influenced by the landscape and peasant subjects of the seventeenth-century Dutch masters.

Millet's *Buckwheat harvest* represents 'Summer' in a set of the 'Four Seasons' commissioned in March 1868 by Frédéric Hartmann, a wealthy industrialist. The artist depicts the harvesting of a coarse grain called buckwheat in his native Normandy, the peasants using distinctively Norman baskets with carrying poles

Millet worked on the commission, based on an earlier group of pastels, for seven years. In March 1873 he mentioned that 'Summer, the buckwheat harvest' only needed 'a good push' to be completed, but when he died in January 1875 the painting was still unfinished.[3] As such, it boldly plays off underdrawing against painted surface.

The broad, dry brush strokes that summarize the edges of clouds are representative of Millet's late style, influenced by his extensive use of pastels from 1863 to 1873.[4] When working for Goupil & Cie in Paris, Van Gogh would have seen the closely related pastel of this work.

The golden-brown tonality of the oil was planned from the beginning in Millet's choice of a yellow-ochre ground for the canvas. The hot, dusty summer effect is intensified by touches of red-oranges, ruddy browns and pairings of yellow and green strokes.[5]

[1]   The 1848 Revolution was a popular uprising against the monarchy, leading to the short-lived Second Republic under Louis-Napoleon. The right to work and to vote were the pressing questions of the time, and the poverty of the working classes of city and country was the underlying condition of events. Unsettled by further strife the Republic ended with a *coup d'état* by which Louis-Napoleon became Emperor.
[2]   For the critical reception of Millet see T. J. Clarke, *The Absolute bourgeois: artists and politics in France 1848–1851*, London, Thames and Hudson, 1973, pp. 72–98.
[3]   *Jean François Millet*, Arts Council of Great Britain, London, 1976, p. 50.
[4]   ibid., p. 52
[5]   Alexandra R. Murphy, *Jean-François Millet*, Museum of Fine Arts, Boston, p. 221.

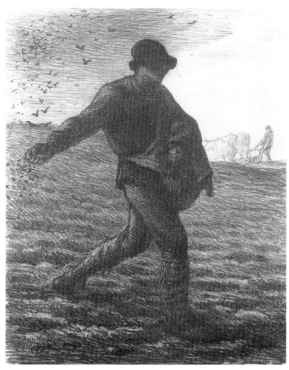

CAT. 11

CAT. 12

JEAN-FRANCOIS MILLET
1814–75

## *13* THE GLEANERS C. *1855*

etching  19.1 x 25.5 cm

inscribed on plate l. r. : Paris Imp.

par Aug. Delâtre Rue S$^t$ Jacque 171

National Gallery of Victoria

Felton Bequest 1949

## *14* THE DIGGERS *1855–56*

etching  23.8 x 34.0 cm

inscribed on plate l. r. : Paris Imp.

par Aug. Delâtre Rue S$^t$ Jacque 171

Collection: National Gallery of Australia, Canberra

Purchased 1980

## *15* SETTING OFF FOR WORK *1863*

etching  38.4 x 30.5 cm

inscribed l. l. : J. F. Millet

National Gallery of Victoria

Felton Bequest 1947

Prints by and after Millet played a significant role in shaping Van Gogh's visual language, serving as vital references from which Vincent sought to learn.

Even before Vincent had decided to be a full-time artist he turned to prints and reproductions of works by Millet as sources of the fundamental rules of drawing. Yet Van Gogh's desire to study the figure drawing of Millet — to develop elementary technique, was magnified by his passionate identification with Millet's representations of peasant life, such as *Setting off for work*, his most highly regarded print. Peasant subject matter was viewed by Van Gogh as imbued with noble and serious sentiment because he held the utmost respect for humble labour in the field.

Van Gogh enlisted Theo's help in securing prints by Millet for copying purposes, writing in September 1880, 'I try to study that master seriously. I know that the large etching of *The diggers* is rare but be on the look out for it, and tell me what it will cost ... I should like to have that print ... even if it is rather expensive'.[1] As early as 1878 he had written to remind Theo that Millet 'made an etching *The diggers*, if you ever happen to see it, you won't forget it soon'.[2] *The diggers* was to Van Gogh an etching in which one could 'see with full clarity what may be expressed by [*bold*] contour'.[3]

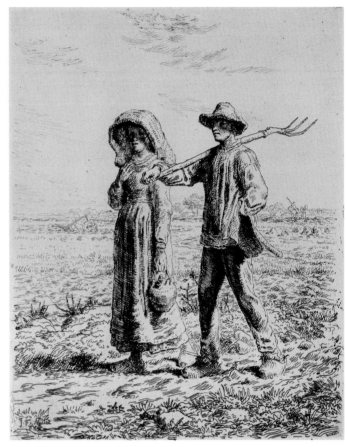

CAT. 15

Vincent knew Millet's *The gleaners* from reproductions and saw it displayed in the 1887 Millet exhibition. In this work, distant but plainly evident, are flocks of crows, a motif that featured prominently in Van Gogh's last works. He saw the 'country around Courrières [in northern France in the winter of 1879–80], haystacks, and brown earth or almost coffee-coloured clay and the flocks of crows made famous by the pictures of Daubigny and Millet'.[4]

1  LT135, Cuesmes, 7 September 1880.
2  LT120, Amsterdam, 3 March 1878.
3  R37, The Hague, 15 June 1883.
4  LT136, Cuesmes, 24 September 1880.

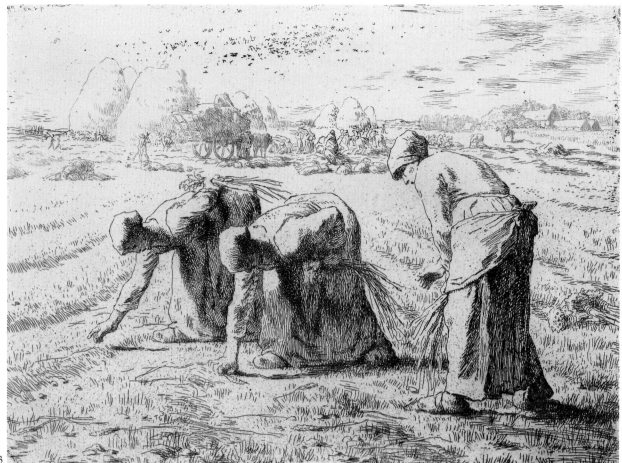

Cat. 13

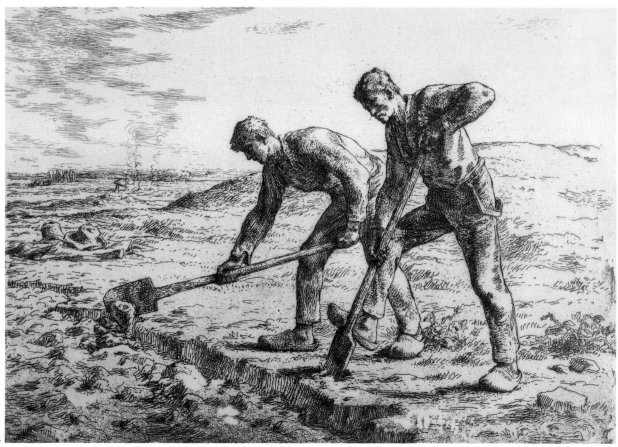

Cat. 14

# ADOLPHE MONTICELLI
## 1824–86

## *16 FETE CHAMPETRE C. 1860*

oil on canvas  41.5 x 62.7 cm

inscribed l. r. : Monticelli

National Gallery of Victoria

Felton Bequest 1909

Fig. 18 Detail of Cat. 16

Adolphe Monticelli was born in Marseilles. On settling in Paris in 1856 he was influenced by the Romantic artist Diaz[1] and thereafter gave free rein to intense colour and texture in his work. The war of 1870 forced his return to Marseilles where he died in poverty .

Monticelli's vigorous handling of paint (Fig. 18) and high-keyed palette were a constant source of inspiration for Vincent van Gogh. In February 1890, Vincent wrote to Theo: 'I think you will like the canvas ... it is in a terribly thick impasto and worked over like some Monticellis'.[2] In comparing himself to Monticelli, Vincent discerned an essential point of difference in their approach to colour: '... if I dared to let myself go, and venture even further, dropping reality and making a kind of music of tones with colour, like some Monticellis. But it is so dear to me, this truth, *trying to make it true*, after all I think, I think, that I would still rather be a shoemaker than a musician in colours.'[3]

Van Gogh's own richly-textured surfaces affirm his interest in Monticelli's technique and in the idea that expressive gesture and rapidly applied brush strokes might have pictorial impact in their own right. Theo and Vincent Van Gogh owned several paintings by Monticelli who was, by all accounts, an imaginative and passionate character, susceptible to regular bouts of melancholy.

*Fête champêtre*[4], a rustic entertainment, belongs to a long series of fantasy scenes first painted by French artists of the Rococo period. These lyrical expressions of happiness and celebration, wholly detached from the practicalities of daily existence, are infused with a subtle but insistent reminder of the transience of all that is beautiful in life.

In Monticelli, we recognize a model for Van Gogh's brush technique — a technique arising from the pursuit of an art in which the paint itself often assumes a greater importance than the actual appearance of things. What is more, we identify Monticelli and Van Gogh as fellow travellers whose personal and artistic missions seemed to them to be at odds with the fashionable styles and attitudes of their era.

1 Narcisse Virgile Diaz de la Pera (1807–76), a French landscape painter who worked first in the Romantic style of Delacroix and later became a central figure in the Barbizon group.

2 LT626, Saint-Rémy, 10–11 February 1890.

3 ibid.

4 Monticelli's *Fête Champêtre* was painted in oil directly on to unprimed canvas, leaving areas of raw canvas exposed within the vigorously applied paint. It has subsequently had another canvas glued to the reverse with an adhesive which has penetrated the raw canvas and cracks in the paint. This adhesive has darkened with age, altering the colour values of the work. In addition layers of natural-resin varnish, which have been applied to the front, have also darkened. These two factors make the work much darker overall than it originally would have appeared and reduce the impact of delicate flecks of brightly coloured paint, but the tonal relationships may not be far removed from what was originally intended.

CAT. 16

## JULES BASTIEN LEPAGE
## 1848–84

## *17 SEASON OF OCTOBER:*
## *THE POTATO GATHERERS 1878*

oil on canvas  180.7 x 196.0 cm

inscribed l. l. : 1878, DAMVILLERS

J. BASTIEN LEPAGE

National Gallery of Victoria

Felton Bequest 1927

Jules Bastien Lepage was born at Damvillers, a village in the north east of France. He studied in Paris with an academic painter and although he showed regularly at the Paris Salon, spent much of his life in his native village painting subjects of peasant life. Both his painting technique and his subject matter had a considerable influence on painters throughout the 1880s, not only in France but in England and Australia.

In the mid 1870s Bastien Lepage, disappointed at not winning a most important travelling scholarship, chose to leave Paris and to reconsider the kind of subjects he would paint. He wrote :

> Nothing is good but truth. People ought to paint what they know and love. I come from a village in Lorrain. I mean first of all to paint peasants and landscapes of my home exactly as they are.[1]

He saw himself as following in the tradition of Millet and the Realist painter Gustave Courbet (1819–77), both of whom are constantly referred to in Van Gogh's letters. His sentiments were also very close to those held by Vincent van Gogh. Vincent knew and admired this painting and made a note of it by sketching the head of the woman in the foreground (Fig. 19)[2].

*Season of October: The potato gatherers* was intended to depict the dignity and hardship of peasant life and labour. It is the second of a pair on the theme of harvest. The first is set in spring and shows haymakers at rest, while this the second, completed a year later, is set in the northern autumn. Unlike Millet's peasant figures these are identifiable people, yet they remain strangely detached from their surroundings. Contemporary critics thought that photography had influenced the rather awkward frozen posture of the two women and remarked on the sudden change of scale from foreground to distance, also perhaps a result of photography's new means of capturing reality.

Fig. 19 Vincent van Gogh
sketch after *Season of October: The potato gatherers*
The Hague  March 1883  pen and ink
Vincent van Gogh Foundation  Van Gogh Museum, Amsterdam

By the 1880s there were numerous sentimental depictions of peasant life made by painters who had never left the city. It was a genre despised by both Vincent and his brother. In a letter of April 1885, replying to a remark of Theo's, Vincent wrote:

> When people from the city paint peasants their figures, splendidly painted though they are, cannot but remind one of the suburbs of Paris, though in my opinion Bastien Lepage's woman digging potatoes is a decided exception.[3]

The honesty of Bastien Lepage's approach to his subject clearly distinguished this work for Vincent.

1    Julia Cartwright, *Jules Bastien Lepage*, London, 1894, p. 17.
2    The sketch was enclosed in a letter to Van Rappard (R30, The Hague, c. 5 March 1883) and the Bastien Lepage head was referred to in R35, The Hague, c. 21 May 1883.
3    LT400, Nuenen, c. 13 April 1885.

CAT. 17

CLAUDE MONET
1840–1926

*18* VÉTHEUIL C. 1878–79

oil on canvas  60.0 x 81.6 cm

inscribed l.r.: Claude Monet

National Gallery of Victoria

Felton Bequest 1937

Claude Monet was born in Paris but grew up by the sea at Le Havre where he was introduced to outdoor painting. He went to Paris in 1859 where he met Pissarro, Courbet and later at Gleyre's studio, Renoir and Sisley. In the First Impressionist Exhibition of 1869,[1] it was a painting by Monet, *Impression sunrise* that established the name of the group as 'Impressionists'. Monet remained its central figure.

In April 1878 Monet went to Vétheuil, a small town on the River Seine midway between Paris and Rouen, to paint for the summer. He explored the river by boat and worked from the water.

Some of Monet's works of this period were criticized for their apparent lack of finish, implying that extreme financial hardship had driven the painter to rush canvases out with undue haste. By contrast, this view of the town shimmering in the afternoon sunlight is a highly finished work. In many respects it reflects what the critic Laforgue wrote in 1883:

> The impressionist sees and renders nature as it is — that is, wholly in the vibration of colour. In the work of Monet and Pissarro everything is obtained by a thousand dancing strokes in every direction like straws of colour — all in vital competition for the whole impression.[2]

When Vincent van Gogh was in Antwerp, he did not know what Impressionism was. Recalling this period later he wrote to Wilhemina, 'one has heard about the impressionists and expects a lot'.[3] He goes on to describe his bitter disappointment on reaching Paris 'with ideas of Mauve, Israëls and other able painters', Impressionism 'all seems so slapdash, ugly, badly painted, badly drawn, bad in colour and just plain wretched'.[4]

His immediate reaction must have been short lived, for he wrote to the English painter Levens from Paris in autumn 1886:

> There is much to be seen here ... Now I have seen them though not being one of the club yet, I have much admired certain

impressionists' pictures — *Degas* nude figure — *Claude Monet* landscape.[5]

By the time Van Gogh reached Paris the old Impressionist group had begun to break up and quarrel among themselves. In his letters Van Gogh makes no distinction between Impressionists and Post Impressionists, but divides them into the 'painters of the Grand Boulevard', that is established painters like Monet, and 'Petit Boulevard' painters like himself. Vincent draws selectively from both strands of painting theory in Paris, from the Impressionists, like Monet and from artists of the younger group like Signac and Seurat.

1  There were eight Impressionist exhibitions held between April 1874 and June 1886. These were held in 1874, 1876, 1877, 1879, 1880, 1881, 1882, 1886: each exhibition lasted one month. They were instigated as an exhibition of independent artists without sanction of jury, after the rejection of works by Monet, Renoir, Cézanne and Sisley in the 1873 Salon. Exhibitions were not confined to members. Of the central group only Pissarro showed in all eight exhibitions; Degas showed in seven, Monet and Gauguin in five and Renoir and Sisley in four.
2  Jules Laforgue, 'L'impressionisme', published posthumously, 1903.
3  W4, Arles, c. 22 June 1888.
4  ibid.
5  459a, Paris, August–October 1886.

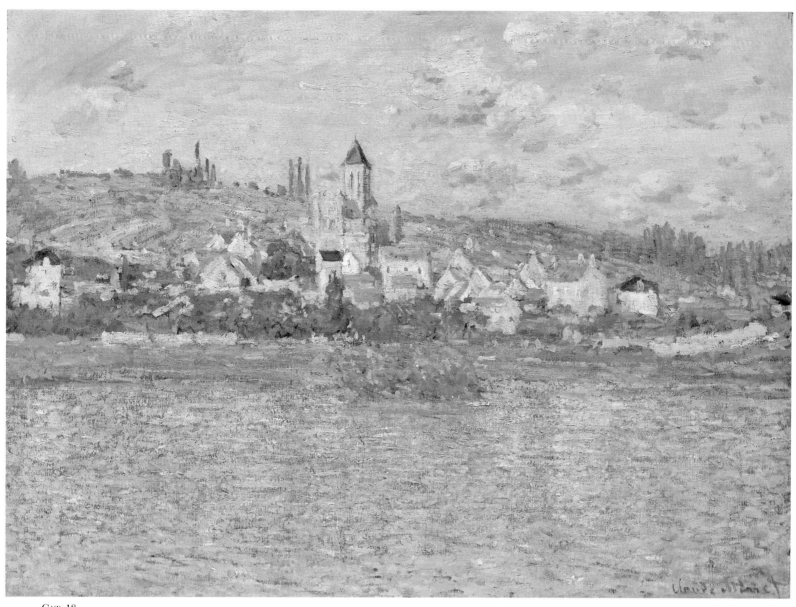

CAT. 18

## EDOUARD MANET
## 1832–83

### 19 THE HOUSE AT RUEIL 1882

oil on canvas 92.8 x 73.5 cm

inscribed l. l. : Manet 1882

National Gallery of Victoria

Felton Bequest 1926

Edouard Manet was born in Paris where he spent most of his life. He studied with the painter Thomas Couture and was a friend of many of the members of the Impressionist group, especially Monet, but did not exhibit with them. Much of his work focuses on urban life. Younger painters looked to his work as the direction for the future of modern art.

In the late summer of 1882, Manet, who was seriously ill, rented a house at Rueil, just outside Paris. From a chair in the garden, sheltered by a wattle tree he made two paintings of the house and garden. This work painted with such vigour and exuberance gives no hint of his physical condition.

The painting is dominated by the strong vertical of a tree trunk which cuts through the centre of the composition. There are no figures, only the façade of the house is shown. Our attention is held by the animated brush work and beauty of the paint, especially in the grassy area under the tree. The blue used extensively in areas of shadow also details the shutters.

When Vincent van Gogh arrived in Paris three years after Manet had died, he already knew something of Manet's work and had expressed some decided views on the painter. 'I have always found Manet's work original' he writes, but goes on, 'I for my part' (in contrast to Zola) 'do not think he can be reckoned among the very finest of this century ... I consider Millet not Manet to be that essentially modern painter who opened a new horizon to many.'[1]

Nevertheless the lesson of direct painting as seen in Manet's *The house at Rueil* was absorbed by Vincent during his two years in Paris, as shown by his painting *Trees in a field on a sunny day* (Cat. 36).

## CAMILLE PISSARRO
## 1830–1903

### 20 THE BANKS OF THE VIOSNE AT OSNY IN GREY WEATHER, WINTER 1883

oil on canvas 65.3 x 54.5 cm

inscribed l. l. : C. Pissarro 83

National Gallery of Victoria

Felton Bequest 1927

[ILLUSTRATED PAGE 23]

Camille Pissarro was born on the island of St Thomas in the West Indies. From 1842 to 1845 he was at school in Paris and from 1855 settled permanently in France, living mostly in areas to the north west of Paris. He met Monet and Cézanne in 1859 and 1861, and worked with the latter thoughout the 1870s. He exhibited in all eight Impressionist exhibitions until 1886, when he joined the younger experimental group around Seurat.

From choice, Pissarro lived most of his life in rural communities with only brief stays in larger centres like Paris, Rouen or Le Havre. This is one of several views of Osny and its environs, a village in which Pissarro and his family had recently settled.

The painting comes from a period when Pissarro had begun to experiment with denser paint layers. The Impressionist technique now proved too limiting and his aim was to find a method of creating more solid form. This painting reflects this preoccupation with complex paint surfaces. The sky is painted in tiny Impressionist-like brush strokes but in such a dense application that it reads as a solid layer of colour. The walls to the left of the composition are heavily worked with the paint scraped back and further colour applied in different directions, while the vegetation to the right stands up in ridges of impasto. A sharp green balances the heavily worked areas. The bleakness of the winter's day is confirmed in a tracery of dead branches which intersect the sky.

[1] LT355, Nuenen, c. 24 January 1884.

CAT. 19

## GEORGES SEURAT 1859–91
## 21 FIELD OF LUCERNE, SAINT-DENIS C. 1884–85

oil on canvas 64.0 x 81.0 cm

inscribed l. l. : Seurat

National Galleries of Scotland

Born in Paris, the son of a property owner, Georges Seurat studied at Ecole des Beaux-Arts with a pupil of Ingres. From 1876 to 1884 he experimented in a series of styles, taking a growing interest in scientific colour theory. In 1884 he met Paul Signac and the two collaborated in developing a new method of optical painting. He exhibited in the Eighth and last Impressionist Exhibition in 1886.

When Van Gogh shifted from Antwerp, Holland to Paris in March 1886, Impressionism was already being challenged by a small band of artists led by Georges Seurat. It was the French art critic Félix Fénéon who named this rising group of artists the Neo-Impressionists.

The thinking that fused together Neo-Impressionist artists was their questioning of the immediacy that characterized the paintings of the Impressionists. Neo-Impressionists were striving to go beyond capturing the appearance of the modern world, to show its very structure. To accomplish this aim, Seurat turned to contemporary scientific theories of colour, optics and perception combined with a systematic application of stippled, dot-like brush work. The technique was to be precise, reasoned and ordered. The Impressionists' energetic brush work was dismissed and the appearance of light was obtained through optical mixing of complementary colours placed strategically upon the canvas. Seurat organized this principle into a system.

In *Field of lucerne, Saint-Denis*, Seurat depicts a region between Saint-Denis and Paris where farming had not yet been overtaken by housing and industry. The simple composition, devoid of pictorial incident, with its high horizon line and wide plain, is dominated by the broad, textured brush marks, less regular than in some of Seurat's later works. Nothing detracts from the unblended interplay of colours in the foreground (see detail, p. 30).

Van Gogh experimented briefly with what is now called Pointillist technique (Fig. 20), then moved to employ an emphatic, clearly divided brush stroke. He made deliberate explorations of the emotional impact of colour tempered by a knowledge of colour theory.

After a short time in Paris Vincent discovered that, 'what is required in art nowadays is something very much alive, very strong in colour, very much intensified'.[1] In answer to this awakening Van Gogh worked consciously for a year at brightening his palette, using

Fig. 20 Vincent van Gogh *Interior of a restaurant* F342
Paris summer 1887 oil on canvas 45.5 x 56.5 cm
State Museum Kröller-Müller Otterlo, The Netherlands

colourful flowers as an appropriate subject. He also studied the use of areas of flat colour in Japanese prints (see Fig. 32–33).

1    W1, Paris, summer or autumn 1887.

CAT. 21

## PAUL SIGNAC
## 1863–1935

# 22 *GASOMETERS AT CLICHY 1886*

oil on canvas  65.0 x 81.0 cm

inscribed l. l. : P. Signac 86

National Gallery of Victoria

Felton Bequest 1948

Paul Signac was born in Paris. He was largely self taught and his early work was influenced by Monet and Manet. He met Seurat in 1884, Pissarro in 1885 and Van Gogh in 1886. With Seurat, its founder, Signac was the leading theorist and propagandist of the new colour theories; the method of painting with 'points' or dots of colour gave them the name 'Pointillists'.

*Gasometers at Clichy* by Signac was on public view during the first months of Vincent's stay in Paris. It was included in the Eighth Impressionist Exhibition where the pictures of Seurat, Signac and Pissarro were shown in a room separated from the main display.

During the early spring of 1887 Signac and Van Gogh painted together in the Paris suburb of Asnières (Fig. 21 and see Cat. 36–37) and along the banks of the Seine. Since reading Charles Blanc's book, *The Artists of my Time* in 1884, Vincent had been interested in colour theory. He did not immediately take up the new painting methods propounded by Signac and Seurat and never adopted their rigorous and restrictive division of colour, though by spring 1887 he was experimenting with stipple effects.

In August 1888, Vincent wrote to Theo from Arles:

As for stippling and making halos and other things, I think they are real discoveries, but we must already see to it that this technique does not become a universal dogma any more than any other. This is another reason why Seurat's 'Grande Jatte' [see Fig. 12], the landscapes with broad stippling by Signac and Anquetin's boat, will become in time even more personal and even more original.[1]

Vincent's contact with the Pointillists did not convert him to their theories but effected a dramatic change in his work. He abandoned the Realist style and dark palette of his Nuenen, Amsterdam and early Paris paintings. This would lead on to the dramatic and explosive colour of the later Arles paintings.

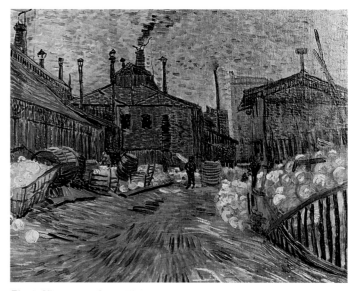

Fig. 21 Vincent van Gogh *The factory at Asnières*  F318
Paris  summer 1887  oil on canvas  46.5 x 54.0 cm
The Barnes Foundation, Merion, Pennsylvania

In this intensely modern subject, *Gasometers at Clichy*, Signac shows the new urban Paris with its increasingly industrialized landscape. It was a subject of special significance for this anarchistic and socialist painter.

Reviewing this painting in the 1886 exhibition, a contemporary critic noted the dazzling effect of the Neo-Impressionist palette, describing the 'frenetic intensity of light', 'its scorched grass and its incandescent roofs', and '... an abyss of blinding blue ...'

1    LT528, Arles, August 1888.

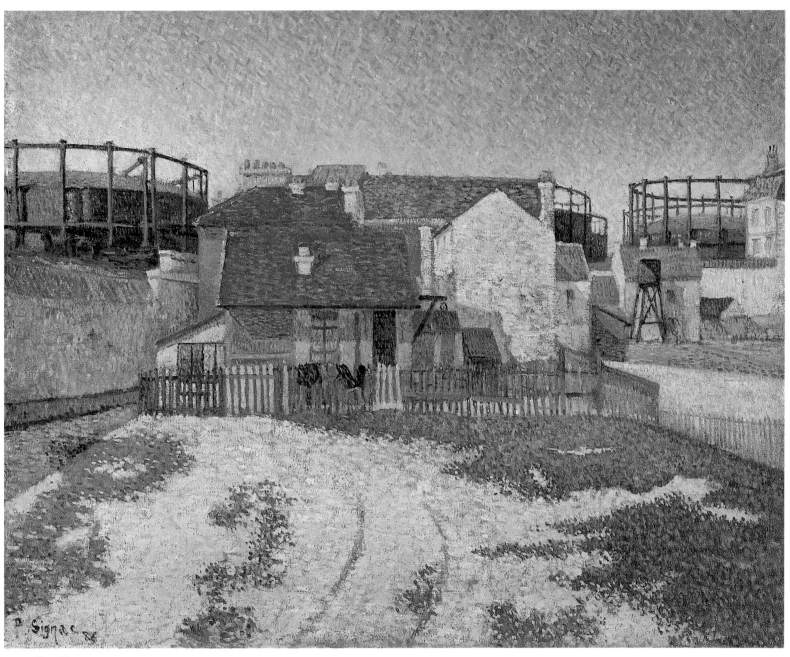

CAT. 22

## 23 PEASANTS' HOUSES, ERAGNY 1887

oil on canvas 59.0 x 71.7 cm

inscribed l. l. : C. Pissarro 1887

Art Gallery of New South Wales

Purchased 1935

On 15 March 1888 Pissarro wrote to his son Lucien,

I got the money from Theo van Gogh, it was three hundred francs. The picture sold was a *Peasant house* which belonged to the Boussod & Valadon Gallery and Van Gogh has taken another canvas of the same size ...[1]

Vincent's brother Theo was now manager of modern paintings for the Paris dealer. Through his own enthusiasm for modern painting he was responsible for bringing the works of the lesser known or less popular independent painters to the public's attention. He was the first to handle the new Pointillist works of Pissarro.

The painting Pissarro refers to is this work of 1887, painted at the height of his involvement with and enthusiasm for the new colour theories of Seurat and Signac. At this time in Paris, Vincent also became absorbed with the Pointillists' colour theories and experimented with their methods, as a means of developing his own bold and expressive use of colour.

In autumn 1885, Pissarro had met Signac and through him Seurat. Although Pissarro was a generation older than these painters he felt an instant rapport with them, both with their theories and with Signac's anarchistic politics. In their colour theories he was able to find a way forward for his own painting, but adopting this new palette and technique lost him both buyers and artist friends.

Pissarro and his son had become friends of Theo and Vincent in 1887. Among Vincent's colleagues, Pissarro was frequently spoken of as 'old father Pissarro' and seen as a mentor for younger painters. Vincent quotes him in June 1888, when making this pronouncement, very much in tune with the colour theories of the circle of Seurat and Signac, with which Vincent became absorbed in Paris:

What Pissarro says is true you must boldly exaggerate the effects of either harmony or discord which colours produce. It is the same as in drawing — accurate drawing, accurate colour, is per-haps not the essential thing to aim at, because the reflection of reality in a mirror, if it could be caught, colour and all, would not be a picture at all, no more than a photograph.[2]

In *Peasants' houses, Eragny* of 1887 colour is applied in small comma-like brush strokes according to a strict system of divided colour. Contrasting colours are set side by side, for instance purple opposite orange, creating visual reverberations (which were thought to be the result of 'optical mix') and giving the colours a striking luminosity.

In October 1888 Vincent, still absorbed with Pissarro's colour theory, wrote to Theo from Arles: 'Here under a stronger sun, I have found what Pissarro said confirmed, and also what Gauguin wrote to me, the simplicity, the fading of the colours, the gravity of great sunlight effects.'[3]

---

[1] Letter from Camille to Lucien Pissarro; Eragny, 15 March 1888, from *Camille Pissarro Letters to his Son Lucien* (ed. John Rewald), Kegan Paul, 1943, p. 123.

[2] LT500, Arles, c. 5 June 1888.

[3] LT555, Arles, 17 October 1888.

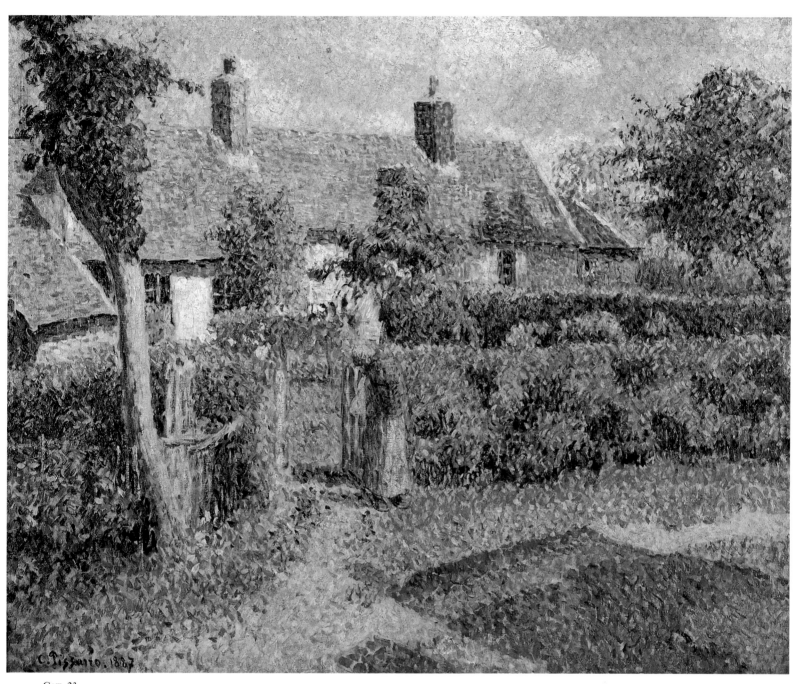

CAT. 23

PAUL GAUGUIN
1848–1903

## 24 BRETON GIRLS DANCING, PONT-AVEN 1888

oil on canvas  73.0 x 92.7 cm

inscribed l. r. : P Gauguin 88

© 1993 National Gallery of Art

Washington

Collection of Mr and Mrs Paul Mellon

In mid June 1888 Gauguin wrote to Theo van Gogh, from Pont-Aven, the farming village where the artist stayed in Brittany:

I'm doing a *gavotte breton*, three little girls in a hayfield. I think you'll like it. The painting seems original to me and I'm quite pleased with the composition.[1]

*Breton girls dancing, Pont-Aven* was painted before Gauguin's visit to Arles (which Theo was to finance) at a time when he and Vincent were each seeking to create a new and more spiritual form of art, beyond Impressionism. Vincent saw the picture when Theo sent it to Arles for Gauguin to rework the hand nearest the frame on the left.

Gauguin's selection of the picturesque elements of provincial life — the traditional costumes and customs of the Breton peasants — distinguishes him from Van Gogh. The rhythmical positioning of the turning girls shows his interest in composition, as does the humorous shorthand view of the sniffing dog. These inventively composed images foreshadow the more decorative direction Gauguin's art was to take. This mainly Impressionist picture marks the transition. The small hatching brush strokes in the foreground are of the kind he learned from Pissarro. The freshness of the colour scheme and play of light on the faces are similarly characteristic of Impressionism.

By contrast, the regional bonnets and collars are carefully drawn and the figures with dark outlines were the subject of a preliminary pastel study. The repetition of shapes leads the eye around the figures in a slow rhythmical movement. The decorative effect of the image is accentuated by the two spots of red and the dark masses of the clothes which stand out against the mustard yellow field.

## 25 YOUNG BRETONS BATHING 1888

oil on canvas

92.0 x 73.0 cm

inscribed l. l. : P Gauguin 88

Hamburger Kunsthalle

[ILLUSTRATED PAGE 61]

Paul Gauguin was born in Paris, but following the death of his father in1849 he moved to Lima, Peru with his mother and sister. Seven years later the family returned to France. In 1865, at the age of seventeen, Gauguin enlisted in the merchant marines and for the next ten years travelled the world as a second lieutenant. Upon his release from service he continued to be an inveterate traveller. During his life he undertook numerous journeys to such disparate locations as Brittany, Panama, Martinique and Tahiti.

*Young Bretons bathing* was painted in 1888 on Gauguin's second visit to Pont-Aven. It is one of a number of male nudes painted in Brittany which show Gauguin's debt to Japanese art and his interest in the current art styles of Japonisme and Cloisonism which had emerged in France in the late 1850s in response to Japanese art (see note p. 60).

The asymmetrical composition, with its extremely high horizon and cut-off tree, shows the influence of Japanese woodblock prints. The flat areas of colour and the clearly defined outlines of the two young men indicate that the artist was already moving towards Cloisonism at the time.

---

1    V. Merlhès (ed.), *Correspondance de Paul Gauguin*, Paris, 1984, no. 151.

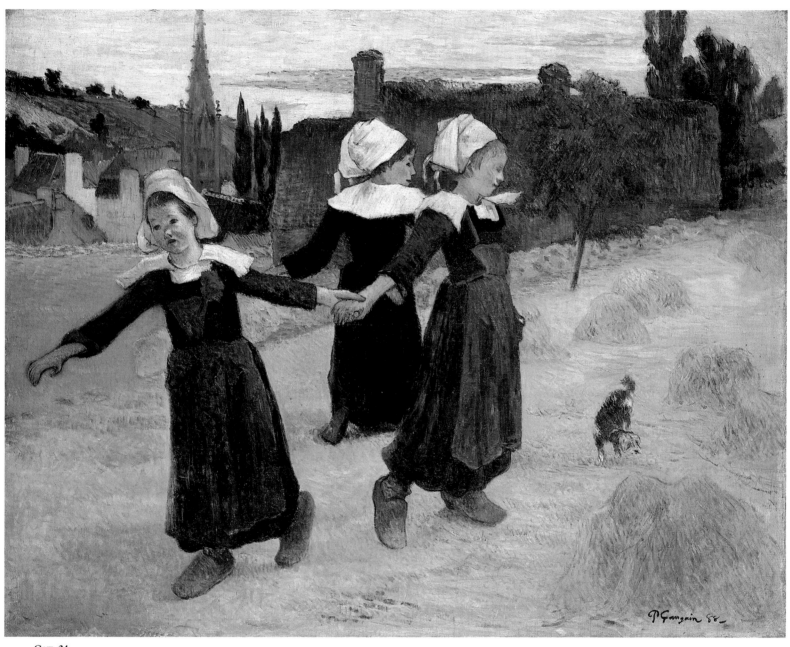

CAT. 24

# JAPONISME

Japonisme is a term coined to describe an art style that developed in France in the 1860s.[1] Following decades of deliberate isolation from the Western world, Japan was opened up to trade with Europe in 1854 and Western traders imported ceramics, lacquers, textiles, bronzes, fans, scroll paintings, books and prints for sale. These exotic and hitherto unobtainable Japanese items were admired for their technical excellence and were actively collected.

French glass makers and ceramic artists soon applied elements of Japanese style to objects but painters found Japanese art and design more difficult to assimilate. Woodblock prints (see Fig. 32–33) were of particular interest to painters, notably Van Gogh who with Theo had a large collection. The prints were made as souvenirs of actors and courtesans, as mementos of famous views and events, and illustrations to literature and history. They were sold to be pinned up at home, as posters are used today.

The woodblock designs make no use of Western perspective or modelling; background and foreground often appear to be on the same vertical plane, emphasized by the use of an extremely high horizon. Boldly drawn figures are usually placed like a frieze across the foreground. Japanese artists enjoy close-up views, therefore people, objects, and interiors are often cut off by the edge of the composition.

From the prints, French artists learned to use patches of contrasting flat colour and to compose their pictures with an off-centre emphasis: this changed the direction of French art. In Paris, in 1887 Van Gogh made three copies of Japanese prints in oil (Fig. 22), and later wrote 'In a way all my work is founded on Japanese art'.[2]

# CLOISONISM

Cloisonism[3] is the name of a technique adopted by nineteenth-century French artists that derived from Medieval art and Chinese and Japanese enamels (Fig. 23). Cloisonné is a process of enamelling where thin vertical strips of flat wire are soldered on to the metal surface of an object to create cloisons, that is, areas to be filled in with coloured pastes of powdered glass which melt when fired in a kiln. This results in flat coloured areas defined by lines, an effect also well known in stained-glass windows, and although made by a different technique, Medieval enamels.

The flat areas of colour defined by lines, characteristic of Cloisonism, were in great contrast to the Impressionists' broken brush marks and superimposed colour nuances. The Impressionists had found colour in shadows — those who followed Cloisonism did away with shadows. The simplified drawing and non-naturalistic colour of Cloisonism influenced modern painting and illustration throughout Europe and was an introduction to more abstract forms of expression.

Fig. 22 Vincent van Gogh
*Japonaiserie: The bridge in the rain* [after Hiroshige]  F372
Paris  summer 1887  oil on canvas  73.0 x 54.0 cm
Vincent van Gogh Foundation
Van Gogh Museum, Amsterdam

Fig. 23 Plate  Japanese c. 1870–80
cloisonné enamel  30.5 cm diam
National Gallery of Victoria  Felton Bequest 1932

1   Japonisme was first used as a term in 1872 by the French art critic Philippe Burty to designate a new field of study.
2   LT510, Arles, 15 July 1888.
3   The term was first used in March 1888 by the French art critic Edouard Dujardin in discussing the paintings of Anquetin.

CAT. 25

# *GENIUS*
# of Vincent van Gogh

## 26 WORN OUT F863

Etten September 1881
pencil and ink 23.5 x 31.0 cm
inscribed l. l. : Worn Out Vincent
Stichting Collectie P. en N. de Boer, Amsterdam
[ILLUSTRATED PAGE 20]

The motif of a hunched, seated figure was a deeply emotive one for Van Gogh and spans his whole artistic career. He used it to convey a wide range of states of being, from physical exhaustion, grief, sorrow and despair, to pondering the meaning of life and impending death.

In *Worn out*, one of two watercolours done in Etten in September 1881, Van Gogh acknowledges his debt to nineteenth-century British art. The title, inscribed in English on the image, is borrowed from Thomas Faed's painting of a sick child and its father, exhibited in 1868 and known to Van Gogh from an engraving.

The image of *Worn out*, however, appears to derive from Arthur Boyd Houghton's frontispiece to the 1865 edition of Charles Dickens's *Hard Times* which Van Gogh read in June 1879.[1] Houghton's pose (Fig. 24) was used directly by Van Gogh for an 1882 drawing and lithograph and for the 1891 painting, all entitled *At eternity's gate*. For *Worn out* the pose has been turned from the diagonal to side on. The watercolour was done from life, from an 'old sick farmer sitting on a chair near the hearth, his head on his hands and his elbows on his knees'.[2]

Fig. 24 Arthur Boyd Houghton 1836–75
Frontispiece to Dickens's *Hard Times*
The Dickens House Museum, London

1    LT131, Cuesmes, 5 August 1879.
2    LT150, Etten, c. September 1881.

## 27 YOUNG SCHEVENINGEN WOMAN, SEATED FACING LEFT F869

The Hague [Etten period] December 1881
watercolour 48.0 x 35.0 cm
inscribed l. l. : Vincent
Stichting Collectie P. en N. de Boer, Amsterdam

From 27 November until just before Christmas 1881 Van Gogh was in The Hague receiving instruction from Anton Mauve (see Cat. 7), who convinced him of the importance of working from life and encouraged him to move from drawing to painting. In mid December, he wrote to Theo:

> I still go to Mauve's every day in the day time to paint, in the evening to draw.
> I have now painted five studies and two watercolours and, of course, a few more sketches ...
> The painted studies are still life, the watercolours are made after the model, a Scheveningen girl.[1]

In the same letter, Vincent enclosed pen and ink sketches of this watercolour and of *Scheveningen woman, knitting, facing right* (F870) ('the one Mauve brushed a little').[2] He also expressed his debt to his 'kind and considerate' tutor, 'through Mauve I have got some insight into the mysteries of the palette and of watercolouring ... I think I shall make better progress now that I have learned something practical about colour and the use of the brush'.[3]

Vincent's enthusiasm for and new-found confidence in the medium are evident in the statement: 'What a splendid thing watercolour is to express atmosphere and distance, so that the figure is surrounded by air and can breathe in it, as it were'.[4]

The subject of the watercolour, a seated woman sewing, was popular amongst The Hague School artists (see Cat. 5–7), its origins lying in Dutch seventeenth-century genre painting, but the precise source appears to be that of Israëls' large canvas, *Expectation*.[5] The theme greatly appealed to Van Gogh who made twenty-three versions of this subject.

1    LT163, The Hague, c. 18 December 1881.
2    ibid.
3    ibid.
4    ibid.
5    De Leeuw et al 1983, p. 301.

CAT. 27

# 28 *SORROW* *F1655*

The Hague 9–11 November 1882

lithograph 39.1 x 29.9 cm (image)

inscribed on stone l. r. : Sorrow; inscribed on stone

l. l. : Vincent; inscribed in ink l. l. : épreuve d'essai

one of only three known impressions

The Museum of Modern Art, New York

Abby Aldrich Rockefeller Fund

In November 1882, Van Gogh began experimenting with lithography, and in that month made six of the nine works that he was to produce in this medium. The artist was interested in lithography primarily as a means of reproducing his drawings, and initially planned a series of some thirty lithographs after his figure drawings, intending to show such a series to magazine editors to help him secure a position as an illustrator. He also toyed with the idea of issuing cheap editions of lithographs amongst working people.

*Sorrow* is the second lithograph that Van Gogh made, and it is based on the earlier drawing of the same title, which the artist had executed in April 1882.

Van Gogh refers to *Sorrow* in his letters on a number of occasions. In the months following his move to The Hague in January 1881, he had concentrated on drawing from the model, attempting to gain mastery of the human figure. Yet slavish imitation of the model was not Van Gogh's aim, as he explained to Theo: 'In my opinion two things which remain eternally true and which complement each other are, Do not quench your inspiration and your imagination, do not become the slave of your model; and, Take the model and study it, otherwise your inspiration will never gain plastic solidity.'[1]

He wanted the drawing to be expressive of '... not sentimental melancholy, but serious sorrow'.[2] His most extensive exposition of the meaning of the work appeared in a letter to Theo, in which he described the fourth version of *Sorrow* (now lost), and a companion drawing of tree-roots (see Fig. 10), which he intended for Theo's birthday: 'Now I tried to put the same sentiment into the landscape as I put into the figure: the convulsive, passionate clinging to the earth, and yet being half torn up by the storm. I wanted to express something of the struggle for life in the pale, slender woman's figure, as well as in the black, gnarled and knotty roots.'[3]

Van Gogh inscribed the embellished drawing of *Sorrow* that he sent to Theo with a quote from one of his favourite authors, Jules Michelet: 'How can there be on earth a woman alone — abandoned'. This quote, together with the knowledge that the model was Sien

Fig. 25 Vincent van Gogh
*Sien resting head on left hand,*
*seated: right profile* F935
The Hague April 1882
pencil, pen and wash 58.0 x 42.0 cm
State Museum Kröller-Müller,
Otterlo, The Netherlands

(Fig. 25), whom Van Gogh loved, directs us to the biographical content of the work. Van Gogh started his relationship with Sien, a pregnant prostitute abandoned by the father of her child, in early 1882, shortly after being rejected by his cousin, Kee Vos, with whom he was deeply in love. Michelet's books on women and marriage, *L'Amour*, 1858 and *La Femme*, 1859 were of great interest to Van Gogh at this time. Defending his adoption of Sien in a letter to Theo, Van Gogh's sentiments echo Michelet's paternalistic attitude towards women: 'Which is the more delicate, refined, manly — to desert a woman or to stand by a forsaken woman? Last winter I met a pregnant woman, deserted by the man whose child she carried.'[4]

Sien's plight moved Van Gogh deeply, but this work was not intended as a purely personal statement. Through such devices as the conventional pose expressive of anguish, the inscribed title Sorrow and the undefined setting, this work transcends the personal and is a universal expression of human suffering.

1   LT241, The Hague, c. 2–3 November 1882.
2   LT218, The Hague, 21 July 1882.
3   LT195, The Hague, 1 May 1882.
4   LT192, The Hague, 3–12 May 1882.

CAT. 28

## 29 *THE SOWER: FACING RIGHT* F852

The Hague  December 1882

pencil and ink  61.3 x 39.8 cm

Stichting Collectie P. en N. de Boer, Amsterdam

Van Gogh felt a deep affinity with Millet, and in particular with his image of *The sower* (see Cat. 11). Throughout his life he made thirty-four versions of the subject (see Fig. 13). They range from a near-literal copy (made using an etching by Paul-Edme Lerat (Fig. 26)) to the completely recast image painted in the blazing colours of Arles, when he wrote of 'longing for that infinity of which the sower, the sheaves of corn are symbols' (Fig. 27).[1]

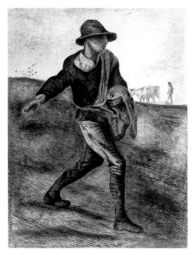

Fig. 26 Vincent van Gogh
*The sower* [after Millet] F830
Etten  April 1881
pen and wash  48.0 x 36.5 cm
Vincent van Gogh Foundation
Van Gogh Museum, Amsterdam

The earliest copies date from 1880[2] when he was living in the bleak mining district of the Borinage among the workers whose lives he had hoped to share and uplift as a lay preacher, 'a sower of God's word'.[3] There he taught himself to draw by copying prints after Millet's peasant subjects while he also studied academic outline and shading exercises. From his time working in an art dealership, Van Gogh knew many of Millet's works, and would have seen a pastel version of *The sower* at the auction in 1875.[4]

His interest in peasant subjects would have been early reinforced by the members of The Hague School (see Cat. 5–7) and the collections he saw in that city, which included works by the Barbizon painters (see Cat. 9–15), and in Paris he would have seen the Salon filled with Realist paintings of peasants.

The present drawing, made at The Hague, is an independent

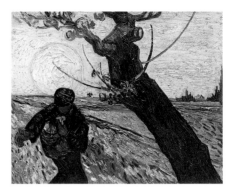

Fig. 27 Vincent van Gogh
*The sower* F451  Arles  November 1888
oil on canvas  32.0 x 40.0 cm
Vincent van Gogh Foundation
Van Gogh Museum, Amsterdam

exploration of Millet's motif. Van Gogh drew the subject freshly from life, with the model in the characteristic pose observed by Millet, but viewed from a different angle. Interest centres on the physiognomy of the worker, with his bristling beard which seems made of the same stuff as the frayed sowing bag, on the boots (a recurring motif in the artist's oeuvre) and on the baggy trousers which have 'the characteristic dents and bumps'[5] left by the bony parts of the anatomy. (Van Gogh had been frustrated before by models who turned up in their Sunday best.) This shapeless clothing speaks of hard labour, and the artist struggled with the problem of representing action, explaining that 'the truth is there is more drudgery than rest in life'.[6]

Van Gogh saw the figure as: 'a ... Sower, with a light-brown fustian jacket and trousers, so this figure stands out light against the black field, bordered by a little row of pollard willows. This is quite a different type, with a clipped beard, broad shoulders, rather thick-set, somewhat like an ox, in that his whole frame has been shaped by his labour in the fields. perhaps more of an Eskimo type, thick lips, broad nose.'[7]

The comparison with an ox might seem commonplace, but from the context it is clear that Van Gogh was referring to the physiognomic theories of the Swiss pastor Johann Caspar Lavater (1741–1801) who typed people as animals. It has been pointed out that Lavater's publications also described the Eskimo and other Northern peoples as small, with expressionless faces, because of a deficient spiritual life resulting from their hardships.[8]

1   B7, Arles, second half of June 1888.
2   LT135, Cuesmes, 7 September 1880.
3   LT93, Dordrecht, 23 April 1877.
4   Emile Gavet collection, sold Hotel Drouot, Paris, 1875.
5   LT148, Etten, beginning of August 1881.
6   LT251, The Hague, c. 3–5 December 1882.
7   ibid.
8   Tilborgh 1989, p. 172.

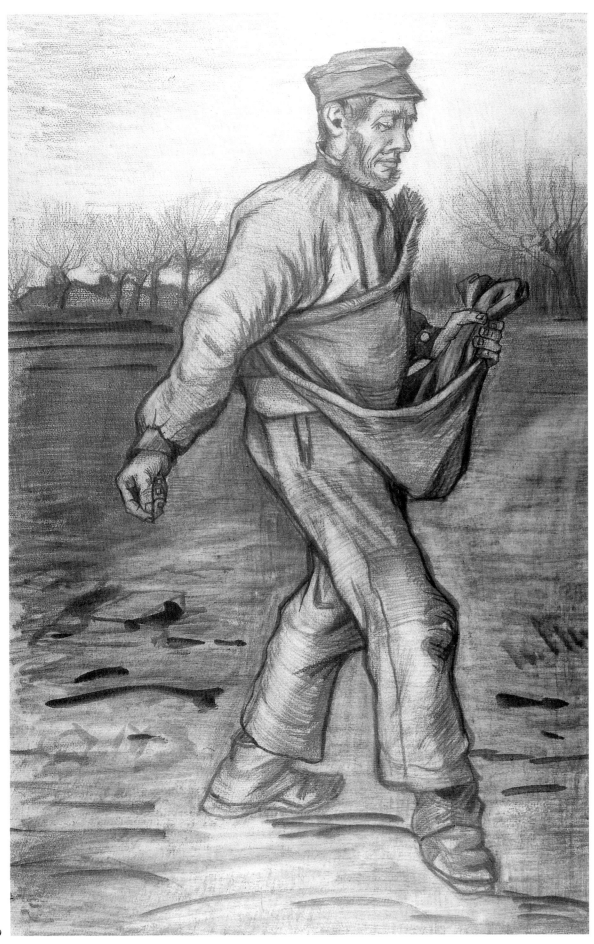

CAT. 29

## 30 *HEAD OF A PEASANT* *F160*A
### [STUDY FOR *THE POTATO EATERS*]

Nuenen December 1884

oil on canvas on panel 39.4 x 30.2 cm

Art Gallery of New South Wales

Foundation Purchase 1990

Images of peasants were painted by many nineteenth-century artists. This subject matter was enjoyed by a middle class public throughout the second half of the nineteenth century and was welcomed for display in Paris's annual Salon exhibitions. Unlike his fellow artists, however, Van Gogh did not paint a romantic, idealized vision of the peasant, his preoccupation with common folk was essentially motivated by 'their unique character' for which he felt 'a great sympathy'.[1] He was convinced that he achieved 'better results by painting [peasants] in their roughness than by giving them a conventional charm'.[2]

Van Gogh began by drawing those 'types of working people' close to nature, hoping to 'arrive at the point of being able to illustrate papers and books'.[3] He was influenced in this direction by his admiration for British illustrators whose work defined as social realism appeared in popular news publications.

In February 1885 Vincent reported that he was painting peasant heads in the daytime and drawing them at night, having completed 'at least some thirty' in both media.[4] In March, painting studies of heads continued into the evening by lamplight in a dark, squalid cottage where Van Gogh 'could hardly distinguish anything on [his] palette'.[5] These studies of heads became the technical foundation from which Van Gogh produced *The potato eaters* of April 1885 (Fig. 28), the painting he considered 'a real *peasant picture. I know it is*'.[6] *Head of a peasant* is a study for the figure seated second from the right in this now acknowledged early Van Gogh master-work, a canvas that he told Theo had 'taken a whole winter of painting studies of heads and hands'.[7]

1   LT136, Cuesmes, 24 September 1880.
2   LT404, Nuenen, 30 April 1885.
3   LT140, Brussels, January 1881.
4   LT394, Nuenen, February 1885.
5   LT395, Nuenen, c. 1 March 1885.
6   LT404, op. cit.
7   ibid.

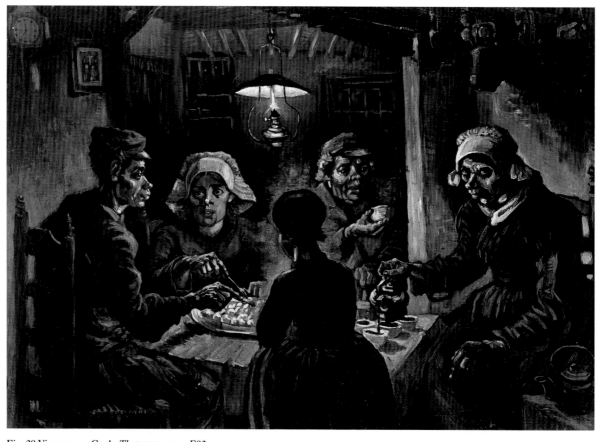

Fig. 28 Vincent van Gogh *The potato eaters* F82
Nuenen April 1885 oil on canvas 82.0 x 114.0 cm
Vincent van Gogh Foundation Van Gogh Museum, Amsterdam

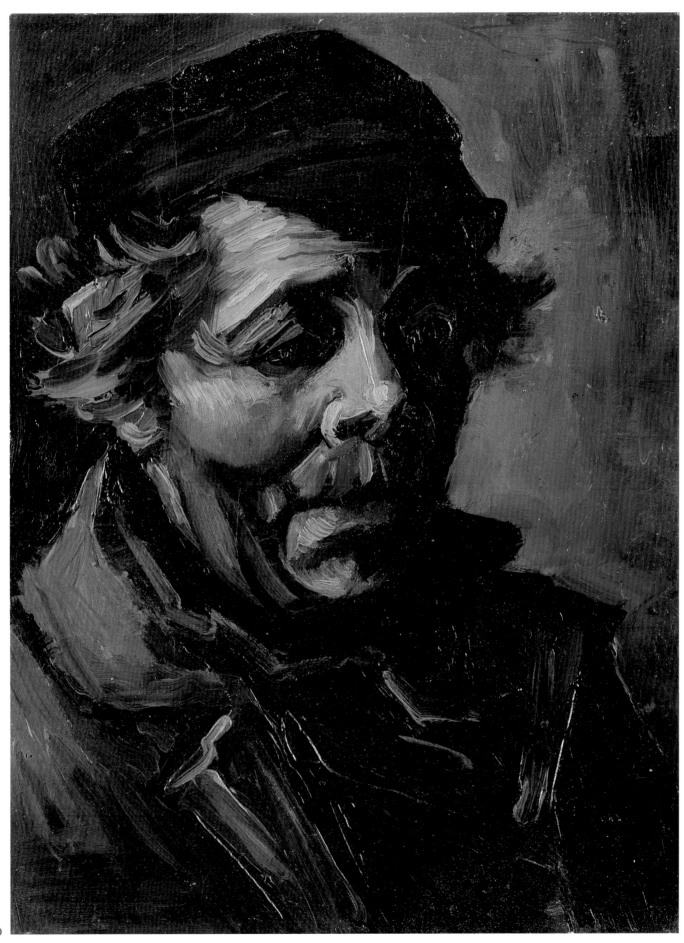

CAT. 30

71

## 31 THE OLD CHURCH TOWER AT NUENEN F84

Nuenen May 1885

oil on canvas 63.0 x 79.0 cm

inscribed l. r. : Vincent

Vincent van Gogh Foundation

Van Gogh Museum, Amsterdam

After spending the autumn of 1883 in the province of Drenthe, Vincent returned to Nuenen, the town where his family had settled in 1882. He remained in Nuenen for two years and painted two major works — *The potato eaters* (Fig. 28) and *The old church tower at Nuenen* — which he later considered to signify his maturing as an artist.

Both works reveal the artist's profound empathy for the plight of the peasant whose hard and frugal life was rooted to the earth which generations of the same families had tilled and harvested.

*The old church tower at Nuenen* depicts the stocky ruins of a medieval church tower rising from a flat field and encircled by stark wooden crosses marking the graves of local peasants. The site was a favourite destination for the artist who made five paintings, five drawings and countless sketches of the churchyard (Fig. 29).

In May 1885, the old disused steeple at Nuenen was demolished and Vincent wrote: 'The old tower will be pulled down next week! The spire has already gone. I'm working on a picture of it.'[1]

The next month he wrote again to Theo:

> Today I sent off the small box ... containing another picture, '*Cimetière de Paysans*'.
>
> I have omitted some details — I wanted to express how those ruins show that *for ages* the peasants have been laid to rest in the very fields which they dug up when alive — I wanted to express what a simple thing death and burial is, just as simple as the falling of an autumn leaf — just a bit of earth dug up — a wooden cross. The fields around, where the grass of the churchyard ends, beyond the little wall form a last line against the horizon — like the horizon of the sea.
>
> And now those ruins tell me how a faith and a religion moldered away — strongly founded though they were — but how the life and death of the peasants remain forever the same, budding and withering regularly, like the grass and the flowers growing there in that churchyard. *Les religions passent, Dieu demur* [religions pass, God endures] is a saying of Victor Hugo's whom they also brought to rest recently.[2]

Fig. 29 Vincent van Gogh
*Public sale of crosses of the cemetery at Nuenen* F1230
Nuenen May 1885 watercolour 37.5 x 55.0 cm
Vincent van Gogh Foundation Van Gogh Museum, Amsterdam

It is highly significant that Vincent's father, the traditionalist preacher, had been buried in that churchyard not long before. The two had waged numerous debates over the collapse of Christianity, and the old tower, already devoid of its spire, seemed to stand as a symbol for Vincent of the decay of traditional faith. Whereas the life of the peasants remains unchanged, faith is transient, shackled to the orthodox and dogmatic religion of Vincent's parents.

1    LT408, Nuenen, c. 11 May 1885.
2    LT411, Nuenen, beginning of June 1885.

CAT. 31

## 32 *LE MOULIN DE LA GALETTE* *F228*

Paris spring 1886

oil on canvas 38.0 x 46.5 cm

Staatliche Muzeen zu Berlin, Nationalgalerie

## 33 *WINDMILLS ON MONTMARTRE* *F273*

Paris summer 1886

oil on canvas 48.2 x 39.5 cm

inscribed l. r. : Vincent

Bridgestone Museum of Art

Ishibashi Foundation, Tokyo

Van Gogh arrived in Paris early in March 1886, unannounced, to stay with Theo. Three months later, the two moved to a larger apartment at 54 Rue Lepic, on Montmartre, where Vincent had a studio with a wonderful view across the city. Not much detail is known about the artist's two years in Paris, for he was almost always with Theo and therefore had no need to write letters. For a few months he was enrolled at Cormon's studio, where younger pupils included Toulouse-Lautrec, Bernard and the Australian John Peter Russell.

He explored and painted his new surroundings. Montmartre was then a village, still comparatively rural with ramshackle cottage gardens, vegetable plots and cheaply-rented shanties overlooked by three ancient windmills on the heights. Van Gogh, who was accustomed to rural surroundings, was delighted with this semi-rustic aspect of Paris and the windmills must have reminded him of his homeland. In the autumn of 1886 he wrote to Levens, an English artist, his most informative letter from Paris, no. 459a, stating that he had painted about a dozen landscapes, 'frankly *green* frankly *blue*. ... the French air clears up the brain and does good — a world of good'. Perhaps one of these was the airy, blue-toned *Windmills on Montmartre*, painted that summer: the brush work shows a new freedom influenced by the work of the French Impressionists which he had now seen at first hand. *Le Moulin de la Galette* was painted earlier and is in the more subdued colour range of the pictures Vincent painted before coming to Paris.

Although the old mills of Montmartre had become a popular place for working people to go on public holidays, Van Gogh chose to depict them almost deserted. *Le Moulin de la Galette*, translated 'girdle-cake', had been made famous a decade earlier in a painting by Pierre Auguste Renoir. Although this picturesque corner still exists today, the surrounding countryside has long since disappeared.

CAT. 32

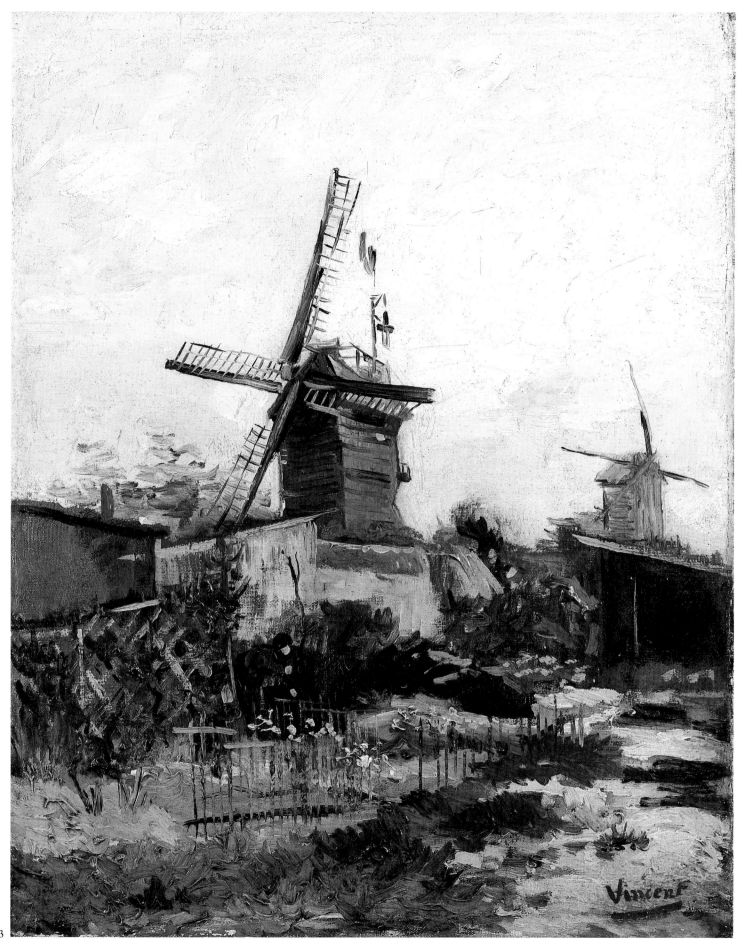

## 34 *HEAD OF A MAN* F209

Paris summer 1886
oil on canvas mounted on plywood
34.2 x 40.8 cm
National Gallery of Victoria
Felton Bequest 1940

*Head of a man* dates from Vincent's first year in Paris, somewhere between the second half of 1886 and early 1887. In his first months in Paris, Vincent was still painting in the low-key colours of Israëls and Mauve. *Head of a man* is a transitional work; it is still Realist in style, but there are moves towards using more colour and to a greater freedom of technique.

According to the few surviving letters from this period, Vincent was painting portraits by the end of 1886 and into 1887. Theo in a letter to their mother, dated 28 February 1887, wrote that Vincent had painted a few portraits which have turned out well, adding 'but he always does them for no payment'.[1]

At this time he also worked on flower studies, still life and city-scapes around Montmartre. In a letter to fellow artist Levens, from about August 1886, he describes exercises in colour in which he had tried 'to render intense colour and not a grey harmony'.[2] The two heads mentioned in the same letter, though neither necessarily refers to this *Head of a man*, are nevertheless described in terms of light and colour rather than portraiture, reinforcing the experimental nature of all these works.

In the summer or autumn of 1887, Vincent wrote to Wilhemina:

What I think of my own work is this — that that picture I did in Nuenen of those peasants eating potatoes [see Fig. 28] is the best one after all. Only since then I have lacked the opportunity to pick my models, but on the other hand I got the opportunity to study the question of colours. And when I find the right models for my figures later on, I hope to be able to show that I am after something different from little green landscapes and flowers. Last year I painted hardly anything but flowers in order to get accustomed to using a scale of colours other than grey — namely pink, soft and vivid green, light blue, violet, yellow, orange, rich red. [3]

Although *Head of a man* is painted in low-key colour in which ochres and browns predominate, there are some areas of pure, bright pigment. The hair, the beard and moustache, which at first sight appear brown or black, on closer inspection contain unexpected passages of pure ultramarine and crimson, sometimes the two applied in a single stroke, especially in the hair. Details of the eyes are painted in short vertical and horizontal strokes, of violet, cobalt and ultramarine, the pupils of the eyes in dark violet, while the underpainting of the moustache is in vertical strokes of delicate light blue and ochre.

*Head of a man* shows evidence of considerable thought and reworking during the course of painting. Wet paint has been applied over wet paint to alter the set of the head, the position of the shoulder, and vigorously to reshape the unruly hair.

The introduction of pure colour into a largely monochromatic palette seems to be in keeping with Vincent's aim of lightening and brightening his palette away from grey harmonies.

This is Vincent's only known portrait in a horizontal format. There is clear evidence that the canvas has been trimmed on all sides, particularly along the lower edge where the collar is cut off mid brush stroke. It is not impossible that the painting was originally in a vertical format and included more of the torso.

1 Quoted by Jan Hulsker, 'What Vincent really thought of Theo', *Vincent* III, 2, 1974.
2 459a, Paris, August–October 1886.
3 W2, Paris, summer or autumn 1887.

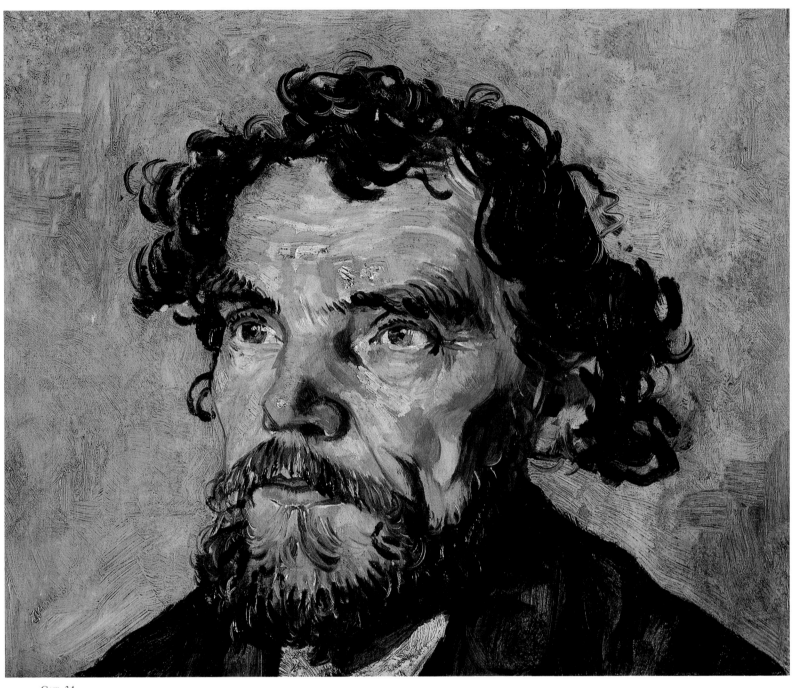

CAT. 34

# 35 *SELF-PORTRAIT* *F268*

Paris summer 1887

oil on canvas 39.8 x 33.7 cm

Wadsworth Atheneum, Hartford, Connecticut

Gift of Philip L. Goodwin in memory

of his mother, Josephine S. Goodwin

This self-portrait is one of twenty-eight painted by Van Gogh in Paris,[1] where he lived with Theo from March 1886 to 20 February 1888.[2] Vincent produced these twenty-eight self-portraits and two self-portrait drawings from the summer of 1887 until February 1888, when he left Paris for Arles, 'the land of the *blue* tones and gay colours'.[3] In fact Vincent painted only ten other self-portraits in the rest of his life (Fig. 30).

It was a time of heightened self-awareness for the artist who wrote to the English artist Levens about working alone, 'and fancy that since I feel my own self more'.[4] His self-reflection is evident also in a letter to Theo of summer 1887 when he wrote:

> As for me — I feel I am losing the desire for marriage and chil-
> dren, and now and then it saddens me that I should be feeling
> like that at thirty-five, just when it should be the opposite ... It
> was Richepin who said somewhere: 'The love of art makes one
> lose real love' ... And at times I already feel old and broken ...
> One must have ambition in order to succeed, and ambition
> seems to me absurd ... Perhaps these days one gets on better by
> looking rich than by looking shabby.[5]

Paris was a transitional period in Van Gogh's art. He wrote to Levens about this time of discovery: 'There is much to be seen here — for instance Delacroix, to name only one master. In Antwerp I did not even know what the impressionists were, now I have seen them and though *not* being one of the club yet I have much admired certain impressionists' pictures.'[6]

Influenced by Impressionism, Vincent lightened his palette and began to apply paint spontaneously. He also 'made a series of colour studies in painting, simply flowers, red poppies, blue cornflowers and myosotys, white and rose roses, yellow chrysanthemums — seeking oppositions of blue with orange, red and green, yellow and violet.'[7] He was now convinced that 'in *colour* seeking life the true drawing is modelling with colour'.[8]

In 1887 Seurat exhibited *Sunday afternoon at the Grande Jatte* (see

Fig. 30 Vincent van Gogh
*Self-portrait* F627 Saint-Rémy September 1889
oil on canvas 65.0 x 54.0 cm Musée d'Orsay, Paris

Fig. 12) at the Eighth Impressionist Exhibition in Paris and this must have confirmed Van Gogh's interest in separate strokes and marks of paint. The background of this self-portrait is plain, enabling the penetrating gaze of the eyes and the individual brush strokes to dominate.

The authenticity of this work had been questioned prior to 1990 when it was X-rayed, revealing the female figure of a peasant underneath. This accords with Vincent's practice in Paris of painting over canvases he had previously worked.

1   See De la Faille 1970.
2   Vincent arrived unexpectedly in Paris from Antwerp in March 1986, and stayed with Theo in the Rue de Laval until June 1886, when he moved with him to Rue Lepic, in Montmartre.
3   459a, Paris, August–October 1886.
4   ibid.
5   LT462, Paris, summer 1887.
6   459a, op. cit.
7   ibid.
8   ibid.

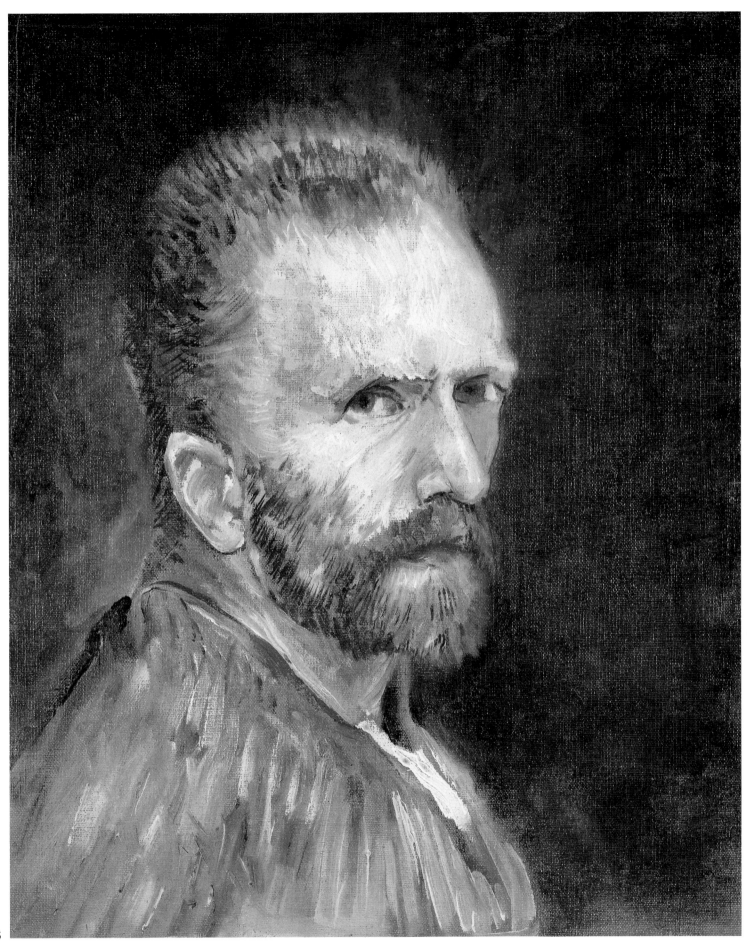

## 36 TREES IN A FIELD ON A SUNNY DAY
F291

Paris summer 1887
oil on canvas 37.5 x 46.0 cm
Stichting Collectie
P. en N. de Boer, Amsterdam

*Trees in a field on a sunny day* shows Vincent's 'sincere personal feeling of colour in nature'.[1] The work is one of many studies made by Van Gogh in the spring and summer of 1887, when he was exploring Paris and its surrounds, following the example of many Impressionist painters who often sought park scenes and themes near water. After the development of railways which made them easy to visit, the villages along the River Seine downstream from Paris were especially popular with Monet (see Cat. 18) and Pissarro (see Cat. 20) among others.

Like Paul Signac (see Cat. 22), Van Gogh preferred to paint areas where the rural landscape had almost been engulfed by the encroaching city. He also found such places within walking distance of his apartment at 54 Rue Lepic, on Montmartre, in Asnières, for example, where his friends Signac and Emile Bernard had studios. According to Bernard:

> Vincent would set out from home with a big canvas on his back and divide it into compartments according to his subjects; in the evening he would bring it back, completely covered, like a little portable gallery where the whole day's emotions were recorded. There were little sketches of the Seine filled with boats, islands with blue awnings, fashionable restaurants with multicoloured sunshades [see Cat. 37], with pink sweetbier; deserted little corners of a park or country houses for sale. Those little sketches, wrested as it were by the artist's brush from the fleeting hours, breathed a springlike poetry. I revelled in their charm ...[2]

He would later cut the large canvas into separate pieces. *Trees in a field on a sunny day* may have been made on one of these productive days.

By this time, Van Gogh had already begun to temper his Impressionist approach by adopting some of the principles of Pointillism. This work, in its energy of application and beauty of colour, demonstrates Vincent's confidence with a new technique.

With rapid brush marks, short lines and spontaneous strokes of colour (see detail p. 14), Van Gogh has caught the atmospheric brilliance of a sunny day, showing that he is painting out of doors in the spirit of Impressionism. As he put it to his sister Wilhemina about a year later, 'It amuses me enormously to paint ... right on the spot ... I find satisfaction in painting things immediately'.[3] Van Gogh's swift application of white, yellow, green and red ochre paint has captured the effects of crisp light filtering through trees.

The buildings in the background identify the location as a place on the Seine near Pont de Clichy. Van Gogh made several paintings of the bridge and the two buildings from different view points. The tree-lined slope of this example resembles a river bank, but the Seine itself is not depicted.

[1]  459a, Paris, autumn 1886.
[2]  Quoted in Cabanne 1985, p. 107.
[3]  W7, Arles, 8 September 1888.

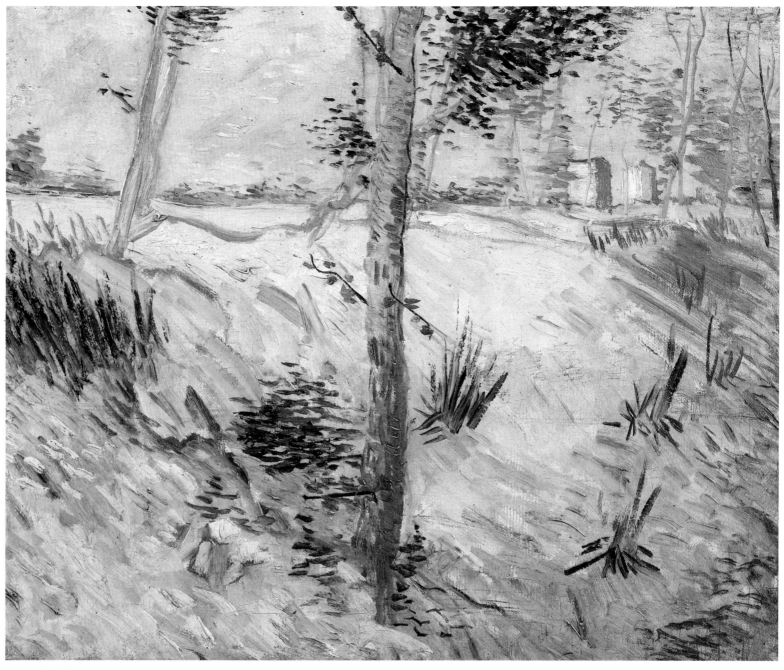

Cat. 36

## 37 *RESTAURANT DE LA SIRENE AT ASNIERES* *F313*

Paris early summer 1887

oil on canvas 54.5 x 65.5 cm

Musée d'Orsay, Paris

© Photo R. M. N.

*Restaurant de la Sirène at Asnières*, like *Trees in a field on a sunny day* (Cat. 36), was painted when Van Gogh was working along the banks of the Seine and in the suburb of Asnières with fellow artists Signac and Bernard. One of the most important works of Vincent's Paris period, it shows his experimentation with Impressionist brush strokes and light effects and the variegated colours and stippling technique of the Neo-Impressionists (see Cat. 21–23).

In a letter of 1886, Vincent had written to Levens about the development of his work: 'And so I am struggling for life and progress in art ... Since I saw the impressionists I assure you that neither your colour nor mine as it is developing itself is exactly the same as their theories ... However I have faith in colour.'[1]

His faith would have been bolstered by the Third Exhibition of the Société des Artistes Indépendants,[2] which contained a number of Pointillist works, including at least ten by both Seurat and Signac. As Vincent wrote to Wilhemina: 'And when I was painting at Asnières last summer, I saw more colour than before.'[3]

In *Restaurant de la Sirène at Asnières* Van Gogh applies bright, unmixed paint with comma-like strokes next to but separate from each other. In comparison with Seurat's scientific approach to colour and precise dotting, these small dabs, lines and marks of pigment, are strewn at random over the canvas in a freer and less consistent manner. This shows Vincent's interest in the broader stippling technique of Signac with whom he was painting at the time. Signac recalled their times at Asnières:

> Yes, I knew Van Gogh from the shop of père Tanguy. I would meet him other times at Asnières and at Saint-Ouen. We painted together on the river banks, we lunched at roadside cafés and we returned by foot to Paris via the avenues of Saint-Ouen and Clichy. Van Gogh, dressed in a blue jacket of a zinc worker, had small dots of colour painted on his sleeves.[4]

Van Gogh later admitted that most of the 230 works painted in Paris had been exercises essential to the learning process: 'It is as nec-essary to have a regular course in impressionism now as it was formerly to have a course in a Parisian studio.'[5]

By comparison with Van Gogh's 1886 landscapes and portraits (see Cat. 32–34), in which the colour and tonality are reminiscent of his Nuenen period, *Restaurant de la Sirène at Asnières* shows that his palette has brightened in response to the work of the Impressionists and Neo-Impressionists.

Just after leaving Paris for the intense light of Arles, Vincent wrote again to Wilhemina: 'Besides, what they want in pictures nowadays is a contrast of colours, and these colours highly intensified and variegated, rather than subdued grey tones.'[6] Van Gogh, retaining his independence from both the Impressionists and Neo-Impressionists, had progressed from his experimental Paris period and began to develop fully his own expressive style and exaggerated use of colour.

[1]  459a, Paris, autumn 1886.
[2]  The exhibition was held at the Pavillon de la Ville de Paris, 26 March to 3 May 1887. Van Gogh exhibited in the three following exhibitions of the Société des Artistes Indépendants: 1888 (3works), 1889 (2 works), 1890 (10 works).
[3]  W1, Paris, summer–autumn 1887.
[4]  Signac to Gustave Coquiot, 1923, quoted in Welsh-Ovcharov 1976, p. 30.
[5]  LT528, Arles, c. 27 August 1888.
[6]  W2, Arles, March–April 1888.

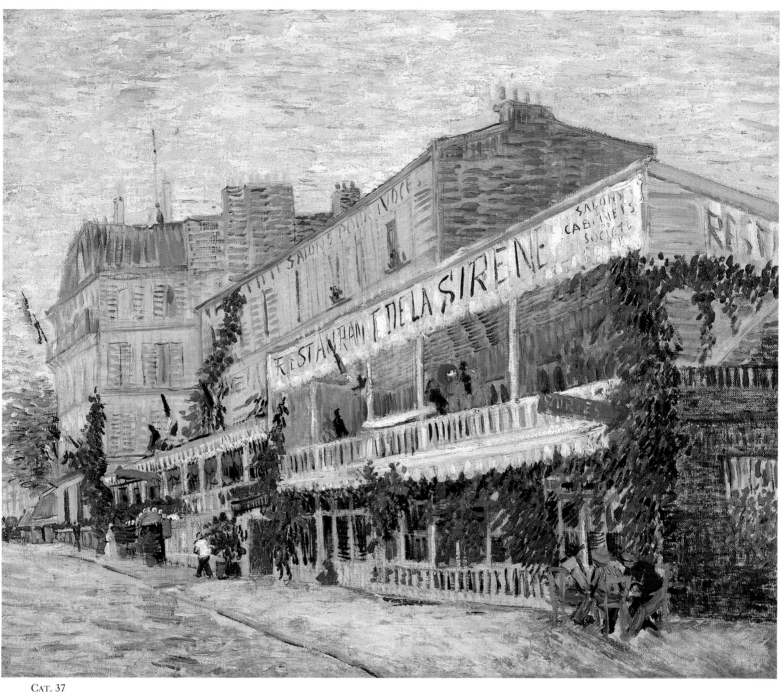

CAT. 37

## *38* *VIEW OF SAINTES-MARIES* *F416*

Saintes-Maries [Arles period]  June 1888

oil on canvas  64.0 x 53.0 cm

State Museum Kröller-Müller

Otterlo, The Netherlands

This landscape was painted on the first or second day of Vincent van Gogh's visit to the village of Saintes-Maries-de-la-Mer, on the Mediterranean coast. Although Van Gogh had mentioned his wish to see the Mediterranean, his visit was triggered by the annual gypsy pilgrimage to the old church of Saintes-Maries. Van Gogh travelled from Arles by horse-drawn carriage, arriving at Saintes-Maries after a three-hour journey across the wind-swept marshland of the Camargue.

On 2 June 1888, Vincent wrote to Theo: 'The Mediterranean has the colours of mackerel, changeable I mean. You don't always know if it is green or violet, you can't even say it's blue, because the next moment the changing light has taken on a tinge of pink or grey ... I do not think there are 100 houses in the village or town. The chief building after the old church and an ancient fortress is the barracks. And the houses like the ones on our heath and peat bogs in Drenthe; you will see some specimens of them in the drawings.'[1]

Here the field of lavender, which dominates the extended foreground in receding rows, leads the eye to the focal point of the picture — the old church. The shimmering blue-green sky fills the background space. A solitary lavender picker can be seen in the middle ground and a second tiny figure, executed with one or two rapid brush strokes, is on the right. The architectural features of the buildings are carefully outlined, forming simple geometric shapes like those found in medieval and oriental enamels, which are then filled with colour. The simplification and organization of the composition are reminiscent of Japanese painting, which Vincent mentioned in a letter to Theo written soon after his return to Arles: 'I wish you could spend some time here, you would feel it after a while, one's sight changes: you see things with an eye more Japanese, you feel colour differently. The Japanese draw quickly, very quickly, like a lightning flash ...'[2]

The time spent at Saintes-Maries was one of the happiest and most productive periods of Van Gogh's life; he produced three paintings and nine drawings (Fig. 31). He had fulfilled his dream of seeing the Mediterranean and described a walk by the sea at Saintes-Maries in a letter to Theo: 'It was not gay, but neither was it sad — it was — beautiful. The deep blue sky was flecked with clouds of a blue deeper than the fundamental blue of intense cobalt and others of a clearer

Fig. 31 Vincent van Gogh *Sailing boats coming ashore* F1430a
Saintes-Maries [Arles period] June 1888  reed pen  24.5 x 32.0 cm
Solomon R. Guggenheim Museum, New York, Thannhauser Collection,
Gift Justin K. Thannhauser, 1978
Photo: Robert E. Mates
© The Solomon R. Guggenheim Foundation, New York

blue, like the blue whiteness of the Milky Way. In the blue depth the stars were sparkling, greenish, yellow, white, pink, more brilliant ... than at home — even in Paris: opals you might call them, emeralds, lapis lazuli, rubies, sapphires. The sea was a very deep ultramarine — the shore a sort of violet and faint russet as I saw it, and on the dunes (they are about seventeen feet high) some bushes Prussian blue.'[4]

1  LT499, Saintes-Maries, 2 June 1888.
2  ibid.
3  LT500, Arles, 4 June 1888.
4  LT499, op. cit.

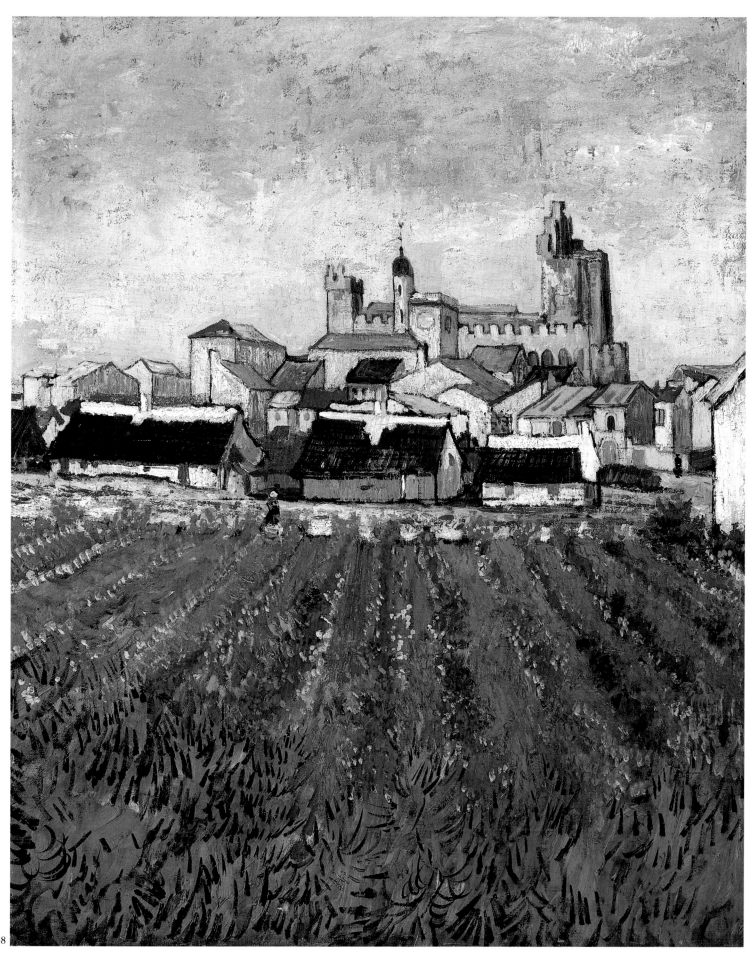

CAT. 38

85

## 39 FARMHOUSE IN PROVENCE F565

Arles June 1888
oil on canvas 46.1 x 60.9 cm
© 1993, National Gallery of Art, Washington
Ailsa Mellon Bruce Collection

Seeking the light and colour of the South which had inspired Monticelli and Delacroix, Van Gogh arrived in Arles on 20 February 1888. He soon began to paint the blossoming orchards, but the full impact of the South (in French *le Midi*, the land of the midday sun) was revealed in June, in the heat of the harvest time. New and strange harmonies had to be explored to match the full intensity of the light:

> Essentially the colour is exquisite here ... When it gets scorched and dusty it does not lose its beauty, for then the landscape gets tones of gold of various tints, green-gold, yellow-gold, pink-gold, and in the same way bronze, copper, in short starting from citron yellow all the way to a dull, dark yellow colour like a heap of threshed corn, for instance. And this combined with the blue ... particularly clear, bright blue — green-blue and violet-blue.
>
> Furthermore, on account of the many yellow hues, violet gets a quick emphasis; a cane fence or a grey thatched roof or a dug-up field makes a much more violet impression than at home.[1]

*Farmhouse in Provence* has just this range of bronze tones, where the insistent yellow of the palette strikes through the mixed colours like radiant heat. The stone wall is cooled with the complementary colour, violet — lilac in the half-tones and purple in the minimal shadows allowed by the midday light.[2] Whereas yellow reminded Van Gogh of Monticelli (see Cat. 16), 'who did the South all in yellow, all in orange, all in sulphur',[3] these violet tones had fascinated the artist in the work of Delacroix. In Arles he found the yellow sunlight which heightens the effect of the complementary hue found in shadows. Other pairs of enlivening complementary colours, dear to the Impressionists, may be discerned throughout the painting, as in the red and green of the flowers in the foreground. In the phrase of the Symbolist critic Albert Aurier, here is the 'constant harmony of the most excessive colours'.[4]

The bright colours made Van Gogh feel that '*here I am in Japan*',[5] for his view of Japan was formed by Japanese prints. These also seem to have suggested the asymmetrical placement of the bright yellow farmhouse, as if cantilevered by the forceful diagonals of the composition, and the daring disparity of scale between the flowers which dominate the foreground and the small figure of a man immediately behind them.

The single figure, back turned to the artist, is his only company in the heat of noon: 'I work even in the middle of the day, in the full sunshine, without any shadow at all, ... and I enjoy it like a cicada ...'[6]

At times, however, he expressed anxiety: 'And very often indeed I think of that excellent painter Monticelli — who they said was such a drinker, and off his head — when I come back myself from the mental labour of balancing the six essential colours, red — blue — yellow — orange — lilac — green. Sheer work and calculation, with one's mind strained to the utmost, like an actor on the stage in a difficult part, with a hundred things to think of at once in a single half hour.'[7]

[1]   W4, Arles, c. 18 June 1888.
[2]   Van Gogh wrote of 'the shadows in the middle of the day much shorter than in our own country', see W4, Arles, c. 16 June 1888.
[3]   W8, Arles, c. 27 August 1888.
[4]   'Les isolés', *Mercure de France*, January 1890, translated Hammacher 1982, p. 200.
[5]   W7, Arles, 9 September 1888.
[6]   B7, Arles, c. 18 June 1888.
[7]   LT507, Arles, 29 June 1888.

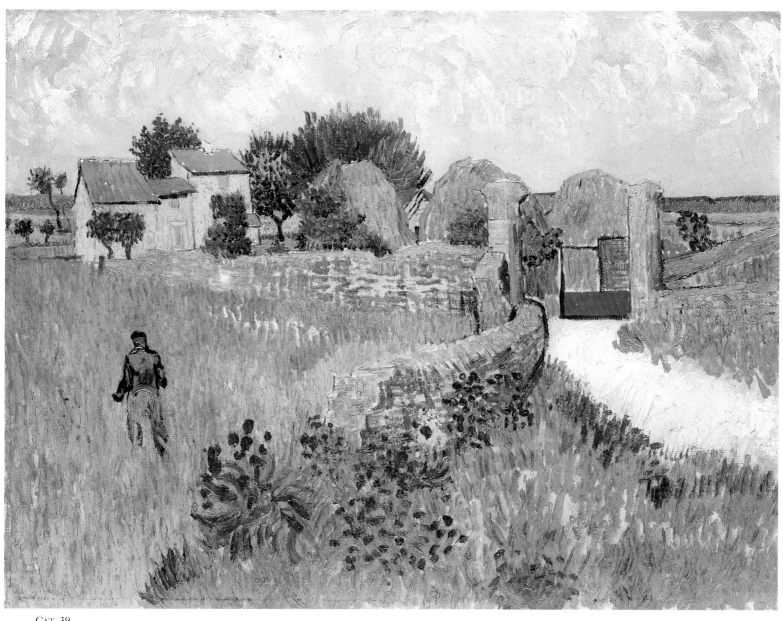

Cat. 39

## *40* THE STEVEDORES IN ARLES *F438*

Arles end August 1888

oil on canvas 54.0 x 65.0 cm

Fundación Colección Thyssen-Bornemisza

In early August 1888, Van Gogh wrote to Theo from Arles: 'I saw a magnificent and strange effect this evening. A very big boat loaded with coal on the Rhône, moored to the quay. Seen from above it was all shining and wet with a shower; the water was yellowish-white and clouded pearl grey; the sky lilac, with an orange streak in the west; the town, violet. On the boat some poor workmen in dirty blue and white came and went carrying the cargo on shore. It was pure Hokusai.'[1]

It was too late in the evening to begin a painting but Van Gogh promised himself he would return to the motif. A few weeks later he wrote again to Theo: 'I saw again today the same coal boat with the workmen unloading it that I told you about before, at the same place as the boat loaded with sand which I sent you a drawing of. It would be a splendid subject.'[2]

Van Gogh made two paintings of this subject, of which this picture, the smaller and more immediate of the two, was probably the preliminary version.

After living in Arles for several months, Van Gogh wrote that he had begun to see things 'with an eye more Japanese'.[3] This new way of seeing had been motivated by the sun-drenched landscape, which the artist felt could only be reproduced by painting with strong, clear colours. He abandoned the Impressionist and Pointillist methods he had experimented with in Paris, heightened his colour and simplified his forms.

The subject of *The stevedores in Arles* — a night scene with strong shadows and atmospheric effects of sunset on water — shows Vincent's interest in Japanese prints (Fig. 32).[4] Also in the Japanese manner is his use of simplified colours, as he wrote to Bernard: 'For the Japanese artist ignores reflected colours, and puts the flat tones side by side, with characteristic lines marking off the movements and the forms.'[5] Although predominantly dark in colour, as befits a night subject, drama is evoked by the bright orange sunset reflected in the water and the artist's clearly visible brush strokes. The intense colour and strong brush work point towards early twentieth-century movements of Fauvism and Expressionism (see Cat. 54–61).

*The stevedores in Arles* was owned by the important German art dealer Paul Cassirer who held eleven major Van Gogh exhibitions before 1910.[6] Through such exhibitions in Germany, artists were able to view influential works by Van Gogh, such as *The stevedores in Arles*.

Fig. 32 Utagawa Hiroshige  Edo (Tokyo) 1797–1858
*Shionata*, from the series 'Sixty-nine stations of the Kiso Highway' late 1830s woodcut  25.7 x 37.8 cm (sheet)  National Gallery of Victoria
Felton Bequest 1909

1   LT516, Arles, early August 1888.
2   LT526, Arles, August 1888.
3   LT500, Arles, c. 5 June 1888.
4   As Pickvance notes this is also an Impressionist subject; see Pickvance 1984, p. 164.
5   B6, Arles, second half of June 1888.
6   Feilchenfeldt 1988, pp. 144–50.

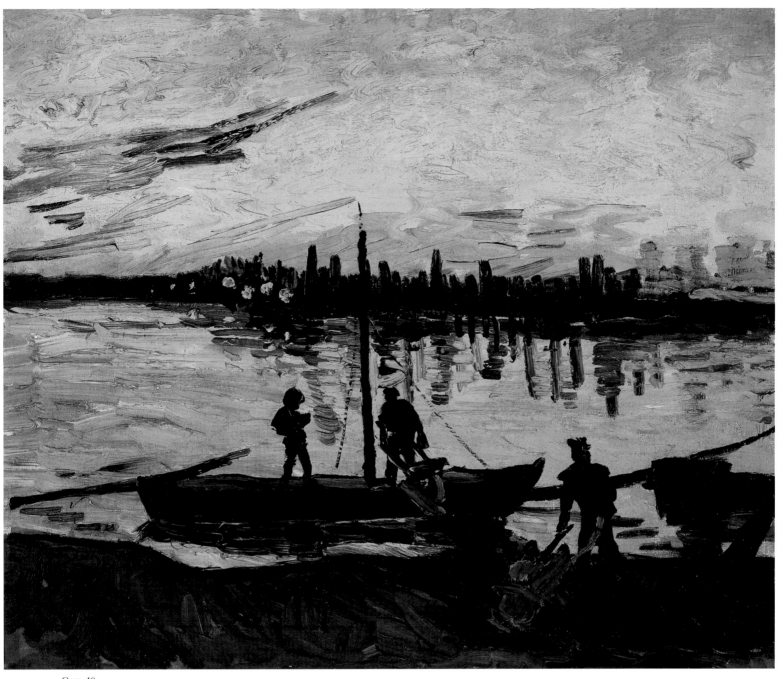

CAT. 40

## 41 *THE PLOUGHED FIELD* *F574*

Arles  September 1888

oil on canvas  72.5 x 92.5 cm

Vincent van Gogh Foundation

Van Gogh Museum, Amsterdam

The landscape around Arles provided Van Gogh with the opportunity to paint a group of 'poetic subjects'[1] which included *The ploughed field* and *The green vineyard* (Cat. 42). He felt confident that these works were painted in a more attractive and harmonious manner than the two groups of work sent previously to Theo from Arles, and that they would be well received by the public. In *The ploughed field* he felt he achieved 'a greater quiet'.[2]

Van Gogh described *The ploughed field* as 'a scenery with nothing but lumps of earth, the furrows the colour of an old wooden shoe under a forget-me-not blue sky with white cloud flocks'.[3]

The bare earth seems full of that poetry of human labour which for both Millet and Van Gogh was tied up with the idea of the peasant's wooden clogs. At this time also Van Gogh read an article on Leo Tolstoy, about his religious sense of the continuity of life through generations of human labour. He admired the aristocratic writer for choosing to 'guide the plough, and dig the earth'.[4]

Sincerity and directness are the values which lie behind the notable simplicity in the composition, which is only a little less radical than Seurat's *Field of lucerne, Saint-Denis* (see Cat. 21). These are qualities the artist saw as opposed to the cleverness of academic training, and as early as 1882 he expressed a belief that 'the public will begin to say: deliver us from artistic compositions, give us back the simple field'.[5]

The painting lives by its subtle management of colour and texture. The dull ochre tones of the tilled earth form a broad contrast with the varied blue of the sky, while the complementary colours of the tiny red roofs and green trees of the horizon provide a sharper note. The harmonious effect is achieved by the use of closely related tones and hues, especially in the soil, a technique which differs from the artist's recent practice of using the most striking complementary contrasts, for example purple and yellow.

The artist spoke of the need 'to get one's brushwork firm and interwoven with feeling'.[6] His method of applying the paint defines the clods and breaks the sweep of the sky into rhythmic segments.

The studies now are really done with a single coat of impasto [thick paint]. The touch is not much divided and the tones are often blended, and altogether I can't help laying it on thick in Monticelli's manner. Sometimes I think I really am continuing that man's work ...[7]

Van Gogh had set up the Yellow House at Arles in the hope of forming a studio where artists could work together, and he saw it as the 'studio in the South' which Monticelli might have headed if he had not committed suicide in 1886. Van Gogh felt a special empathy with the troubled painter who had lived in Marseilles.

1  LT545, Arles, 4 October 1888.
2  LT543, Arles, c. 29 September 1888.
3  LT553b, Arles, 2 October 1888.
4  LT543, op. cit.
5  LT251, The Hague, c. 3–5 December 1882.
6  LT543, op. cit.
7  LT541, Arles, c. 27 September 1888.

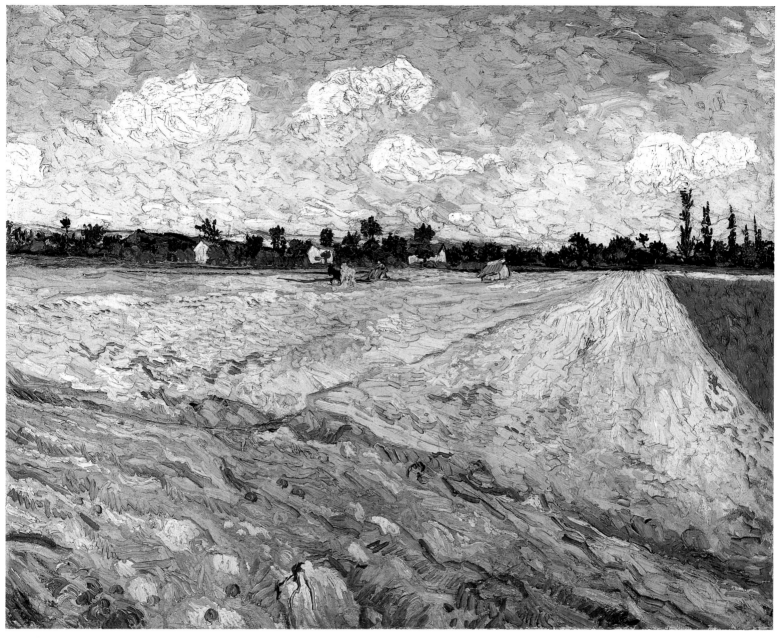

CAT. 41

## 42 *THE GREEN VINEYARD* *F475*

Arles September 1888

oil on canvas 72.0 x 92.0 cm

State Museum Kröller-Müller

Otterlo, The Netherlands

As he waited for Gauguin to join him at the Yellow House in Arles Van Gogh wrote to him about painting the vineyard at nearby Montmajour:

> These days I have an extraordinary feverish energy; at the moment I am struggling with a landscape that has a blue sky over an immense vine, green, purple, yellow with black and orange branches. Little figures of ladies with red sunshades and of vintagers with their cart enliven it even more. In the foreground, grey sand. Yet another square size 30 canvas for the adornment of the house.[1]

*The ploughed field* and *The green vineyard* were part of a complete scheme of decoration projected for the Yellow House at Arles, to comprise thirty canvases.[2] In undertaking work on this scale Van Gogh was encouraged by the memory of Seurat (see Cat. 21), 'his personality and the visit we made to his studio to see his beautiful great canvases'.[3] Indeed he harboured some hope that Seurat would join himself and Gauguin in Arles.[4]

Van Gogh had always been interested in scenes of rural labour. Here in the South it had a gentler aspect and humanity seems peaceably absorbed in a landscape where the artist detected the echoes of the ancient cult of Venus and beauty.[5] The appearance of flower-like parasols in the vineyard lends a holiday air.

The complementary contrast of red sunshades against green recedes to softer contrasts in the distance. 'On the horizon are some grey willows, and the wine press a long, long way off, with a red roof, and the lilac silhouette of the distant town'.[6] In the foreground there appears the full strength of purple grapes against golden leaves. Black branches complement near-white soil, while orange and red among the branches set off the green. Harmony is achieved by the careful balance of bright colours, and also by the use of neutral greyish and brown tones to relieve the stronger hues.

The colours interwoven in great exuberant curves represent an extension of Delacroix's technique of drawing with loosely laid lines. The sky, a swirling impasto of related shades of blue, shows clearly the painter's debt to Monticelli (see Cat. 16).

*The green vineyard* and *The ploughed field* were eventually sent to Paris in May 1889,[7] when the thick paint had been dried in the warmer conditions of the South.[8] Van Gogh thought that the dealer Athanase Bague would like them especially because of the impasto technique, and because they were 'In short, romantic landscapes'.[9]

1   LT544a, Arles, 3 October 1888.
2   LT553, Arles, 14 October 1888.
3   ibid.
4   LT551, Arles, c. 22 October 1888.
5   LT539, Arles, c.17 September 1888; LT544a, op. cit.
6   LT544, Arles, 3 October 1888.
7   LT589, Arles, c. 2 May 1889.
8   LT542, Arles, 24 September 1888.
9   LT546, Arles, 8 October 1888; LT547, Arles, 8–9 October 1888.

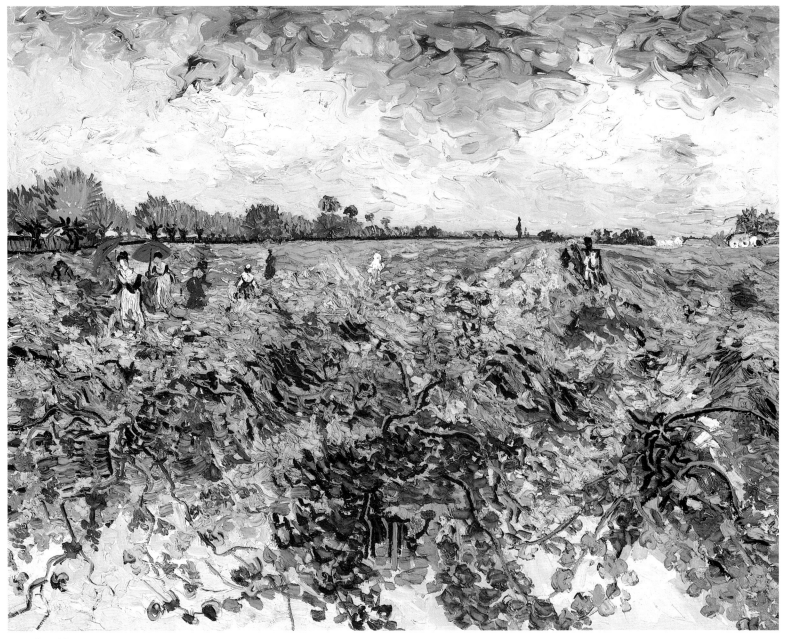

CAT. 42

## 43 *YOUNG MAN WITH A CAP* *F536*

Arles  December 1888

oil on canvas  47.5 x 39.0 cm

Private collection

I want to do figures, figures and more figures. I cannot resist that series of bipeds from the baby to Socrates and from the woman with black hair and white skin to the woman with yellow hair and a sun-burnt brick-red face.[1]

Vincent's desire to paint people of all ages and types sets the scene for this portrait of a young man with black hair and a bronze face.[2] The jaunty angle of the young man's peasant cap and his flick of unruly hair combine with the shadow on his upper lip to tell us that he is on the verge of manhood, probably aged about fifteen. The candour of his gaze adds to the effect of untroubled youth, as does the casual arrangement of his shirt and cravat.

The comparative realism of this portrait is, however, offset by the intensity of the colours which interact through contrasts of yellow and blue, green and red. In September 1888, Vincent wrote to Theo from Arles:

> ... I foresee that other artists will want to see colour under a stronger sun, and in a more Japanese clarity of light ... Why did the greatest colourist of all, Eugène Delacroix, think it essential to go South and right to Africa? Obviously, because not only in Africa but from Arles onward you are bound to find beautiful contrasts of red and green, of blue and orange, of sulphur and lilac ... And all true colourists must come to this, must admit that there is another kind of colour than that of the North.[3]

With its bold areas of flat colour in separate compartments, and strong outlines, this picture is a good example of Cloisonism (see note p. 60), the style that Vincent and his friends — Gauguin, Bernard, Anquetin, Lautrec, and others — were then developing. The origins of this style lay in their mutual dissatisfaction with the natural limitations of Impressionism and desire to create a simpler, more direct and universal kind of art. The style itself, was based on their study of the popular and decorative arts of less sophisticated cultures and, especially for Vincent, of Japanese colour woodblock prints. A copy of Utagawa Kuniyoshi's *An actor at the Sumida River* (Fig. 33) was in Vincent and Theo's collection of Japanese prints.

Although *Young man with a cap* is not referred to specifically in

Fig. 33 Utagawa Kuniyoshi  Edo (Tokyo) 1797–1861
*An actor at the Sumida River* from the series
'The seven Gods of luck along the Sumida River' 1853
woodcut  34.6 x 24.5 cm (sheet)
National Gallery of Victoria  Gift of Dr Lilian Alexander 1934

Vincent's letters, it is closely related to his portraits of the Roulin family, particularly those he made of Roulin's two sons in early December. Such was the satisfaction he derived from these portraits that, as he told Theo, he was hoping for more sitters:

> You know how I feel about this, how I feel in my element, and that it consoles me up to a certain point for not being a doctor. I hope to get on with this and to be able to get more careful posing, paid for by portraits ... Just now I am completely swamped with studies, studies, studies, and this will go on for a while.[4]

1   B15, Arles, c.18 August 1888.
2   This work was on long-term loan to the National Gallery of Victoria from 1978 to 1984.
3   LT538, Arles, September 1888.
4   LT560, Arles, c. 4 December 1888.

CAT. 43

## *44* THE CHAIR AND THE PIPE *F498*

Arles  December 1888–January 1889

oil on canvas  91.8 x 73.0 cm

inscribed u. l. on bulb box: Vincent

The Trustees of the National Gallery, London

One of the best known images in modern art, Vincent's empty chair has been turned by popular myth into a symbol of the artist's loneliness. In fact the picture was painted at a moment of relative togetherness, during Gauguin's visit to Arles. As Van Gogh put it to Theo, 'the last two studies are odd enough. Size 30 canvases, a wooden rush-bottomed chair all yellow on red tiles against a wall [daytime]. Then Gauguin's armchair, red and green night effect, walls and floor red and green again, on the seat two novels and a candle, on thick canvas with a thick impasto.'[1]

The differences between this pair of paintings were intended to characterize their individual approaches to art. The contrasting styles of the two chairs also reflected the personalities of their occupants, the chairs having been bought by Vincent with that in mind. Whereas his own chair is a simple, solidly-crafted peasant type, the elegant armchair was in the guest room which Vincent had furnished especially for his friend.[2]

In similar fashion, the candle and novels on Gauguin's chair suggest his friend's more mystical and abstract approach by contrast with the comforting reality of the pipe and tobacco pouch on his own. The unnatural gaslight in the upper left of the companion picture, Gauguin's chair (Fig. 34), is matched by a natural image — the box of sprouting onions in this picture. With their significance underlined by the presence of the artist's name on the box, these sprouting onions are a metaphor for the artist's dependence on contact with nature.

The effect of reality in this picture is heightened by the firm directional brushstrokes with which Van Gogh reconstructs the chair and tiled floor. With similar directness, he outlines with red the full sunlight yellows on the back of the chair; and edges with blue the cooler yellows below the seat and around the legs. These emphatic outlines around areas of bright colour are related to his experiments with Cloisonism (see note p. 60), the style invented by Gauguin, Bernard and others in Brittany from their study of Breton carvings, popular prints made in Epinal in north-eastern France, and Japanese colour woodcuts (see Fig. 32–33). Through his intense correspondence and exchange of paintings with these artists, Van Gogh collaborated in the development of this new anti-Impressionist style.[3]

Fig. 34 Vincent van Gogh
*Gauguin's armchair, candle and books*  F499
Arles  December 1888
oil on canvas  90.5 x 72.0 cm
Vincent van Gogh Foundation
Van Gogh Museum, Amsterdam

After Gauguin's departure, and his own fortnight in hospital, Van Gogh added some touches to this picture, referring to it in a letter to Theo as 'my own empty chair'. This reference is sometimes interpreted as a premonition of death. It recalls his weeping at the sight of his father's empty chair after the latter's death in 1885; and also his attachment to an engraving of Charles Dickens's empty chair, done after the author's death by his illustrator, Luke Fildes.

On 1 December 1882, Vincent wrote to Theo from The Hague: '*Edwin Drood* was Dickens's last work, and Luke Fildes, brought into contact with Dickens through those small illustrations, entered his room on the day of his death, and saw his empty chair; and so it happened that one of the old numbers of the *Graphic* contained that touching drawing, "The Empty Chair".'[4]

He also mentioned to Theo 'I am very anxious to show you the wood engravings. I have a splendid new one, a drawing by Fildes, the empty chair of Dickens from the *Graphic* of 1870.'[5]

---

1  LT563, Arles, c. 23 November 1988.
2  See Bailey 1992.
3  The French word *cloison* comes from a kind of enamelware with fine metal divisions between flat areas of colour.
4  LT251, 2–3 December 1882.
5  LT220, 26 July 1882.

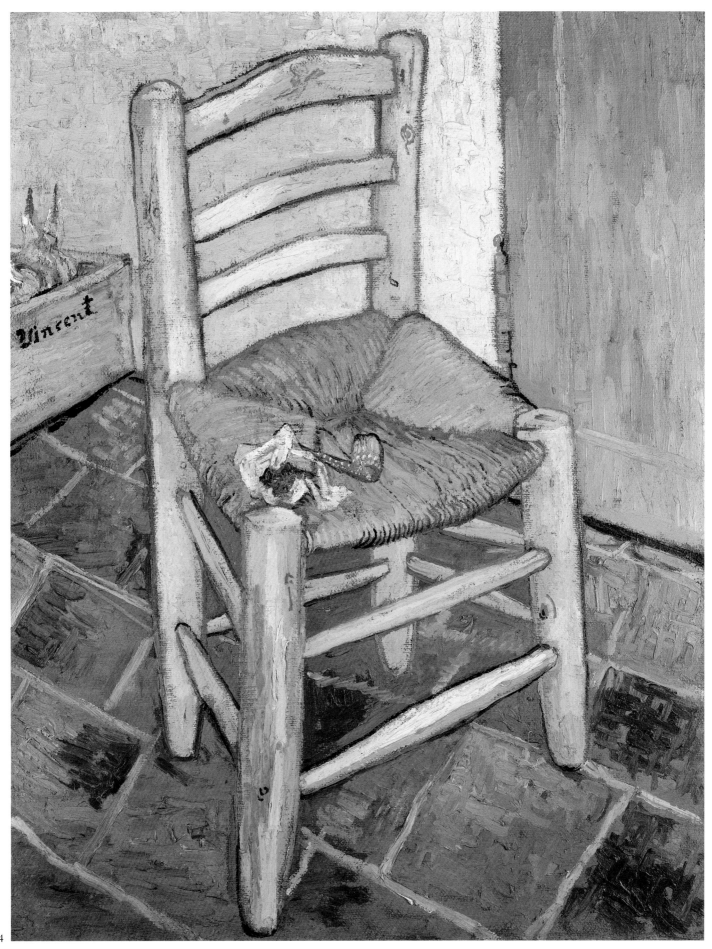

## 45 PORTRAIT OF THE POSTMAN JOSEPH ROULIN F439

Arles January–February 1889
oil on canvas 65.0 x 54.0 cm
State Museum Kröller-Müller
Otterlo, The Netherlands

His voice has a strangely pure and touching quality in which there is to my ear at once a sweet and mournful lullaby and a kind of faraway echo of the trumpet of revolutionary France.[1]

This is one of six portraits Van Gogh made of Joseph-Etienne Roulin, an *entreposeur des postes* who handled the mail at the Arles railway station. The only person who appears more often in works by Vincent, apart from the artist himself, is Roulin's wife.

Van Gogh had met Roulin, who was to become his friend and drinking companion, in August 1888, when he wrote to Theo 'I do not know if I can paint the postman *as I feel him*; this man ... is a revolutionary', and 'a good republican because he wholeheartedly detests the republic which we now enjoy'.[2] His first two portraits of Roulin were painted then: one a half-length with hands, and the second a life-size head done at a single sitting. Vincent wrote at this time to his youngest sister Wilhemina:

> I am now engaged on a portrait of a postman in his dark-blue uniform with yellow. A head somewhat like Socrates, hardly any nose at all, a high forehead, bald crown, little grey eyes, bright red chubby cheeks, a big pepper-and-salt beard, large ears. This man ... reasons quite well, and knows a lot of things. His wife is delivered of a child today, and he is consequently feeling as proud as a peacock, and is all aglow with satisfaction.
>
> In point of fact I greatly prefer painting a thing like this to doing pictures of flowers.[3]

His third portrait was painted as part of a set of Roulin's whole family, including Roulin's wife, two sons and baby daughter, in late November or early December. These three portraits were all set against a plain background.

The present picture, one of three similar versions set against decorative backgrounds, was painted when Van Gogh was in hospital in Arles after Roulin, who supported him during his illness but then moved to Marseilles, had visited him for the last time. 'By the way', he told Theo — 'only yesterday our friend Roulin came to see me ... His visit gave me a lot of pleasure, he often has to carry loads you would call very heavy, but it doesn't bother him, as he has the strong constitution of the peasant; he always looks well and even jolly.'[4] He went on, 'But for me, who am perpetually learning from him, what a lesson for the future it is when one learns from his talk that life does not grow any easier as one gets on in life'.[5]

The frontal pose and impassive expression, together with the twin streams of Roulin's beard, convey the idea of strength and endurance; the glimpse of yellow shirt or cravat in the centre forms a triangle with the gold buttons of his double-breasted uniform. The lettering on his cap places him as a 'petit bourgeois' (lower middle class), the type with which Van Gogh identified; while the lively bunches of wildflowers around the head suggest Roulin's affinity with nature, a quality Van Gogh sought in his own life. Vincent wrote to Theo in January 1889, close to the time when this portrait was painted: 'I have rarely seen a man of Roulin's temperament, there is something in him tremendously like Socrates, ugly as a satyr, as Michelet called him, "until on that last day a god appeared in him that illumined the Parthenon".'[6]

1   LT573, Arles, 23 January 1889.
2   LT520, Arles, 11 August 1888.
3   W5, Arles, 31 July 1888.
4   LT583, Arles, c. 1–5 April 1889.
5   ibid.
6   LT572, Arles, 19 January 1889.

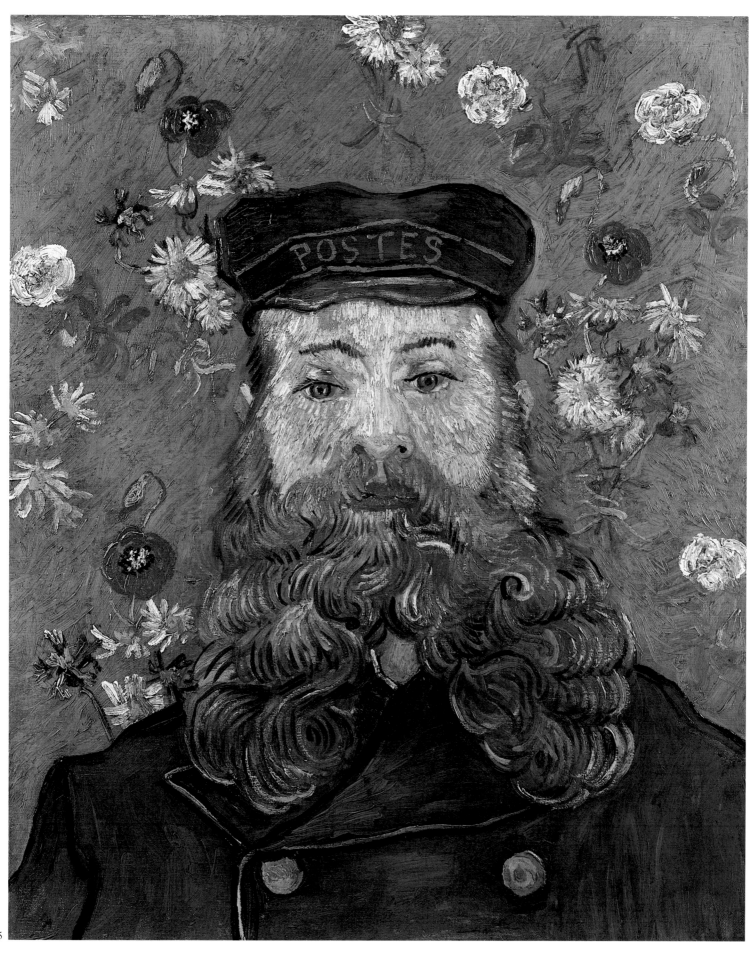

CAT. 45

99

## 46 *THE SHEEP SHEARERS* *F634*
### [AFTER MILLET]

Saint-Rémy  September 1889
oil on canvas  43.0 x 29.0 cm
Vincent van Gogh Foundation
Van Gogh Museum, Amsterdam

In May 1889 Van Gogh went into the care of the asylum of Saint-Paul-de-Mausole in Saint-Rémy-de-Provence. In September, lacking access to live models, he returned to his earlier practice of making copies after the works of his 'great predecessors'. In so doing he was acknowledging the benefit of the academic system of learning by copying.

> ... if some person or other plays Beethoven, he adds his personal interpretation — in music and more especially in singing — the *interpretation* of a composer is something, and it is not a hard and fast rule that only the composer should play his own composition.
>
> Very good — and I, mostly because I am ill at present, I am trying to do something to console myself, for my own pleasure.
>
> I let the black and white by Delacroix or Millet or something made after their work pose for me as a subject.
>
> And then I improvise colour on it, not, you understand, altogether myself, but searching for memories of *their* pictures — but the memory, 'the vague consonance of colours which are at least right in feeling' — that is my own interpretation.
>
> Many people do not copy, many others do — I started on it accidentally, and I find that it teaches me things, and above all it sometimes gives me consolation. And then the brush goes between my fingers as a bow would on the violin, and absolutely for my own pleasure. Today I tried the 'Woman Shearing Sheep' in a colour scheme ranging from lilac to yellow.[1]

The sheep shearers hold the sheep upside down on top of a barrel while another sheep lies trussed on the ground to the left of the woman. That the shearer is a woman is not unusual in the nineteenth century. Even in certain parts of Australia German women were especially valued for their skills as shearers of prize merino flocks.

LT607, Saint-Rémy, 19 September 1889.

## 47 *THE SHEAF-BINDER* *F693*
### [AFTER MILLET]

Saint-Rémy  September 1889
oil on canvas  44.5 x 32.0 cm
Vincent van Gogh Foundation
Van Gogh Museum, Amsterdam

During September Van Gogh made twenty-eight copies; including twenty after Millet. Van Gogh delighted in translating these black and white images into 'the language of colour'. The number of paintings after Millet indicates the admiration Van Gogh held for the painter he called 'Father Millet' and regarded as his 'spiritual mentor'.

Van Gogh, like Millet, saw in the peasants' absorption in their work a romanticized nobility. The sheaf-binder struggles with unruly nature, his awkward posture and the lively brush strokes emphasizing the difficulty of his task.

In *The sheep shearers* (Cat. 46) and *The sheaf-binder* (both copied from Jacques-Adrien Lavieille's etchings after Millet's *Les Travaux des Champs*) Van Gogh has limited his palette and blue and yellow predominate. He had written from Nuenen, in February 1885:

> And I am also looking for blue all the time. Here the peasants' figures are as a rule blue. That blue in the ripe corn or against the withered leaves of a beech hedge — so that the faded shades of darker and lighter blue are emphasized and made to speak by contrast with the golden tones of reddish-brown — is very beautiful and has struck me here from the very first. The people here instinctively wear the most beautiful blue that I have ever seen.
>
> It is coarse linen which they weave themselves, warp black, woof blue, the result of which is a black and blue striped pattern. When this fades and becomes somewhat discoloured by wind and weather, it is an infinitely quiet, delicate tone that particularly brings out the flesh colours.
>
> Well, blue enough to react to all colours in which hidden orange elements are to be found ...[1]

There is little shadow in these paintings after Millet. They are as much images of summer and sunshine as they are of work. In his cell in the asylum, these images of an orderly life in the outside world would have had especial significance for Van Gogh.

[1]  LT394, Nuenen, February 1885.

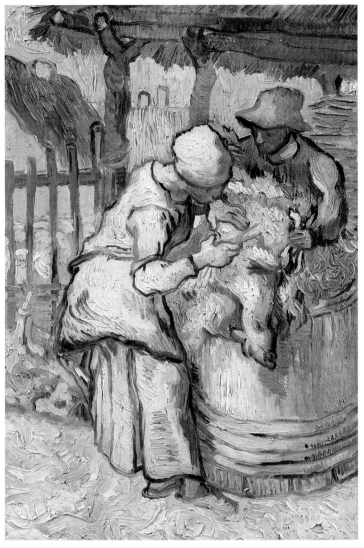

CAT. 46

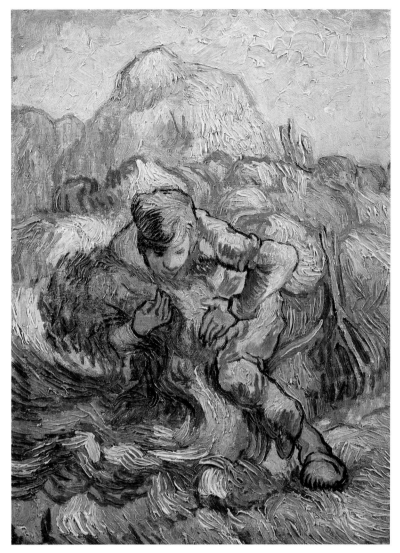

CAT. 47

# 48 *NIGHT: THE WATCH* F647
## [AFTER MILLET]

Saint-Rémy October 1889

oil on canvas 72.5 x 92.0 cm

Vincent van Gogh Foundation

Van Gogh Museum, Amsterdam

During his early days in art dealership in Paris in 1875 Van Gogh had been able to see the sale of Millet's drawings from the collection of Emile Gavet. His admiration was such that he wrote to Theo, 'I felt like saying, "Take off your shoes, for the place where you are standing is Holy Ground"'.[1] There he would have seen the beautiful pastel *Night: The watch* 1867, and on the wall of his room in Montmartre he hung the wood engravings after this design (Fig. 35).[2]

In the asylum at Saint-Rémy Van Gogh painted compositions after his favourite prints. He wrote to Theo: 'I let the black and white by Delacroix or Millet or something made after their work pose for me as a subject.'[3] He wanted to learn[4] but soon saw himself as continuing Millet's mission by developing compositions which Millet had 'had no time to paint in oil.'[5] He also wished to perpetuate the design in lithograph for 'the great general public'.[6]

Sensitive to the possible charge of merely copying he told Theo, 'It is rather translating — in another language — that of colour — the impressions of light and shade in black and white'.[7] The colour was independent of the original. It was Van Gogh's own interpretation, as a musician interprets Beethoven, 'And then my brush goes between my fingers as a bow would on the violin, and absolutely for my own pleasure'.[8]

*Night: The watch* is built up from lines of many contrasting colours, which combine to form iridescent half-tones and shadows where the colours neutralize each other. This weaving of colours,[9] is a bold development of the legacy of French painting from Delacroix to Seurat. It is no longer a mere description of the colours of nature, though lessons have been learned from the Impressionists' study of colour. The linear application of paint is closer to Millet's pastel than to contemporary practice in oils and reinforces the steep recession of the floor with its long cast shadows.

Van Gogh's *Night: The watch* is a gentle and harmonious vision of the peasant family, the man making a basket, the woman sewing, the figures drawn together by the light of the oil lamp which illumines a baby in its cradle and casts long shadows across the floor, while a lesser light warms the cat at the hearth.

Van Gogh's imagery unites tradition and personal experience. In

Fig. 35 Jacques-Adrien Lavieille after
Jean-Francois Millet *Night: The watch*
published in *L'Illustration* 61 1873, p. 57
Vincent van Gogh Foundation
Van Gogh Museum, Amsterdam

The Hague in 1882 he had been deeply moved while contemplating the cradle made ready for Sien's child. He found in it 'the eternal poetry of the Christmas night ... as the old Dutch masters saw it, and Millet'. Above it he hung 'the great etching by Rembrandt ... the two women by the cradle, one of whom is reading from the Bible by the light of a candle, while great shadows cast a deep chiaroscuro all over the room.'[10] This was his image of longing for family life, and he even believed the sight of this cradle would effect a reconciliation with his father. A woman rocking a cradle was the subject of the major portrait, *La berceuse* (F 508), of which he made five versions in Arles.

Like the cradle, the old-fashioned lamp had also long held a special fascination. Van Gogh acquired one from a weaver in 1884 and drew it in a letter to Theo, mentioning the connection with Millet's *Night* and the 'Rembrandtesque effects' of lamplight.[11] Though many artists have invested everyday objects with symbolic content, few can be regarded as poets of furniture at the level of Van Gogh, whose painting of his own chair, *The chair and the pipe* (see Cat. 44) is one of the great icons of nineteenth-century art.

1   LT29, Paris, 29 June 1875.

2   LT30, Paris, 6 July 1875. This and three other designs by Millet were issued by Jacques-Adrien Lavieille in 1860 as *The four times a day*. Van Gogh made his first copy after *Night* in 1880, at the beginning of his career as an artist, see LT134, Cuesmes, 20 August 1880.

3   LT607, Saint-Rémy, 19 September 1889.

4   ibid.

5   LT623, Saint-Rémy, c. 10 January 1890.

6   ibid.

7   ibid.

8   LT607, Saint-Rémy, 19 September 1889.

9   In Paris Van Gogh experimented with multicoloured skeins of wool. There would appear to be a connection with Delacroix's technique which was associated with weaving in contemporary critical writing.

10   LT213, The Hague, beginning of April 1882.

11   LT367, Nuenen, c. 15 May 1884. The sketch is reproduced in the Dutch edition of 1990, letter 449, p. 1210.

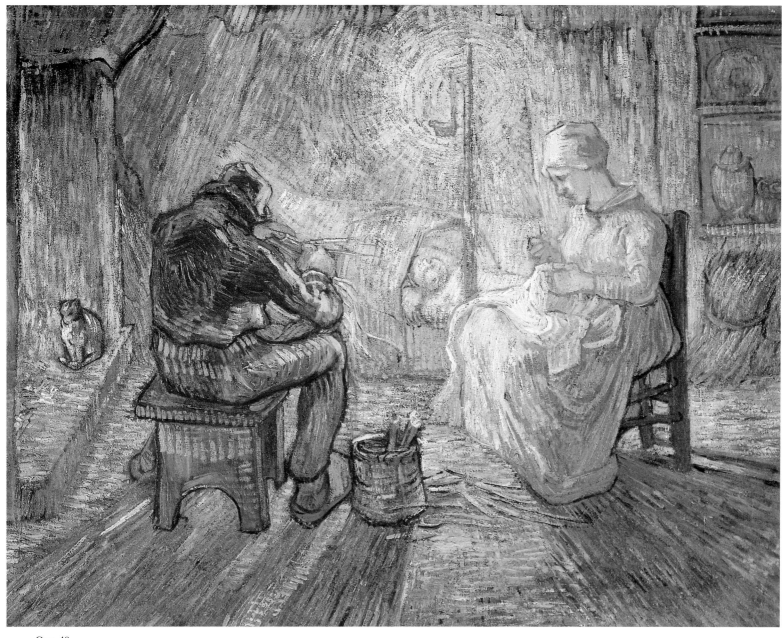

Cat. 48

## *49* *FIRST STEPS* *F668*
### [AFTER MILLET]

Saint-Rémy January–February 1890

oil on canvas 72.4 x 91.1cm

The Metropolitan Museum of Art

Gift of George N. and Helen M. Richard, 1964

Van Gogh started copying works by Jean-François Millet as early as 1880. In 1882 Van Gogh read Alfred Sensier's biography of Millet and was deeply moved. Encouraged to become an artist, he wrote to Theo: 'Reading Sensier's book about Millet gives one courage'.[1] Furthermore, he saw Millet as 'a guide and counsellor to the young painters in all things',[2] who 'can perhaps best teach us to see, and get "a faith"'.[3]

*First steps* is another from the series of works after Millet made by Van Gogh when he was in the asylum at Saint-Rémy. Vincent had written to Theo asking him to send photographs and prints of his favourite painters, including Delacroix and Rembrandt as well as Millet. After receiving the photographs in October 1889, including one by Braun after Millet's *The first steps*, he wrote to Theo exclaiming, 'How beautiful that Millet is, "A child's first steps"'.[4] Soon after he wrote again telling Theo:

> This week I am going to start on the snow-covered field and Millet's 'The first steps', in the same size as the others. Then there will be six canvases in a series [including *Night: the watch*, Cat. 48] and I can tell you, I have put much thought into the disposition of the colours while working on the [four] 'Hours of the Day'.[5]

Three months later, Vincent returned to the Braun photograph, drew a grid on it (Fig. 36) to establish the proportions, and made this oil copy of *The first steps* by Millet.

The use of colour was so important to Van Gogh that he was 'confounded' at how little colour Millet employed.[6] The subject matter of *First steps* particularly appealed to Van Gogh; although it is a peasant family, this special family scene occurs in all houses. As Vincent explained in a letter to Theo:

> I can very well do without God both in my life and in my painting, but I cannot, ill as I am, do without something which is greater than I, which is my life — the power to create.
>
> And if, frustrated in the physical power, a man tries to create thoughts instead of children, he is still part of humanity.

Fig. 36 Photograph by Braun after Jean-François Millet
*The first steps*, showing Vincent's grid lines
Vincent van Gogh Foundation Van Gogh Museum, Amsterdam

> And in a picture I want to say something comforting, as music is comforting. I want to paint men and women with that something of the eternal which the halo used to symbolize, and which we seek to convey by the actual radiance and vibration of our colouring.[7]

Van Gogh has used soft tones of blue and yellow, unusual for his Saint-Rémy period, to express the family's joy. The blossom on the tree also serves to celebrate the occasion. Van Gogh has succeeded in reinterpreting Millet's painting with loose brush strokes and a harmonious palette to produce this scene of intimate family life.

1   LT227, The Hague, 20 August 1882.
2   LT400, Nuenen, c. 13 April 1885.
3   LT393, Nuenen, 24 January 1885.
4   LT611, Saint-Rémy, October 1889.
5   LT623, Saint-Rémy, October 1889.
6   LT590, Saint-Rémy, 3 May 1889.
7   LT 531, Arles, 3 September 1888.

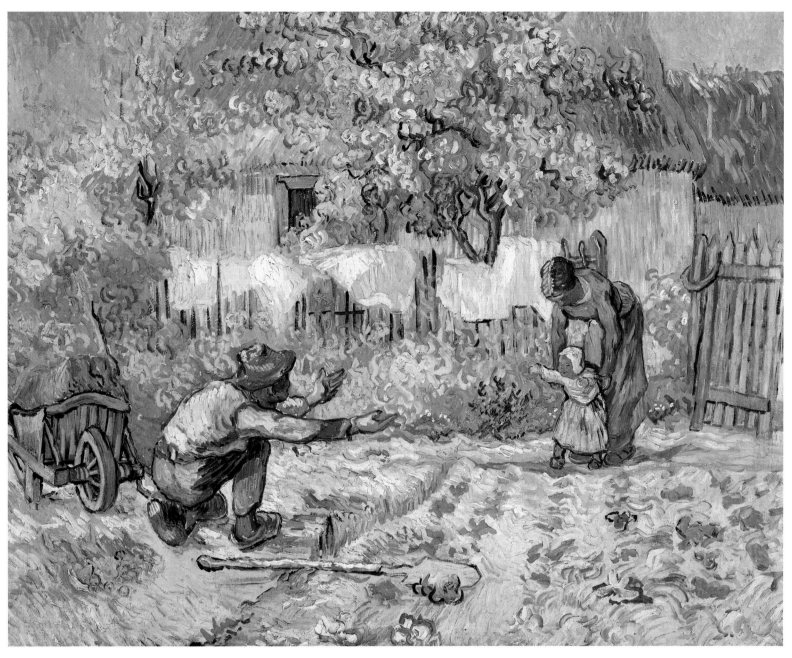

CAT. 49

## 50 *FARMS NEAR AUVERS* *F793*

Auvers-sur-Oise July 1890

oil on canvas 50.2 x 100.3 cm

Tate Gallery, London

Bequeathed by C. Frank Stoop 1933

Arriving in Auvers on 20 May 1890 Van Gogh was pleased with the peaceful country town spread out along the banks of the Oise, some twenty miles from the noise and bustle of Paris, where Daubigny (see Cat. 10) and Cézanne had painted before him.

Auvers is very beautiful, among other things a lot of old thatched roofs, which are getting rare. So I should hope that by settling down to do some canvases of this there would be a chance of recovering the expenses of my stay — for really it is profoundly beautiful, it is the real country, characteristic and picturesque.[1]

The next day he began his series of works showing the thatched cottages at Chaponval, the old village on the west side of the town. The appealing subject, picturesque as a work of the Barbizon School (see Cat. 9–15) was also bound up with childhood memories. Only three weeks earlier, in Saint-Rémy, at a time when he was feeling very low, Van Gogh was moved to paint 'a souvenir of Brabant, cottages with moss-covered roofs'.[2] In Daubigny's Auvers he might also have recalled his early enthusiasm for 'a Daubigny which I could not get enough — thatched roofs against the slope of a hill'.[3]

The Symbolist critic Albert Aurier thought of Van Gogh's cottages as 'squatting houses, passionately contorted, as if they were beings who rejoice, suffer, and think'.[4] The canvases of Auvers show just such animate dwellings: quaint upbeat gables with red roofs (F802), a dilapidated house whose humped roof-ridge suggests the back-bone of a weary beast, and low-walled cottages with decaying thatch in a neighbourhood of melancholy children (F780).

*Farms near Auvers* is the most serene and panoramic of the views of old cottages. Quietly undulating horizontal lines define roofs, eaves and hills. The air of calm is reinforced by the double-square proportions of the canvas, a format the painter had only recently adopted, perhaps as a result of seeing a large, frieze-like painting by Pierre Puvis de Chavannes.[5] In the centre triangular gables punctuate the rhythm. (Compare Pissarro's *The Banks of the Viosne at Osny in grey weather, winter* (Cat. 20), painted not many miles away.) A group of trees is among the later elements worked into the composition, and provides anchoring verticals.

The painting is unfinished: the roofs show isolated rectangular brush strokes which are merely first selections of colour for a richly textured thatch. The violet path is sketchy and the fields seem to have only an underpainting. Here we have the privilege of seeing the deliberate process by which this apparently impetuous painter built up his major compositions (see detail p. 62). In an illuminating comment written in June 1889 Van Gogh reported using 'thick layers of white lead, which gives firmness to the ground', and putting other colours over this, a method which he believed Monticelli also used.[6]

As Van Gogh lay in his coffin decked with yellow flowers *Farms near Auvers* may have been among his recent works which Emile Bernard described as 'forming something like a halo around him, and rendering — through the brilliance of the genius that shone from them — this death even more painful for us artists'.[7]

'Well the truth is, we can only make our pictures speak.'[8]

[1] LT635, Auvers-sur-Oise, 20 May 1890.

[2] LT629a, Saint-Rémy, 29 April 1890.

[3] LT215, The Hague, 16 July 1882.

[4] *Mercure de France*, January 1890, translated by R. Pickvance, see Pickvance 1986. Van Gogh had painted the thatched cottages on the Mediterranean coast at Saintes-Maries-de-la-Mer in May 1888. Aurier may also have known works from the Dutch period.

[5] The new format was mentioned for the first time in LT644, Auvers-sur-Oise, 24 June 1890. Puvis de Chavannes, *Inter artes et naturam*, is discussed more than once in the letters from Auvers.

[6] LT596, Saint-Rémy, 25 June 1889.

[7] Emile Bernard, letter to Albert Aurier, 1 August 1890.

[8] LT652, Auvers-sur-Oise, 23 July 1890.

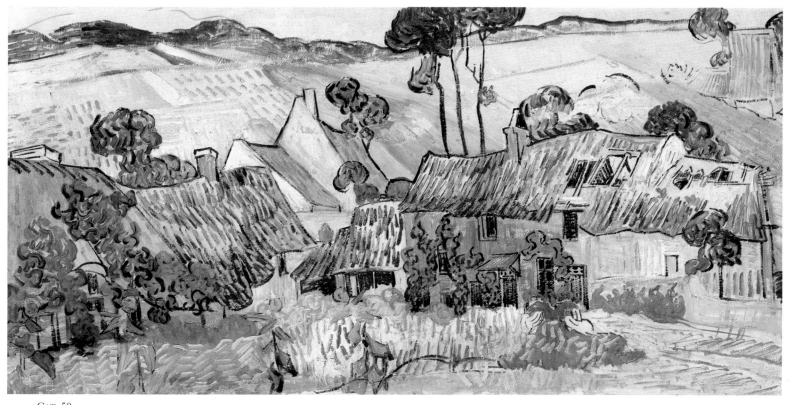

Cat. 50

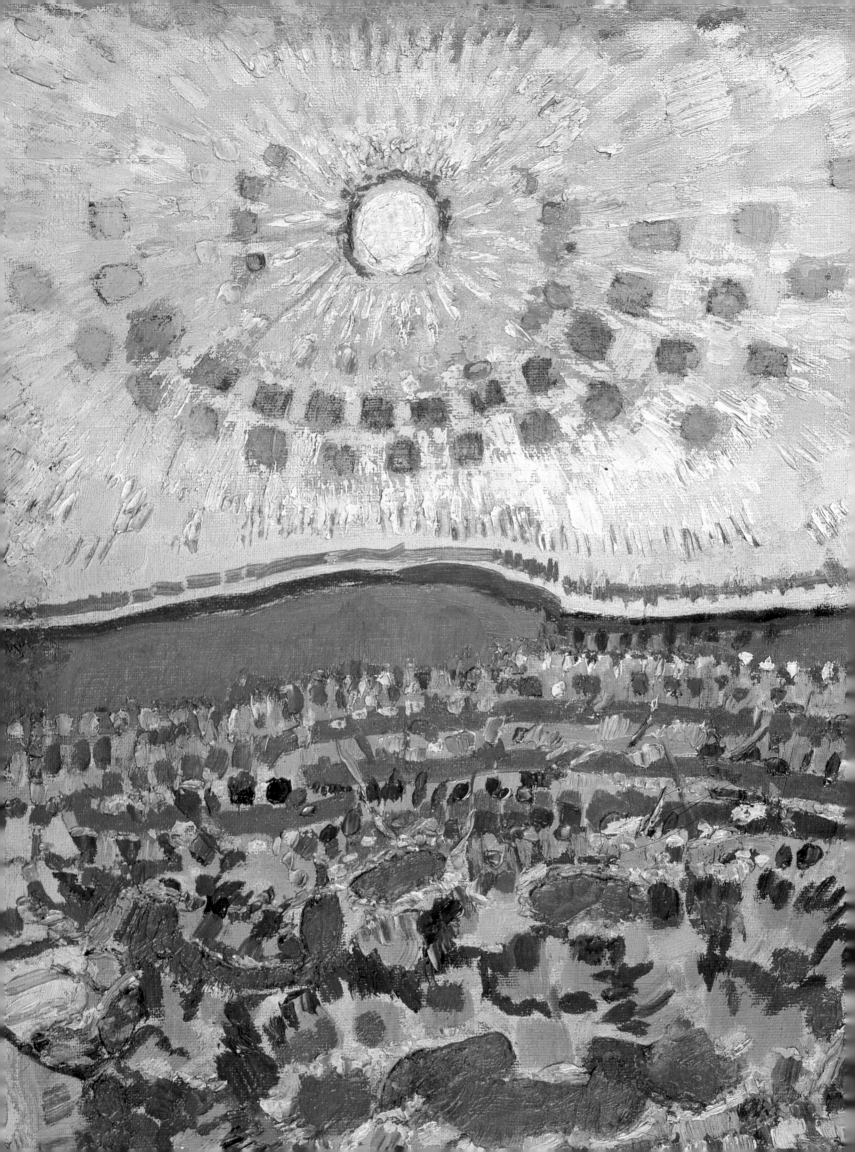

# *INFLUENCE*
# of Vincent van Gogh

## JOHN PETER RUSSELL
## 1858–1931

### 1 PORTRAIT OF VINCENT VAN GOGH 1886

oil on canvas 60.0 x 45.0 cm

inscribed u. l. : J. P. RUSSELL PARIS 1886

AMITIE VINCENT PICTOR

Vincent van Gogh Foundation

Van Gogh Museum, Amsterdam

FRONTISPIECE

Born in Sydney, John Peter Russell arrived in Paris in 1884, after attending the Slade School of Art in London for three years. In Paris he came into contact with some of the most progressive figures in French art, including Monet, Auguste Rodin and most importantly, Vincent van Gogh.

In March 1888 Russell moved permanently to Belle-Ile, an isolated island off the coast of Brittany. The three years he spent in Paris saw his greatest artistic development. If Van Gogh did not initiate his interest in colour, his influence prompted Russell's continued colour experiments.

Russell painted Van Gogh's portrait in November 1886.[1] The two artists had met in Paris in April 1886 when they were students at art school run by Fernand Cormon. Although Van Gogh only remained at the school for a few weeks, he and Russell became close friends and Van Gogh often visited Russell's studio at no. 15 Impasse Hélène. It was here that Russell painted Van Gogh's portrait. To signify that he is an artist, Russell shows him holding a pencil in his right hand and has inscribed the words Vincent Pictor (painter) in the upper section.

Russell's portrait was greatly admired by Van Gogh, who wrote to Theo: '... and carefully keep my portrait by Russell that I am so fond of'.[2] The portrait also prompted favourable comment from A. S. Hartrick, a fellow student at Cormon's art school who wrote: 'he had just painted that portrait of him in a striped blue suit looking over his shoulder ... It was an admirable likeness, more so than any of those done by himself or Gauguin.'[3]

### 51 ALMOND TREE IN BLOSSOM C. 1887

oil on canvas on panel 45.7 x 53.3 cm

Joseph Brown Collection, Melbourne

The theme of fruit trees in blossom was common in Japanese art and reflects Russell's interest in Japanese motifs which had been popular amongst French artists since the 1860s. Van Gogh was familiar with Japanese prints (see Fig. 32-33) before he went to Paris and bought many for himself, making a few direct copies of specific prints.

*Almond tree in blossom* was probably painted by Russell in the spring of 1887. Set against a bronze background, the decorative frieze of white petals shows his familiarity with Japanese art. The thick tree trunk and spindly branches create a criss-cross pattern across the picture, which has been cropped at the edges, causing the image to be read in terms of colour and design rather than realism.

Vincent painted blossom subjects from the first half of 1887 until shortly before his death when he painted *Blossoming almond tree* (Fig. 37) to celebrate the birth of his nephew, Vincent Willem.

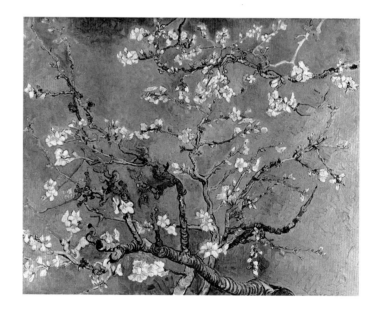

Fig. 37 Vincent van Gogh
*Blossoming almond tree* F671
Saint-Rémy February 1890
oil on canvas 73.5 x 92.0 cm
Vincent van Gogh Foundation
Van Gogh Museum, Amsterdam

1   Hammacher 1982, p. 139.
2   LT604, Saint-Rémy, 5–6 September 1889.
3   Ann Galbally, *The Art of John Peter Russell*, Sun Books, Melbourne, 1977, p. 33.

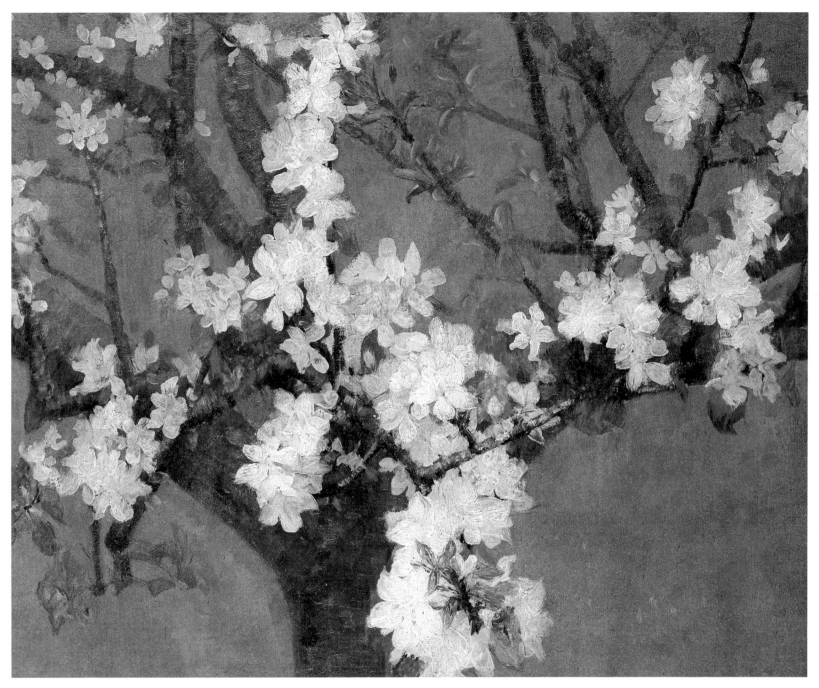

Cat. 51

PAUL GAUGUIN
1848–1903

*52  TWO BRETON GIRLS
BY THE SEA 1889*

oil on canvas  92.5 x 73.6 cm

inscribed l. r. : P. Gauguin 89

The National Museum

of Western Art, Tokyo

Matsukata collection

Van Gogh wrote to Gauguin in May 1888,[1] inviting him to live and work with him in Arles. With Theo's financial help, Gauguin accepted his offer and moved into the Yellow House in October 1888. It was to be a short but intense stay, full of creative exchanges. At the end of December the two artists quarrelled over basic artistic matters and Gauguin left Arles.

Although the artists quarrelled and parted company they admired each other's work, exchanged paintings and kept in contact through spasmodic correspondence. In October 1889, Gauguin wrote to Van Gogh from Le Pouldu, describing his latest series of paintings:

What I myself have done above all this year are simple peasant children, walking by the edge of the sea with their cows. Only, because I don't like trompe l'oeil [meant to deceive the eye] landscapes of the open air, I am trying to put into these desolate figures the savageness that I see there and which is also in me. Here in Brittany the peasants have the air of the middle ages about them and they don't look for a moment as though they believe that Paris exists or that it is 1889.[2]

Here the girls have a monumentality and primitive air far removed from Gauguin's Impressionist treatment of the *Breton girls dancing, Pont-Aven* (see Cat. 24). Gauguin originally called the work *Les deux pauvresses* (Two pauper girls) and described the faces of the peasants as '... almost Asiatic, yellow and triangular, severe'.

The girls are dressed in pinafores and *marmottes* (headscarves). Gauguin often painted peasants in their traditional Le Pouldu costumes, as he explained in a letter to Van Gogh:

The clothes are almost symbolic of the superstitions of Catholicism. Look at the back of the costume marked with a cross, the head covered with a black veil like nuns ... Still fearful of God and the local priest the Breton people hold their hats and all their utensils as though they were in church; I paint them thus in this state and not with southern flair.[3]

Bound to the earth by a life of toil, Gauguin has emphasized this struggle by exaggerating the peasants' hands and feet, with which they must work the land.

The peasant girls stand in a flattened landscape reminiscent of Japanese prints. Gauguin was one of the leaders of the tendency during the late 1880s to emphasize a structure of strong contour lines filled in by flattened areas of bright colour. This style, known as Cloisonism, was employed for a time by both Gauguin and Van Gogh (see note p. 60). Vincent's use of complementary colours enabled him to express the character of a person or place rather than its appearance. Like Van Gogh, Gauguin has tried to capture the essence of peasant life. After his time in Arles, Gauguin became more assured in his use of colour and painted in a more rhythmical and stylistic manner.

1    494a, Arles, 28 May 1888.
2    Letter 36 from Gauguin to Van Gogh, dated 20 October 1889, quoted in D. Cooper, *Paul Gauguin: 45 Lettres à Vincent, Théo et Jo van Gogh*, Staatsuitgeverij, 's-Gravenhage, 1983, p. 274.
3    ibid.

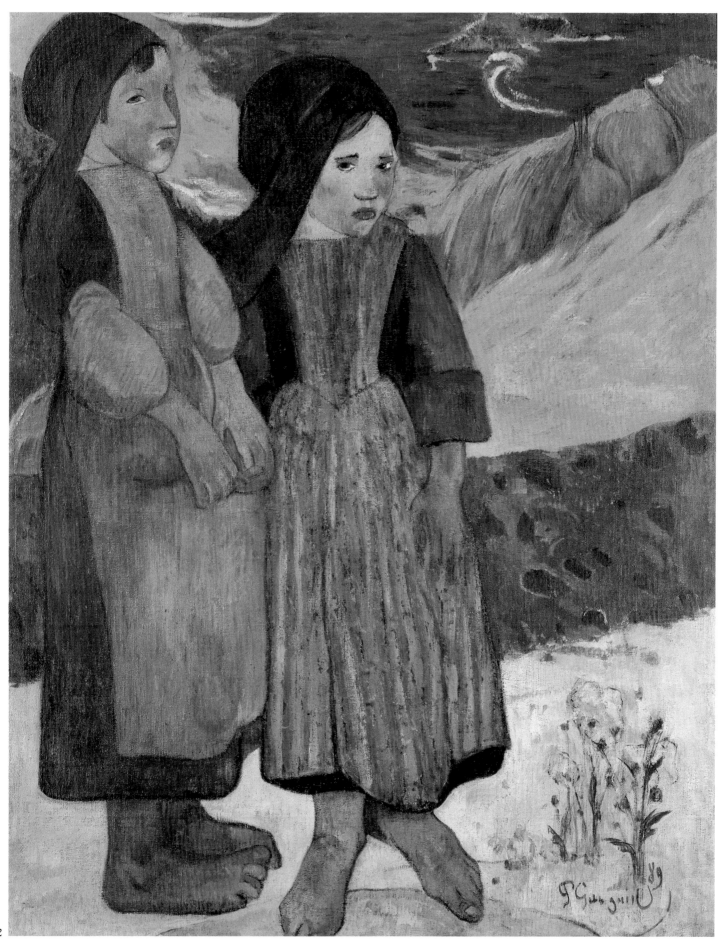

CAT. 52

## PABLO PICASSO
## 1881–1973
## 53 *STILL LIFE* *1901*

oil on canvas 59.0 x 78.0 cm

inscribed l. l. : Picasso

Museu Picasso, Barcelona

© DACS, London 1993

[SHOWN IN BRISBANE ONLY]

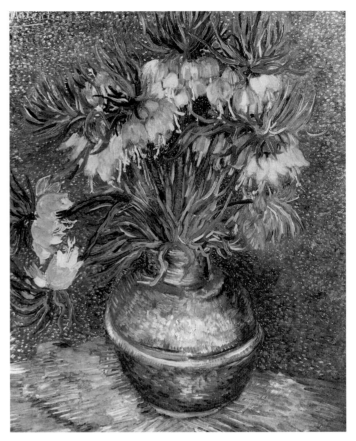

Fig. 38 Vincent van Gogh
*Still life: fritillaries in a copper vase* F213
Paris summer 1887 oil on canvas 73.5 x 60.5 cm
Musée d'Orsay, Paris

In May 1901 the twenty-year-old Pablo Picasso made his second visit to Paris and began to prepare for an exhibition at Galerie Vollard. His departure from Spain was largely prompted by his disappointment with the academic practices taught at the Royal Academy in Madrid which spurred him to search for examples of progressive modern art.

For his first exhibition in Paris, Picasso made approximately sixty-four paintings, drawings, pastels and watercolours. Young and energetic, with confidence and talent, he was able to satisfy his inexhaustible curiosity and absorb a range of new artistic styles that he saw around him. When the exhibition opened on 24 June 1901, critics praised Picasso's genius but expressed some concern at his simultaneous adoption of fashionable artistic styles all of which he then attempted to make his own, as Félicien Fagus wrote in his review: 'Like all pure painters he adores colour for its own sake ... Besides the great ancestral masters, many likely influences can be distinguished — Delacroix, Manet, Monet, Van Gogh, Pissarro, Toulouse-Lautrec, Degas, Forain, Rops ... Each one a passing phase, taking flight as soon as caught.'[1]

*Still life* is a work in which the influence of Van Gogh is most noticeable. Although he had not arrived in Paris at the time of the Van Gogh retrospective, Picasso was able to examine original works by Van Gogh owned or handled by Ambroise Vollard. Van Gogh's vibrant *Still life: fritillaries in a copper vase* 1887 (Fig. 38) had been purchased by Vollard in 1897 and may well have been seen by the young Picasso.

The artist later remarked that Van Gogh 'managed to break through and make a broad path to all the possibilities of the future'.[2] *Still life* is vigorously painted with thick brush strokes of bright colour. The picture was almost certainly exhibited in April 1902 and described, in Adrien Farge's introduction to the catalogue as the 'luxurious still life' in which the artist was inspired by his 'passion for colour'.[3]

Towards the end of 1901 Picasso began increasingly to use blue paint therefore this still life may be seen as a transitional work. Related drawings, showing the remains of a sumptuous meal, indicate that the work is a comment on the gluttony of the rich in ironic contrast to the starvation of the poor which was to become the focus of Picasso's Blue period paintings.

1   Quoted in John Richardson, *A Life of Picasso Volume 1 1881–1906*, Random House, New York, 1991, p. 199.

2   Arnold 1992, p.14.

3   J. Boggs, *Picasso & Things*, Cleveland Museum of Art, 1992, p. 44.

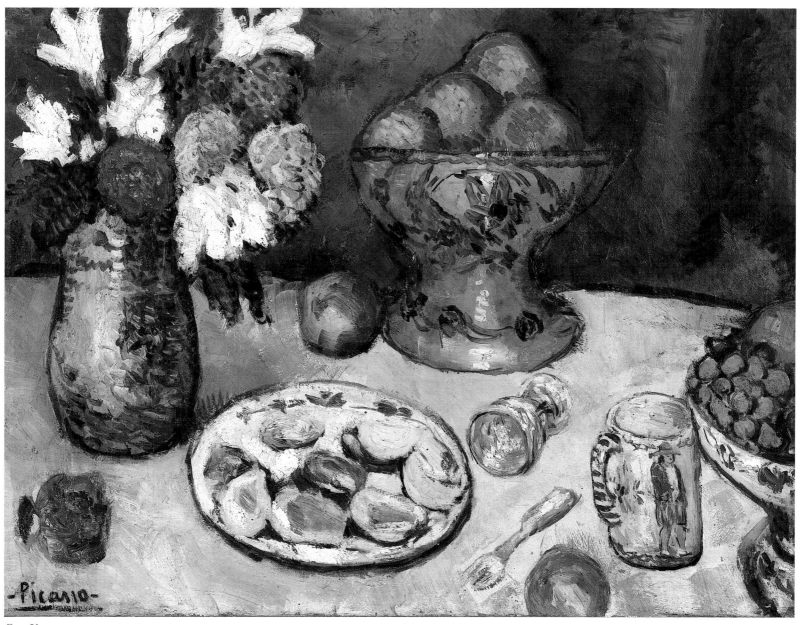

CAT. 53

## ANDRE DERAIN
## 1880–1954
## *54 VINEYARDS IN SPRING 1906*

oil on canvas  89.5 x 116.5 cm

inscribed l. r. : a derain

Offentliche Kunstsammlung Basel, Kunstmuseum

Photo: Martin Bühler, Basel

© DACS London, 1993

André Derain was born at Chatou just outside Paris and painted at an early age, taking lessons from a local landscape artist, Jacomin. In 1899 he began studying painting under Eugène Carrière at the Académie Camillo where he met Henri Matisse who later convinced Derain's parents of their son's talent. The following year Derain met Maurice de Vlaminck, with whom he shared a studio.

On the occasion of the 1901 Van Gogh exhibition at Bernheim-Jeune Gallery, Derain introduced Vlaminck to Matisse. It was then too early for these three artists, the future initiators of Fauvism, to act upon Van Gogh's example, but the exhibition of seventy-one works had a lasting impact on Derain. In September of that year he was called up for military service and wrote to Vlaminck that Van Gogh 'is much in my thoughts',[1] asking him to let him know if he had seen any more works by the artist. He later wrote back to his friend:

> You break my heart, talking about Manet and Van Gogh ... it is almost a year now since we saw the Van Gogh exhibition, and really, the memory of it haunts me ceaselessly. I can see his real meaning ever more clearly.[2]

On his return to Paris in September 1904, Derain studied at the Académie Julien and both he and Vlaminck renewed their acquaintance with the Matisse circle which, through a series of exhibitions, was beginning to attract attention. A Van Gogh exhibition of forty-five works was held at the Salon des Artistes Indépendants in 1905, coming at the right time to enable the Fauves [3] to develop their own ideas.

On 28 July 1905, Derain wrote an important letter to Vlaminck, summarizing what he had learned so far: 'A new conception of light consisting in this: the negation of shadows. Light here is strong, shadows very luminous ... I must eradicate everything involved with the division of tones.'[4] This meant a new purified form of colour painting where light is rendered by contrasts of hue, not of tone, and in which 'lines and colours are intimately related and enjoy a parallel existence

Fig. 39 Vincent van Gogh
*Old vineyard with peasant woman* F1624
Auvers-sur-Oise  May 1890  pencil, gouache  43.5 x 54.0 cm
Vincent van Gogh Foundation  Van Gogh Museum, Amsterdam

from the very start'.[5] Such a new form of colour, beyond Impressionism, is hinted at by Van Gogh who wrote to Theo: 'But the painter of the future will be *a colourist such as has never yet existed.*'[6]

In October–November of that year Le Salon d'Automne held an important exhibition (which included works by Derain, Matisse and Vlaminck) at the Grand Palais. In reviewing the exhibition, the critic Louis Vauxcelles coined the term Fauves (wild beasts) in discussing a sculpture by Albert Marque: 'The purity of this bust comes as a surprise in the midst of the orgy of pure colours: it is Donatello among the wild beasts.'[7]

In *Vineyards in spring*, Derain has raised the horizon line in order to enlarge the foreground, a device also employed by Van Gogh. The undulating rhythm of trees and grasses creates a complex pattern of lines, reminiscent of Vincent's landscape drawings (Fig. 39).

1   A. Derain, *Lettres à Vlaminck*, Paris, 1955, p. 57.
2   ibid., pp. 59–60.
3   Wild beasts, as they were nicknamed for the violence of their colour.
4   ibid., pp. 154-55.
5   A. Derain quoted in D. Sutton, *André Derain*, Phaidon, London, 1959, p. 12.
6   LT482, Arles, 5 May 1888.
7   L. Vauxcelles, 'Le Salon d'Automne', *Gil Blas*, 17 October 1905.

CAT. 54

117

# GEORGES BRAQUE
## 1882–1963
### 55 BOATS ON THE BEACH, L'ESTAQUE 1906

oil on canvas  49.5 x 59.7 cm

inscribed l. l. : G. Braque / 06

Los Angeles County Museum of Art

Gift of Anatole Litvak

Georges Braque was born in Argenteuil-sur-Seine, a small town on the Seine near Paris where many of the Impressionists had found inspiration during the 1870s. At eight years of age his family moved to the busy harbour town of Le Havre in Normandy, where his father, an amateur artist, had relocated his painting and decorating business. Braque, an apprentice in the family business, started evening classes at the local Ecole des Beaux-Arts in 1897. 'I did not decide to become a painter, any more than I decided to breathe.'[1]

In 1900 he moved to Paris and continued to study painting at night. After his year of military service, 1901–02, he decided he would paint professionally and studied until 1904 at the Académie Humbert. The young inquisitive artist was impressed by the work of the Impressionists and particularly excited by Van Gogh's paintings. He visited the 1905 Salon d'Automne and was attracted to the idea of pure colour as practised by the Fauves. He adopted the style and exhibited with the other Fauves, including Derain (Cat. 54) at the 1906 Salon d'Automne and the Salon des Indépendants.

In 1906, Braque moved to L'Estaque near Marseilles in order to paint in the intense light of the Mediterranean. Van Gogh had suggested twenty years earlier: ' ... if they are really painters trying to make progress in virgin fields, boldly recommend the South to them. I believe that a new school of colourists will take root in the South ... to express something by colour itself.'[2]

The colours of *Boats on the beach, L'Estaque* are far more vivid than Braque had used before. Separate brush strokes of pure colour capture the bright colours and radiance of the sun. This is evident in the colour reflections from the hull of the anchored boats on the rippling surface of the water. These contrast to the shorter strokes of mauve, green and carmine, in unusual combinations, that make up the sky. These effects resemble Van Gogh's attempts to capture: '... beautiful contrasts of red and green, of blue and orange, of sulphur and lilac.'[3] The idyllic subject — a small port and its surrounds — is reminiscent of Van Gogh's painting trips to places such as Saintes-Maries (Fig. 40, see Cat. 38). The high horizon line and the thick textured

Fig. 40 Vincent van Gogh
*Fishing boats on the beach* F413
Arles June 1888  oil on canvas  64.5 x 81.0 cm
Vincent van Gogh Foundation
Van Gogh Museum, Amsterdam

paint also show the influence of Van Gogh's work.

*Boats on the beach, L'Estaque* represents Braque at the height of his Fauvist period, which lasted less than two years, but he later referred to the Fauvist paintings as his first creative works.[4]

1  Braque quoted in Jean Leymarie, *Georges Braque*, Prestel-Verlag, New York, 1988, p. 9.
2  LT555, Arles, 17 October 1888.
3  LT538, Arles, c. 17 September 1888.
4  Douglas Cooper, 'Georges Braque: the Evolution of a Vision', in *An Exhibition of Paintings: G. Braque*, Arts Council of Great Britain, London, 1956, p. 5.

CAT. 55

# ERICH HECKEL
## 1883–1970
## *56 PUTTO (STONE FIGURE) 1906*

oil on cardboard  70.0 x 50.0 cm

inscribed l. l. : E. Heckel 1906

Museum Folkwang, Essen

Erich Heckel was born in Doben, Saxony. During his school years, Heckel met Karl Schmidt-Rottluff, who shared his interest in art and literature. Both young men went to Dresden Technical College to study architecture and with fellow students, founded the artists' association *Die Brücke* (The Bridge) in 1905. As one of the focal points of German Expressionism a number of other artists joined the group, including Emil Nolde and Max Pechstein (see Cat. 57, 58) in 1906.

The name *Die Brücke* was apparently inspired by a passage from the German philosopher Friedrich Nietzsche's *Thus Spoke Zarathustra*: 'What is great in man is that he is a bridge and not an end: what can be loved in man is that he is a going across and a going under'. Inspired by the achievements of German artists of the past, they were seeking to build a bridge between past and future German art. Self-taught and independent of academic teaching, the group stated in their manifesto that they wanted to create 'a physical and spiritual freedom opposed to the values of the comfortably established older generation. Anyone who honestly and directly reproduces the creative force that is within him is one of us.'[1]

Vincent van Gogh's first solo exhibition in Germany was held in the Berlin gallery of art dealer Paul Cassirer in 1901. Subsequent exhibitions followed and Cassirer organized the first major retrospective of Van Gogh's work in Germany in 1905. Significantly, Heckel and his fellow artists saw this touring exhibition of fifty-four works at Galerie Arnold, Dresden in November of that year. Previously enthused only by reproductions of Vincent's work, the artists were able to see his paintings for the first time which had a great impact on their work.

In order to break away from artistic conventions the group emphasized the instinctive and spontaneous. Van Gogh had earlier encouraged such an approach and described his technique to his friend Emile Bernard:

My brush stroke has no system at all. I hit the canvas with irregular touches of the brush, which I leave as they are. Patches of thickly laid-on colour, spots of canvas left uncovered, here and there portions that are left absolutely unfinished, repetitions, savageries; in short, I am inclined to think that the result is so disquieting and irritating as to be a godsend to those people who have fixed preconceived ideas about technique.

... I try to grasp what is essential in the drawing — later I fill in the spaces which are bound by contours — either expressed or not, but in any case felt — with tones which are also simplified, by which I mean that all that is going to be soil will share the same violet-like tone, that the whole sky will have a blue tint, that the green vegetation will be either green-blue or green-yellow ...

In short, my dear comrade, in no case an eye-deceiving job.[2]

The raw elements of Van Gogh's work appealed to them as did his independence and total commitment to his art. After the Dresden exhibition Heckel in particular, employed Van Gogh's bold colour, thick impasto and curved brush strokes. In *Putto (stone figure)*, Heckel has constructed the form using bands of complementary and contrasting colour. The high-key colours are heavily built up to give the figure textural substance, showing the artist's debt to Van Gogh.

By 1908, however, Heckel had moved away from Van Gogh's influence to a flatter, more deliberate composition and the paths of individual artists belonging to *Die Brücke* diverged long before the group disbanded in 1913.

1    Kirchner, manifesto of *Die Brucke* 1906 in Victor H. Miese (ed.) *Voices of German Expressionism*, Prentice-Hall, New Jersey, 1970, p. 13.

2    B3, Arles, 9 April 1888.

CAT. 56

# EMIL NOLDE
## 1867–1956
### *57 PAINTER SCHMIDT-ROTTLUFF 1906*

oil on canvas  52.0 x 37.0 cm

inscribed l. l. : Nolde 1906

© Nolde-Stiftung Seebüll

Emil Hansen was born in Nolde, a town close to the German-Danish border, from which he later took his surname. Following several jobs as a commercial draughtsman, he accepted a post to teach industrial design and drawing at St Gall, Switzerland in 1892. After the unexpected success of a large edition of postcards which reproduced his watercolours, he decided to become a full-time artist in 1897.

Rejected by the Munich Academy of Art, he attended a number of private art schools including the Académie Julien, Paris in 1900. Although he first saw work by Van Gogh in 1898[1] and Impressionist paintings in Paris, they had little effect on his work then. It was not until 1905 when Nolde came into contact with Karl Ernst Osthaus, art collector and founder of the Museum Folkwang, Essen and the first museum director to purchase work by Van Gogh,[2] that Vincent had a strong influence on his art. In his autobiography *Jahre der Kämpfe* (The Years of Struggle), Nolde comments on his work leading up to 1905: '... What I produced were always only beginnings and I was never satisfied. In Munich and Berlin I had seen a lot of contemporary art. I had become acquainted with the works of Van Gogh, Gauguin and Munch; I was enthralled, filled with reverence and love, I needed to absorb all that'.[3]

Nolde gradually found his own colour harmonies and in February 1906 had a solo exhibition at the Galerie Arnold in Dresden. Shortly afterwards Nolde was invited to join the German Expressionist group, *Die Brücke*  In his letter of invitation to Nolde, Karl Schmidt-Rottluff (1884–1976), one of the group's founding members mentioned Nolde's 'storms of colour'. Pleased to be a member, Nolde invited Schmidt-Rottluff to Alsen, an island near the German-Danish border, where Nolde and his wife Ada spent their summers. It was here that he painted this portrait.

With encouragement from Schmidt-Rottluff, Nolde employed a heavy impasto reminiscent of Van Gogh, who wrote to Theo in August 1888 about a portrait he was about to paint of his friend the Belgian artist, Eugène Boch (Fig. 41) : '... Instead of trying to reproduce exactly what I see before my eyes, I use colour more arbitrarily, in order to express myself forcibly. I should like to paint the portrait of an artist

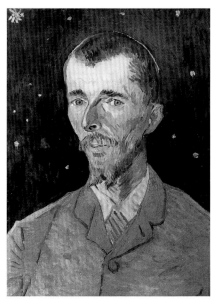

Fig. 41 Vincent van Gogh
*Portrait of Eugène Boch, a Belgian painter*  F462
Arles  September 1888
oil on canvas
60.0 x 45.0 cm
Musée d'Orsay, Paris

friend, a man who dreams great dreams, who works as the nightingale sings, because it is his nature. He'll be a blond man. I want to put my appreciation, the love I have for him, into the picture. So I paint him as he is, as faithfully as I can, to begin with. But the picture is not yet finished. To finish it I am now going to be the arbitrary colourist. I exaggerate the fairness of the hair, I even get to orange tones, chromes and pale citron-yellow.'[4] In his daring use of pure colour, Nolde has eclipsed the 'arbitrary colourist', Vincent.

At the end of 1907, Nolde left *Die Brücke* and detested being labelled an Expressionist due the limitations of the term.[5] He returned to the relative isolation of the German-Danish borderlands and continued to paint in bright colours but with a more formal arrangement.

[1]  Emil Nolde, quoted in Költzsch & Leeuw 1990, pp.315—16

[2]  In 1902 Karl Ernst Osthaus bought *The reaper* from Paul Cassirer and soon after *Portrait of a young man*, and built a fine collection of works by Van Gogh in the following years .

[3]  Emil Nolde, quoted in Költzsch & Leeuw 1990, p. 344.

[4]  LT520, Arles, 11 August 1888.

[5]  Emil Nolde, in Victor Miesel (ed.), *Voices of German Expressionism*, Prentice-Hall, New Jersey, 1970, p. 37.

CAT. 57

MAX PECHSTEIN
1881–1955
58 *BRIDGE OVER THE SEINE
WITH SMALL STEAMER* 1908

oil on canvas  46.3 x 54.9 cm

inscribed l. r. : Paris 08 M. Pechstein

Collection: National Gallery of Australia, Canberra

Purchased 1988 with the assistance

of Loti and Victor Smorgon, Melbourne

© DACS, London 1993

Born at Zwickau, Max-Hermann Pechstein began a four year apprenticeship with a scenic painter in 1896 after which he enrolled at the Dresden School of Applied Arts. Pechstein was an exceptional student: in 1902, he won five of the six annual prizes and, after transferring to the Dresden Art Academy, he won the *Prix de Rome*, the travelling scholarship for painting, in 1906. The previous year Pechstein saw the Vincent van Gogh retrospective exhibition at the Galerie Arnold in Dresden and, like many of his contemporaries, came under his influence. Pechstein looking back on this time exclaimed: 'Van Gogh was a father to us all!'[1] He met Erich Heckel and, having much in common, joined *Die Brücke*, participating in their first exhibition in 1906.

In January 1908 Pechstein saw the largest then Van Gogh exhibition of a hundred works, held at the Bernheim-Jeune Gallery in Paris. *Bridge over the Seine with small steamer* has been dated to soon after that Van Gogh exhibition[2] and Van Gogh's example is evident in Pechstein's expressive handling of paint and swirling brush strokes. In Paris, Pechstein also came into contact with the Fauves, a group of artists around Matisse, who used vital colour and expressive brush marks. They also played an important part in his development:

> I lived in that city, giving myself delightedly to everything the eye could see and the heart could feel ... It was there that my fight against impressionism began, which *Die Brücke* had already started in Dresden. However, the struggle went on in a different formal language, to match the French élan.[3]

The subdued palette Pechstein employed in *Bridge over the Seine with small steamer* is in accordance with the work of the Fauves as is his preference for a decorative and rhythmical composition.

This is the last sign of Van Gogh's influence on Pechstein's work and he left Paris in 1908 to settle in Berlin where he became the first member of *Die Brücke* to achieve public success. This acclaim was in part due to the fact that he was the only member to have a formal training but it was primarily the result of his more sensuous and graceful style. Although he was expelled from *Die Brücke* in 1912, for holding a solo show instead of exhibiting with the group, Pechstein was celebrated at the time as the most important representative of the Expressionist movement.

1  Max Pechstein quoted in Bernard S. Myers, *The German Expressionists: A Generation in Revolt*, Praeger, New York, 1957, p. 26.

2  M. Lloyd & M. Desmond, *European and American Paintings and Sculptures 1870-1970 in the Australian National Gallery*, Canberra, 1992.

3  Max Pechstein, quoted in Költzsch & Leeuw *1990*, p. 368.

CAT. 58

## WASSILY KANDINSKY
### 1866–1944
### *59 HOUSES IN MURNAU 1908–09*

oil on paper mounted on composition board

50.0 x 65.0 cm

Dallas Museum of Art, Dallas

Dallas Art Association Purchase 1963

© ADAGP, Paris and DACS, London 1993

### *60 BEDROOM IN AINMILLERSTRASSE 1909*

oil on cardboard  48.5 x 69.5cm

inscribed l. r. : Kandinsky 1909

Städtische Galerie im Lenbachhaus Munich

© ADAGP, Paris and DACS, London 1993

Fig. 42 Vincent van Gogh
*Vincent's bedroom in Arles*  F482
Arles  October 1888
oil on canvas  72.0 x 90.0 cm
Vincent van Gogh Foundation
Van Gogh Museum, Amsterdam

Kandinsky was born in Russia, where he studied law and political economics and had a keen interest in ethnology. In 1896 he moved to Munich, having turned down a law professorship in order to begin a serious career as an artist. The following year he attended Anton Azbe's painting school where he was introduced to the work of Van Gogh. In 1900 he studied at the Munich Academy but the following year left to found the exhibition society and art school, the 'Phalanx' (1901–04).[1] After the group disbanded Kandinsky travelled through Europe spending time in both Paris and Berlin.

In the summer of 1908, Kandinsky spent six weeks in the village of Murnau, south of Munich, and after buying a house in 1909, returned there frequently until 1914. *Houses in Murnau* is one of a series of the Bavarian village, which Kandinsky painted with far greater freedom of colour and technique. Kandinsky previously had resisted the immediacy of Van Gogh's paintings, preferring to concentrate on the more decorative elements of Art Nouveau and folk art then popular in Munich. The bright colours are reminiscent of Russian folk painting, but the simple brush strokes and expansive areas of colour are the first signs of Kandinsky's move away from depicting reality.

Kandinsky's *Bedroom in Ainmillerstrasse* reveals his debt to Van Gogh, in both subject and handling of paint. The subject of an artist's bedroom, transformed into an icon in *Vincent's bedroom in Arles* 1888 (Fig. 42), was also painted by other contemporaries of Kandinsky, including André Derain, Ernst Ludwig Kirchner, Egon Scheile and Jan Sluijters.

Kandinsky would almost certainly have seen the painting of Vincent's bedroom which was included in the Van Gogh exhibition of 1908 at Paul Cassirer's Gallery in Berlin and again in the Van Gogh exhibition held at the Modern Gallery, Munich between October and December in 1909.[2] The bedroom depicted here is in Kandinsky's Munich apartment in Ainmillerstrasse 36 into which the artist had moved on 4 September 1908. Decorative elements of Art Nouveau are still evident, but Kandinsky's loose brush strokes and the indefinite space of the room show a further move towards the liberation of form and colour.

In 1911 Kandinsky went on to co-found *Die Blaue Reiter* (The Blue Rider), the name given to the second group of German Expressionists. Whereas Van Gogh and *Die Brücke* attempted to express emotion, Kandinsky was concerned with the spiritual content of the work and a more intellectual form of expression.

Van Gogh's example was important to Kandinsky due to his vigorous brush strokes and his unorthodox approach to the representation of nature. However, 1908–09 represents only one phase of Kandinsky's development as an artist: in 1910, he made his first experiments with completely abstract art.

1    Works by Van Gogh were included in the Tenth Phalanx Exhibition in 1904.
2    Kandinsky was in Berlin from September 1907 until the end of April 1908. Paul Cassirer's exhibition held in April 1908 contained twenty-seven works by Van Gogh, including *Vincent's bedroom in Arles* (F482) and it was also among forty-nine paintings by Van Gogh in Brakl's exhibition in Munich, where Kandinsky moved in 1908.

CAT. 59

CAT. 60

127

## JAN SLUIJTERS
## 1881–1957
## *61 OCTOBER SUN 1910*

oil on canvas 50.0 x 55.0 cm

inscribed l. l. : J S (monogram) 10

Frans Halsmuseum, Haarlem

Jan Sluijters was born at 's-Hertogenbosch (Bois-le-Duc), North Brabant. His father was a skilful draughtsman who encouraged Jan to draw from an early age. In 1893 the family moved to Amsterdam where he began his art training at the State Normal School for Drawing and he became aware of The Hague School artists, including Anton Mauve (see Cat. 7) and the Maris brothers. From 1900 to 1903 he received a strict classical training at the State Academy of Fine Arts. Sluijters recalled that when a fellow student wanted to discuss the work of Van Gogh, he was severely reprimanded by the teacher who declared that he did not want Van Gogh's name to be pronounced within the walls of the academy. Paradoxically, it was Sluijters's success in this rigid atmosphere that was to introduce him to the work of Vincent van Gogh and to other trends in modern art.

In 1904, Sluijters won the *Prix de Rome*, the important travelling scholarship for artists that included a grant to study in Italy. There he copied the obligatory old masters but he was more interested in contemporary work, became dissatisfied and left Italy early. He travelled through Spain, Portugal and then to Paris, which was a turning point in the young artist's life, introducing him to the latest movements in art. The large Van Gogh retrospective at the Salon des Artistes Indépendants had been held the previous year and Vincent's influence would have been intensified when Sluijters saw the Fauves exhibiting at the Salon d'Automne which opened soon after his arrival.

As a condition of the *Prix de Rome* the artist sent back a number of works to Holland and his allowance was withheld. The committee decided that Sluijters was 'treading the false paths of modernism' and he returned home. He experimented with a number of styles learnt in Paris but his use of bright colours and strong brush strokes show the prevailing influence of Van Gogh's late work.

In 1910 Sluijters moved to Laren in North Holland, where he painted in the open air a number of bright Expressionist landscapes including *October sun*. Sluijters attempted to capture the atmosphere and the conditions of the day and season: 'If I wanted to paint a sunlit landscape, I would first rather want to turn my back on it. Only when I felt the sensation that was created by the glistening of the sun on the landscape, would I start to put together yellows and blues and greens, from which the landscape would emerge.'[1]

Fig. 43 Vincent van Gogh
*Wheatfield seen from the window of Vincent's room in St Paul's hospital* SD1728
Saint-Rémy autumn 1889 chalk, pen and ink 47.5 x 56.0 cm
State Museum Kröller-Müller, Otterlo, The Netherlands

In this series of landscapes Sluijters, like Van Gogh before him (Fig. 43), employed the motif of the sun or moon and stars to energize the landscape with intense colour. The flickering iridescence of the sun's rays, translated by Sluijters into short brush strokes, transforms the landscape into a play of abstract colour. Critics in The Netherlands had described Van Gogh's paintings as 'deliberate intensifications of nature's harmonies'[2] and stated that the 'raw colour expression produces a very strong, direct effect of beauty'.[3] The same could have been said about Sluijters's work. Subsequently, his paintings were well received and he went on to be one of the leading painters in The Netherlands during the first half of the twentieth century.

1   Jan Sluijters, quoted in Költzsch & Leeuw 1990, p. 248.

2   Eliza Johan de Meester, 'Vincent van Gogh', in *Nederland*, March 1891, pp. 312–19; quoted in Zemel 1980.

3   Frederik van Eden, 'Vincent van Gogh', in *De Nieuwe Gids*, 1 December 1890, pp. 263–70; quoted in Zemel 1980.

CAT. 61

129

# FURTHER READING ON VINCENT VAN GOGH

Arnold, Wilfred N. 1992, *Vincent van Gogh: Chemicals, Crises, and Creativity*, Birkhäuser, Boston.

Bailey, Martin 1990, *Letters from Provence: Vincent van Gogh*, Collins & Brown, London.

Bailey, Martin 1992, *Van Gogh in England — Portrait of the Artist as a Young Man*, Barbican Art Gallery, London.

Barrielle, Jean-Francois 1984, *The Life and Work of Vincent van Gogh*, Chartwell, Secaucus, New Jersey.

Bionda, Richard & Blotkamp, Carel (eds) 1990, *The Age of Van Gogh, Dutch Painting 1880–1895*, Waanders, Zwolle, The Netherlands.

Brooklyn Museum 1971, *Van Gogh's Sources of Inspiration: 100 Prints from his Personal Collection.*

Cabanne, Pierre 1985, *Van Gogh*, 2nd edn, Thames and Hudson, London.

Cachin, Françoise & Welsh-Ovcharov, Bogomila 1988, *Van Gogh à Paris*, Editions de la Réunion des Musées Nationaux, Paris.

Chetham, Charles 1976, *The Role of Vincent van Gogh's Copies in the Development of his Art*, Garland, New York.

Chipp, Herschel B. 1968, *Theories of Modern Art: A Source Book by Artists and Critics*, University of California Press, Berkeley.

Faille, J.-B. de la 1970, *The Works of Vincent van Gogh: His Paintings and Drawings*, Weidenfeld and Nicolson, London.

Faille, J.-B. de la 1992, *Vincent van Gogh: The Complete Works on Paper, Catalogue Raisonne*, 2 vols, Alan Wofsy Fine Arts, San Francisco.

Feilchenfeldt, Walter 1988, *Vincent van Gogh & Paul Cassirer, Berlin: The Reception of Van Gogh in Germany from 1901 to 1914*, Cahier 2, Waanders, Zwolle, The Netherlands.

Gogh, Vincent van 1990, *De brieven van Vincent van Gogh*, 4 vols, eds H. van Crimpen & M. Berends-Albert, SDU Uitgeverij, 's-Gravenhage.

Gogh, Vincent van 1988, *The Complete Letters of Vincent van Gogh*, 3 vols, ed. J. van Gogh-Bonger, Thames and Hudson, London.

Gogh, Dr V. W. 1968, *Vincent van Gogh on England*, NV't Lanthuys, Amsterdam.

Hammacher, A. M. & Renilde 1982, *Van Gogh: a Documentary Biography*, Macmillan, New York.

Hefting, Paul (ed.) 1980, *A Detailed Catalogue of the Paintings and Drawings by Vincent van Gogh in the Collection of the Kröller-Müller National Museum*, Otterlo.

Hulsker, Jan 1980, *The Complete Van Gogh: Paintings, Drawings, Sketches*, Phaidon, Oxford.

Hulsker, Jan 1990, *Vincent and Theo van Gogh: a Dual Biography*, Fuller, Ann Arbor, Michigan.

Kôdera, Tsukasa (ed.) 1993, *The Mythology of Vincent van Gogh*, John Benjamin, Amsterdam.

Kôdera, Tsukasa 1986, *Vincent van Gogh: From Dutch Collections: Religion-Humanity-Nature*, National Museum of Art, Osaka.

Költzsch, Georg-W. & Leeuw, Ronald de (eds) 1990, *Vincent van Gogh and the Modern Movement: 1890–1914*, Luca Verlag, Freren.

Pickvance, Ronald 1984, *Van Gogh in Arles*, Abrams, New York.

Pickvance, Ronald 1986, *Van Gogh in Saint-Rémy and Auvers*, Abrams, New York.

Pickvance, Ronald 1992, *'A Great Artist is Dead': Letters of Condolence on Vincent van Gogh's Death*, Waanders, Zwolle, The Netherlands.

Rappard-Boon, Charlotte van, Gulik, Willem van, Bremen-Ito, Keiko van 1991, *Catalogue of the Van Gogh Museum's Collection of Japanese Prints*, Waanders, Zwolle, The Netherlands.

Rewald, John 1956, *Post-Impressionism from Van Gogh to Gauguin*, Museum of Modern Art, New York.

Stein, Susan Alyson 1986, *Van Gogh: A Retrospective*, Bay Books, Sydney.

Tilborgh, Louis van (ed.) 1989, *Van Gogh & Millet*, Waanders, Zwolle, The Netherlands.

Tralbaut, Marc Edo 1969, *Vincent van Gogh*, Macmillan, London.

Uitert, Evert van 1987, *Van Gogh in Brabant: Paintings and Drawings from Etten and Nuenen*, Waanders, Zwolle, The Netherlands.

Uitert, Evert van, Tilborgh, Louis van & Heugten, Sjraar van 1990, *Vincent van Gogh: Paintings*, Rijksmuseum Vincent van Gogh, Amsterdam.

Walther, Ingo F. & Metzger, Rainer 1990, *Vincent van Gogh: The Complete Paintings*, 2 vols, Benedikt Taschen, Cologne.

Welsh-Ovcharov, Bogomila 1980, *Vincent van Gogh and the Birth of Cloisonism: an overview*, Art Gallery of Ontario, Toronto.

Wolk, Johannes van der 1987, *The Seven Sketchbooks of Vincent van Gogh*, Thames and Hudson, London.

Wolk, Johannes van der, Pickvance, Ronald & Pey, E. B. F. 1990, *Vincent van Gogh: Drawings*, Rijksmuseum Kroller-Muller, Otterlo.

Zemel, Carol M. 1980, *The Formation of a Legend: Van Gogh Criticism 1890–1920*, UMI Research Press, Ann Arbor, Michigan.

# INDEX

133

# LENDERS TO THE EXHIBITION

Art Gallery of New South Wales, Sydney
Cat. 7 Anton Mauve *Returning home: End of the day*
Cat. 23 Camille Pissarro *Peasants' houses, Eragny*
Cat. 30 Vincent van Gogh *Head of a peasant*

Art Gallery of South Australia, Adelaide
Cat. 11 Jean-François Millet *The sower*

Bendigo Art Gallery
Cat. 10 Charles-François Daubigny *Barley fields*

Bridgestone Museum of Art, Tokyo
Cat. 33 Vincent van Gogh *Windmills on Montmartre*

Dallas Museum of Art
Cat. 59 Wassily Kandinsky *Houses in Murnau*

Frans Halsmuseum, Haarlem
Cat. 61 Jan Sluijters *October sun*

Fundación Colección Thyssen-Bornemisza
Cat. 40 Vincent van Gogh *The stevedores in Arles*

Hamburger Kunsthalle, Hamburg
Cat. 25 Paul Gauguin *Young Bretons bathing*

Joseph Brown Collection, Melbourne
Cat. 51 John Peter Russell *Almond tree in blossom*

Lou and Brenda Klepac, Sydney
Cat. 8 Anthon van Rappard *The Westerkade in Utrecht with barges*

Los Angeles Museum of Art
Cat. 55 Georges Braque *Boats on the beach, L'Estaque*

The Metropolitan Museum of Art, New York
Cat. 49 Vincent van Gogh *First steps* [after Millet]

Musée d'Orsay, Paris
Cat. 37 Vincent van Gogh *Restaurant de la Sirène at Asnières*

Museu Picasso, Barcelona
Cat. 53 Pablo Picasso *Still life*

Museum Folkwang, Essen
Cat. 56 Erich Heckel *Putto (stone figure)*

Museum of Fine Arts, Boston
Cat. 12 Jean-François Millet *Buckwheat harvest, summer (II)*

The Museum of Modern Art, New York
Cat. 28 Vincent van Gogh *Sorrow*

National Galleries of Scotland, Edinburgh
Cat. 21 Georges Seurat *Field of lucerne, Saint-Denis*

National Gallery, London
Cat. 44 Vincent van Gogh *The chair and the pipe*

National Gallery of Australia, Canberra
Cat. 14 Jean-François Millet *The diggers*
Cat. 58 Max Pechstein *Bridge over the Seine with small steamer*

National Gallery of Art, Washington
Cat. 24 Paul Gauguin *Breton girls dancing, Pont-Aven*
Cat. 39 Vincent van Gogh *Farmhouse in Provence, Arles*

National Gallery of Victoria, Melbourne
Cat. 2 Thomas Faed *The mitherless bairn*
Cat. 3 Frank Holl *The deserter*
Cat. 4 Fred Walker *The right of way*
Cat. 5 Jacob Maris *The old mill*
Cat. 6 Willem Maris *Ducks*
Cat. 9 Théodore Rousseau *A grove of trees*
Cat. 13 Jean-François Millet *The gleaners*
Cat. 15 Jean-François Millet *Setting off for work*
Cat. 16 Adolphe Monticelli *Fête champêtre*
Cat. 17 Jules Bastein Lepage *Season of October: The potato gatherers*
Cat. 18 Claude Monet *Vétheuil*
Cat. 19 Edouard Manet *The house at Rueil*
Cat. 20 Camille Pissarro *The banks of the Viosne at Osny in grey weather, winter*
Cat. 22 Paul Signac *Gasometers at Clichy*
Cat. 34 Vincent van Gogh *Head of a man*

The National Museum of Western Art, Tokyo
Cat. 52 Paul Gauguin *Two Breton girls by the sea*

Nolde-Stiftung, Seebüll
Cat. 57 Emil Nolde *Painter Schmidt-Rottluff*

Offentliche Kunstsammlung Basel, Kunstmuseum
Cat. 54 André Derain *Vineyards in spring*

Private collection
Cat. 43 Vincent van Gogh *Young man with a cap*

Staatliche Muzeen zu Berlin, Nationalgalerie
Cat. 32 Vincent van Gogh *Le Moulin de la Galette*

Städtische Galerie im Lenbachhaus, Munich
Cat. 60 Wassily Kandinsky *Bedroom in Ainmillerstrasse*

State Museum Kröller-Müller, Otterlo
Cat. 38 Vincent van Gogh *View of Saintes-Maries*
Cat. 42 Vincent van Gogh *The green vineyard*
Cat. 45 Vincent van Gogh *Portrait of the postman Joseph Roulin*

Stichting Collectie P. en N. de Boer Foundation
Cat. 26 Vincent van Gogh *Worn out*
Cat. 27 Vincent van Gogh *Young Scheveningen woman, seated facing left*
Cat. 29 Vincent van Gogh *The sower: facing right*
Cat. 36 Vincent van Gogh *Trees in a field on a sunny day*

Tate Gallery, London
Cat. 50 Vincent van Gogh *Farms near Auvers*

Vincent van Gogh Foundation Van Gogh Museum, Amsterdam
Cat. 1 John Peter Russell *Portrait of Vincent van Gogh*
Cat. 31 Vincent van Gogh *The old church tower at Nuenen*
Cat. 41 Vincent van Gogh *The ploughed field*
Cat. 46 Vincent van Gogh *The sheep shearers* [after Millet]
Cat. 47 Vincent van Gogh *The sheaf-binder* [after Millet]
Cat. 48 Vincent van Gogh *Night: The watch* [after Millet]

Wadsworth Atheneum, Hartford, Connecticut
Cat. 35 Vincent van Gogh *Self-portrait*

# EXHIBITION MANAGEMENT

**PLANNING COMMITTEE**

Robert Edwards AO (Chairman)
Chief Executive & Director
Art Exhibitions Australia Limited
James Mollison AO, Director
National Gallery of Victoria
Graeme Newcombe, General Manager
National Gallery of Victoria
Jacky Healy, Deputy Director Public Programs
National Gallery of Victoria
Carol Henry, General Manager
Art Exhibitions Australia Limited
Graham Jephcott, Business Manager & Company
Secretary, Art Exhibitions Australia Limited
Doug Hall, Director, Queensland Art Gallery
Dr Caroline Turner, Deputy Director & Manager,
International Programs, Queensland Art Gallery
Anthony Adair, Public Affairs Manager
The Shell Company of Australia Limited
Karyn Freeman, Head, Corporate Communications
& Community Affairs
The Shell Company of Australia Limited
Owen Phillips, Passenger Marketing Manager
Singapore Airlines Limited
Sue Bender, Regional Marketing Executive
South-West Pacific, Singapore Airlines Limited
John Zeccola, Marketing & Sales Co-ordinator
Australian Air Express Pty Ltd
Ruth Jones, Public Relations Manager
Sheraton Towers Southgate
Ruth Davidson, Public Relations Manager
Sheraton Brisbane Hotel & Towers
Peter Harvie, Managing Director
Clemenger Harvie

**FURTHER SPONSORS**
**Melbourne Season:**

3MP
The Herald Sun
Television Victoria
**Brisbane Season:**
The Courier Mail
The Sunday Mail

**Special thanks are due to the National Gallery of Victoria
Business Council for its commitment to this project.**

**NATIONAL GALLERY OF VICTORIA**

*Board of Trustees*

Will J. Bailey AO (President)
Daryl Jackson AO (Deputy President)
Lyn Williams
Rhonda Galbally AO
Marc Besen AO
Darvell Hutchinson (Treasurer)
Professor Jennifer K. Zimmer
Dulcie Boling
Bill Conn

**STAFF**

Special thanks are due to Gordon Morrison and Tony Ellwood for their
efficient organization of loans in consultation with Carol Henry of Art
Exhibitions Australia Limited.
Many thanks to the following staff members who have worked on the
exhibition:

Bill Blakeney, Geoff Burke, Mark Brewster, Margot Capp, Robert Cirelli,
Susan Chizik, Isobel Crombie, Shirley Day, Catherine Earley,
Bronwen Edwards, Caroline Fry, Frances Grindlay, Julia Hadlow,
Olivia Hickey, Phil Jago, Elaine Jamison, Lyndsay Knowles, Liz Krstevski,
Gillan Leahy, David Legg, Virginia Lovett, Garth McLean, Jennie Moloney,
Gordon Morrison, Gina Panebianco, Mae Anna Pang, Graham Parker,
John Payne, Tony Preston, Ron Richardson, Helen Skuse,
Garry Sommerfeld, Steven Ward, Michael Watson,
Marcus Williams, Adam Worrall, Tony Wright

**ART EXHIBITIONS AUSTRALIA LIMITED**

*Board of Directors*

Michael Darling (Chairman)
The Hon. Mr Justice John S. Lockhart (Deputy Chairman)
Dr Jean A. Battersby AO
Betty Churcher AM
Ann Lewis AM
Alan McGregor AO
Robert S. McKay
James Mollison AO
Robert Edwards AO (Chief Executive)
**STAFF**
Jill Davies, Marina Fuccilli, Lorraine Wright